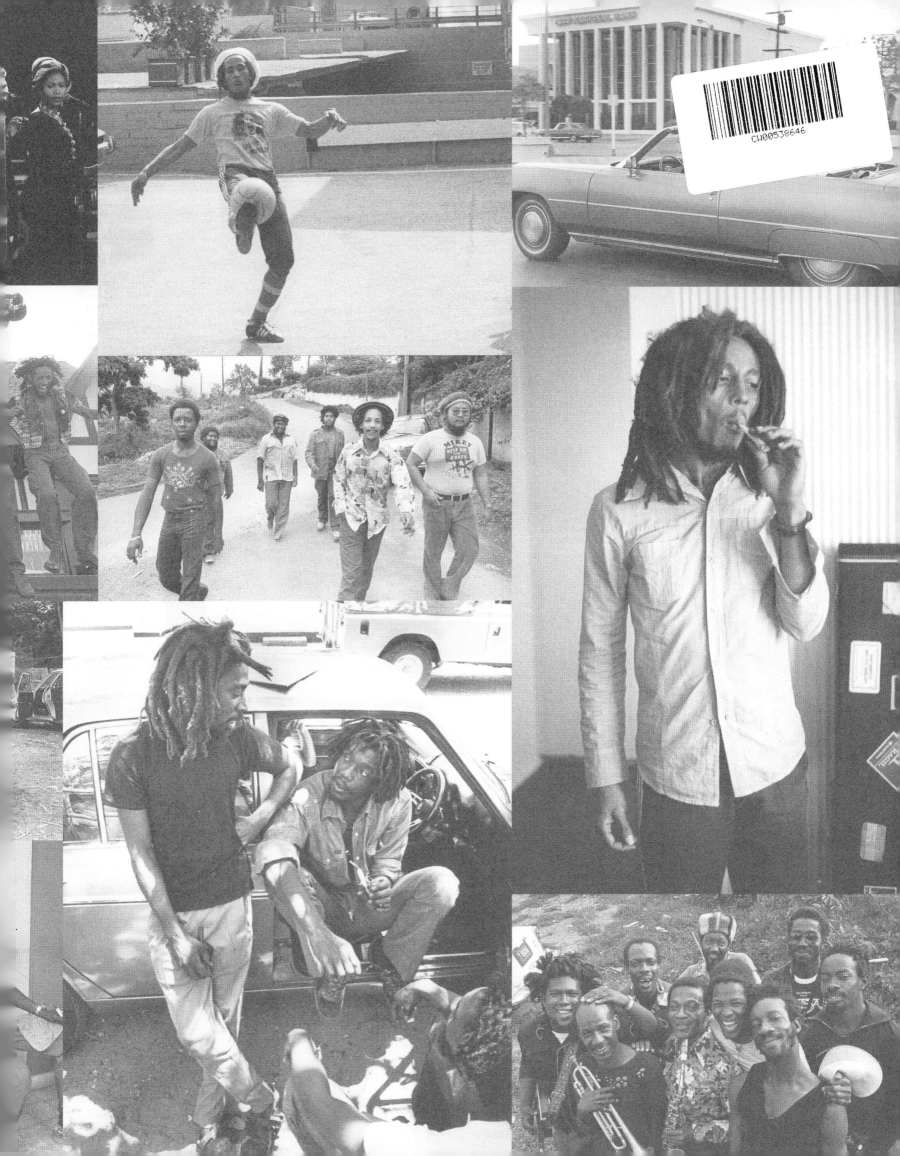

BOB MARLEY

AND THE GOLDEN AGE OF REGGAE

1975-1976 THE PHOTOGRAPHS OF KIM GOTTLIEB-WALKER

BOB MARLEY AND THE GOLDEN AGE OF REGGAE 1975-1976
THE PHOTOGRAPHS OF KIM GOTTLIEB-WALKER

ISBN: 9781848566972

Published by Titan Books
A division of Titan Publishing Group Ltd
144 Southwark Street
London
SE1 0UP

First edition August 2010
3 5 7 9 10 8 6 4
© 2010 Kim Gottlieb-Walker
Visit our website: www.titanbooks.com

Edited by Nadine Käthe Monem

Thank you to...
Cameron and Roger

And all those who set us on the path which led to Island and Bob and helped along the way including: Brian Blevins, Bob Cato, Marty Cerf, Charlie Comer, Countryman, Warren Cowan, Sandy Friedman, Neville Garrick, Danny Holloway, Dickie Jobson, Lloyd Leipzig, Allen Levy, Roger Lewis, Harvey Miller, Charley Nuccio, Steven X Rea, David Rensin, Compton Russell, Greg Russell, Greg Shaw, Mary Steffens, Bruce Talamon, Don Taylor and Dean Torrance.

Nick, Viv, Nadine, Natalie, Katy, Chris, Katherine and the whole Titan team.

To all of the contributors and writers quoted in this book and all the wonderful folks in Jamaica we met, interviewed and photographed. And of course, to Chris Blackwell for making it all possible.

This book is dedicated to the memory of those who have moved on but will always be with us... Bob, Peter, Jacob... and my mother, Blanche Gottlieb who gave me my first camera and taught me about light. And to those still gracing my life, my Dad, Sy Gottlieb, a truly kind and generous man and my husband, Jeffrey — our life together has been a wonderful adventure, every day. With love...

To receive advance information, news, competitions, and exclusive Titan offers online, please register as a member by clicking the "sign up" button on our website: www.titanbooks.com
Did you enjoy this book? We love to hear from our readers. Please e-mail us at: readerfeedback@titanemail.com or write to Reader Feedback at the above address.

A CIP catalogue record for this title is available from the British Library.
Printed and bound in China.

BOB MARLEY
AND THE GOLDEN AGE OF REGGAE
1975-1976 THE PHOTOGRAPHS OF KIM GOTTLIEB-WALKER

TITAN BOOKS

While restoring these photos, removing dust and scratches, I was reminded that photography is simply the recording of light and dark, it is nothing more. And yet, those tiny grains of light can come together to make the image of a human being and sometimes can capture a moment in time that reflects a soul.

When I opened my I & Eye Reggae Gallery in Second Life a few years ago, several rasta avatars came to see my photographs and they told me they wept to see people they loved again — Bob Marley, Peter Tosh, Jacob Miller and others — as if brought back to life.

For those who knew and loved the subjects of this book, may it bring them back (or forward as the rastas would say) to life for you, if only for a moment. And for the generations that follow, may it introduce you to the music and the people who made it live.

Kim Gottlieb-Walker, 2010

CONTENTS

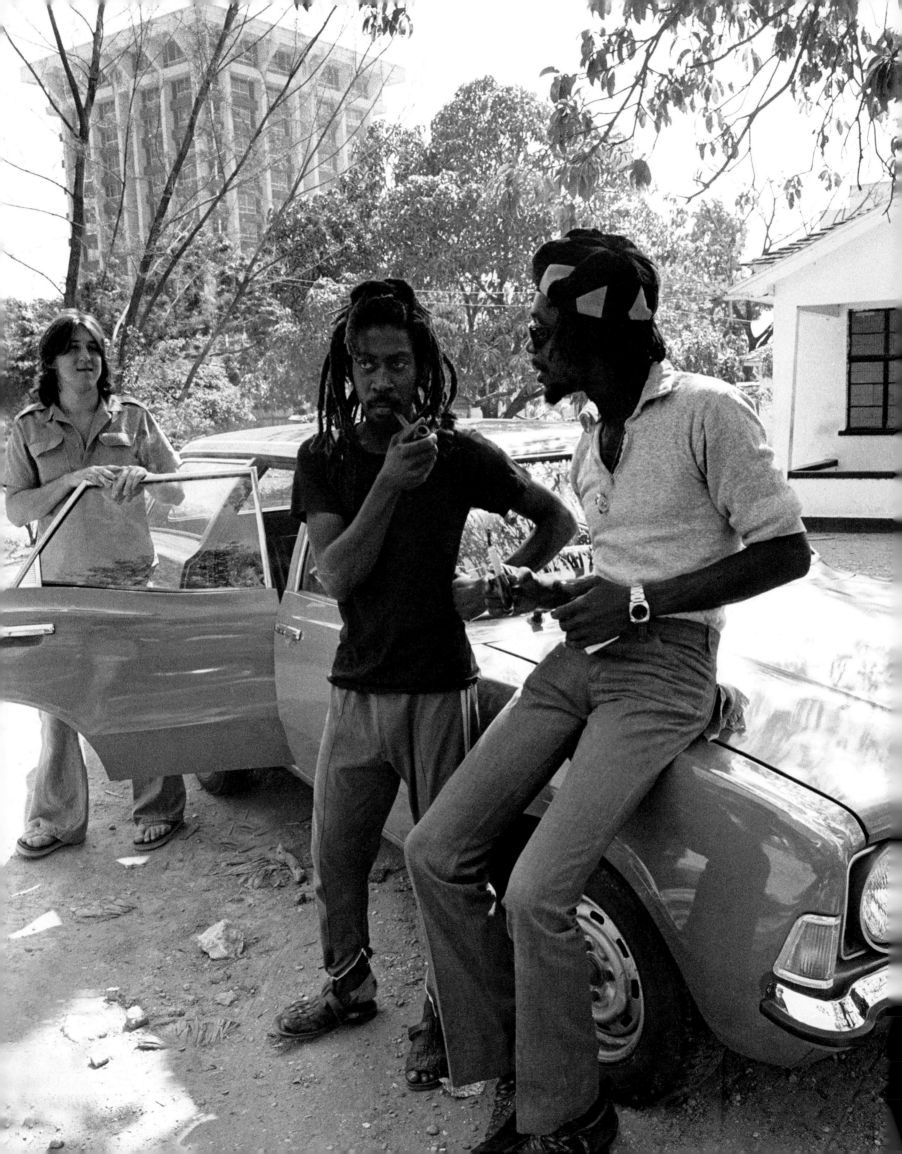

ROOTS, FAMILY, ICONS, OUR JAMAICAN ADVENTURE AND THE GLORIES OF KIM GOTTLIEB-WALKER'S CAMERA

Cameron Crowe

It's true. I'm still obsessed with those early years in the 1970s. I was just a kid, but the emotions and the music and the spirit in the air never left me. It's all part of that emotional heartbeat we develop early on, and we either stay true to it, forget it and move on… or, in my own lucky case, I was able to make a movie about it. *Almost Famous* was certainly no box-office powerhouse, but years later it's the one movie I've written or directed that seems to resonate best over time. I can see it in the eyes of people who want to talk about it. It's a personal movie about loving music and the natural community that forms around that love. It's also about 1973, and that window when music was filled with mystery and the newsstands weren't overflowing with pop culture. Music fans had much to wonder about, and much to listen to, and most of all, so much to talk about. I first met Jeff Walker and Kim Gottlieb in that magical time.

Rock itself was changing, adapting to a newer and larger audience. The business of selling music was still occupied by oddballs, sonic prophets and music-loving mavericks like Island Records' Chris Blackwell, or Shelter Records' Denny Cordell. The singer-songwriter movement had exploded with Cat Stevens' *Tea for the Tillerman*, James Taylor's *Sweet Baby James*, Carole King's *Tapestry* and Joni Mitchell's *Blue*. All of them were the stepchildren of Bob Dylan's early adventures in personal songwriting. As Neil Young said

recently, "Dylan was the first lyric punk." And so it was in these early days. All kinds of new songwriting heroes were sprouting up. In my journeys as a fledging rock journalist, just out of high school, I one day found myself on the phone with a cool-sounding dude from LA.

Jeff Walker was a fellow journalist and a publicist too. He easily negotiated both sides of the media coin. He was a music writer with a day-job in publicity — a job that sometimes had him acting as a conduit in setting up

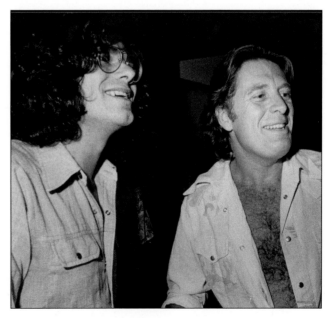

Left: Cameron Crowe, Bunny Wailer and Peter Tosh, 1976
Above: Jeff Walker and Chris Blackwell, 1975

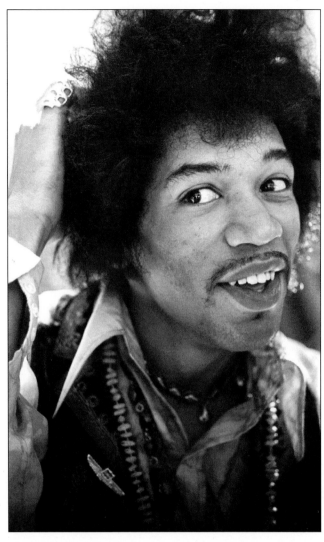

Above: Jimi Hendrix, 1967.

Right: Emmylou Harris jams with Gram Parsons, 1973.

interviews for a firm called Rogers and Cowan. Jeff had arranged for me to interview Jim Croce on the artist's tour stop in San Diego. The interview had gone well. Croce had snuck me past security, and we'd talked for a local underground paper, *The San Diego Door*, with me hidden in the dressing room of a 21-and-over club (I was 15). I promptly skipped high school the next day to hang with Croce and his guitarist, Marty, by their hotel pool. This was certainly the life. I couldn't wait to tell Jeff. In Jeff Walker, I had a compadre on the path of documenting our musical heroes. He was like a slightly older brother, one grade ahead of me, but with the same influences and references. Jeff liked authenticity in his favorite music, especially great songwriting, and we both savored interviews with the artists who specialized in these areas. Later, when Jeff was appointed music editor of a magazine called *Music World*, our friendship expanded professionally too. Walker was the most excited and knowledgeable editor I'd ever

worked with. He always took my post-interview phone calls in a flash, with a "How did it go?!!!?"

Our conversations about the questions, the interviews, and the nuances of both could stretch for hours. He pushed me to dig deeper, and dig deeper I did. Jeff was often first to point me in important new directions. He was the first guy to tell me about Nick Drake, or an obscure English folk band, or to delightfully load me with writing assignments that would send me in some amazing directions.

One day I mentioned to him that I'd gotten the assignment to do a 'bio' on Gram Parsons, a then little-known new solo artist and former member of The Byrds and The Flying Burrito Brothers. (A 'bio' was a two-page summary of an artist's career, commissioned by the record company and sent out to the press with no by-line. It was an anonymous and easy way for a freelancer to pick up a hundred dollars and stay afloat.) Jeff nearly jumped out of his skin. He spoke excitedly about the value of this upcoming interview, the importance of Gram Parsons, and Parsons' seminal instinct to combine a love of (then slightly uncool) country stars like Merle Haggard and Buck Owens with a powerful knowledge of rock pop. Parsons' passionate experiment had quietly fueled the Rolling Stones' "Wild Horses" and also helped inspire a wave of country-rock bands like Poco and of course, The Eagles. (To their credit, The Eagles are still passionate about singling out Parsons as the prime pathfinder to their gargantuan success. Their early song "My Man" is dedicated to Gram and his influence.)

Jeff loaded me up with an extra assignment on Parsons for *Music World*, and also arranged for his wife, the extraordinary artist and photographer Kim Gottlieb, to accompany me on the interview with Gram. I remember Jeff showing me some photos Kim had taken of Jimi Hendrix. I was floored. Kim's talent in slipping past the trappings of an artist's stardom were instantly obvious. It was all there in her series on Hendrix. Her camera reflected her own spirit, warm and loving and the results were striking. For once, Hendrix didn't look vaguely suspicious of the camera or the photographer. Suddenly he was no longer the most exotic animal at the zoo, photographed through the bars of a pop culture cage. Here was a shot of the artist himself, at ease, with a full and open heart.

Our interview at Gram Parsons' tour-manager's house in Encino turned out to be historic. Parsons was a soft-

voiced Southern charmer. He was starting a rehearsal for his first solo tour and band equipment was set up in the ramshackle living room. Kim, artfully adjusting her hair around the straps of the camera bags and equipment she was carrying, set about photographing Parsons with ease and familiarity. It was one of the few in-depth interviews the artist had ever given, and at one point in the proceedings, the singer-songwriter-guitarist, adorned in a floppy hat, took me aside and shared some information. He was expecting one more musician, he said with a sparkle. He'd seen her in a club. She was a young girl from DC he wanted to try out as a singer in his solo band. He clearly had a crush on her. "She's got the greatest name," he confided. He paused importantly. "Emmylou Harris."

Harris showed up a few hours later, straight from the airport, radiating a beautiful combination of nerves and anticipation, and holding her guitar-case like a schoolgirl holding a copy of *Franny and Zooey*. And then she began to sing. Her voice gave us all shivers. As Parsons guided her through a version of an old Byrds song, "I'd Probably Feel A Whole Lot Better," the two sang facing each other and we all shared a look or two or ten. The whole room tilted their way. I secretly pressed the 'on' button of my tape recorder now hidden in my orange canvas bag. (The tape is a bit muffled, the microphone was hidden in the orange bag too.) It was an afternoon of quiet lightning, and we all felt it.

It was also a remarkable glimpse of Kim's style. Life unfolded and she quietly caught the highlights. Gram and Emmylou's budding love affair, the looks between them, and Parsons' shy crush… it's all there in Kim's photos. Kim's supportive and soulful sensibility always led her to know exactly where to be with her camera. I watched her quietly work alongside the heartbeat of the music and the emotions in the room. Always a fan, always an assistant to the groove, Kim is a joyful audience as well as a documentarian. Her style is simple. Listen…snap… snap… listen… snap…. listen. It's no surprise that her work never interrupts, only inspires and celebrates the creative flow she's there to capture. Though it's said elsewhere in the wonderful collection of her work that you are now holding, it bears repeating — her proofsheets are surprisingly economical. She is not a blitzclicker, she is a collector of fine moments. And when Parsons died less than three months after our afternoon session, Kim's photos from that day became one of the few surviving documents of Parsons and his short, now-legendary life and career. And Emmylou Harris is still singing about that musical love affair that changed their lives.

My friendship with Jeff and Kim flourished in the years to come. Along with our endless pow-wows about music,

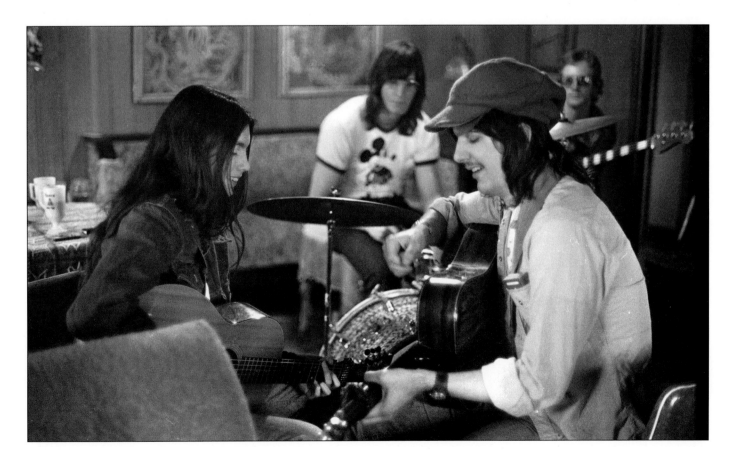

the sharing of craft and anecdotes, facts and records and songs and photos, I also had the benefit of watching how a truly dedicated relationship worked. Their son, Orion, was a perfect romantic collaboration. I watched these young parents, Jeff and Kim, raise their son with the same passion and artistry they brought to their love of music. Their instincts were something to behold. Ry grew up with all the music we loved. And it was right about this time that Jeff and Kim began talking about a new kind of music, a wave of songs and culture coming from Jamaica. It was the future, Jeff said, and it was as important as Dylan to the generation just before us. He was talking about ska, and reggae and dub… and a group he called "The Beatles of Jamaica" — Bob Marley and the Wailers.

Jeff was now working as a publicist with Island Records, and he'd visited Jamaica, walked the mean and soulful

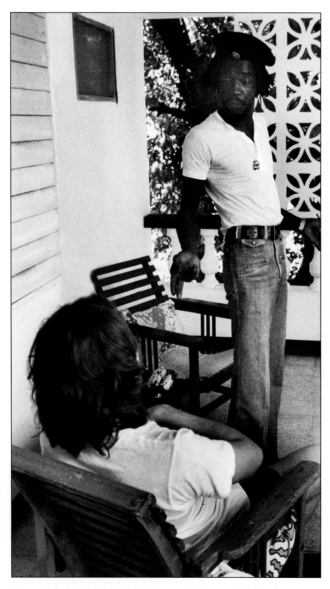

Above: Peter Tosh enlightens Cameron, Chela Bay Hotel, 1976.

Right: Bunny Wailer and Cameron Crowe in Jamaica, 1976.

streets, and hung out with Marley. Kim had been there too. It was Kim who was the first 'outsider' to photograph Marley and the young Jamaican masters around him, wildly creative artists who had previously seen a camera only as the wicked tools of tourists. Her photos would soon fill the walls of record stores and clubs around the island.

There was something special in Jeff and Kim's early conversations about this growing musical movement. They were positively giddy, but also reverent. The music was more than a commercial enterprise for these reggae artists, the Walkers stressed, it was a lifestyle and a faith. It was about culture, and the rhythm and roots of the rastafari movement. Marley's charismatic power was rooted in something more than a pursuit of simple success. It was a mission and a passion, and though Marley, with his rock star looks and universal melodies, was the reigning star of the island… the key to the movement was also in the often mysterious and mystical group of players who surrounded, played and competed with him.

As part of Jeff and Kim's attempts to spread the word about reggae, and to prepare for the release of the Wailers' *Rastaman Vibration* album, Jeff had taken a few journalists over to Kingston to meet and interview Marley. The great Lester Bangs was one of the first writers to visit, and Lester's trademark piece about the experience is also discussed elsewhere in this collection. I was in the next group. This was a smaller touring party — just us — Jeff and Kim and Ry and me. It was a family adventure, with a mission attached. Together we would further explore Jamaican culture, and the intricacies of the relationships Jeff and Kim had forged in their previous visits. With Jeff and Kim as tour guides, we worked our way through the Kingston music scene. Our trip would center around an interview with Bob Marley, of course, but there were many other musicians to track down. I had prepared especially well for Marley, who was often verbally elusive (as Bangs captures brilliantly in his piece), and discussed his work in a thick Jamaican patois filled with passion but little concrete information about his craft and methods. But this much was clear before we even began our journey, the island was bubbling with scores of characters as deep and colorful as the music itself. And with Jeff and Kim's help, I would interview as many of them as I could.

It has often been noted that only Motown Records in the 1960s could rival the plethora of street anthems and

the sheer volume of local hits that came out of this small island in the late 1960s and early 70s. That explosion was in full evidence in the heady days of our 1976 trip. Thanks to Jeff and Kim's encouragement and my early assignments for *Music World*, I'd also found my way into *Rolling Stone* magazine. They too were ready for my reports from Jamaica. So. Armed with a bunch of assignments, and a spanking new professional Uher stereo-cassette recorder in a leather case, off we traveled to the land of dub. Bob Marley was still in New York City on a business trip, but was scheduled to meet us at his home in Strawberry Hill the day after we arrived.

We landed in the afternoon, and were immediately enveloped by a sweet and strong elixir — the Jamaican humidity. We stayed at a white stucco hotel, and planned the attack of our interviews as Ry ran happily between our adjoining rooms. Word quickly reached us that Bob Marley would now be arriving a day later than we'd originally thought ('soon come'), so we worked through some of his famous bandmates and former collaborators. First on the list was solo artist and ex-Wailer Peter Tosh. Sharp and mercurial, with a serrated blade of anger just beneath an obliging surface, Tosh met us at our hotel. Tosh and Bunny Wailer, both original members of Marley's band, had left the group several years earlier. Their own albums were things of ferocious beauty. Tosh sized me up, and considered my questions with a sharply appraising stare… and a ganga-filled pipe in hand. It was a powerful conversation, and Kim's photographs capture Tosh's raging monologues about the preciousness of the art and the music and the care with which it must be protected. He was no shy Betty. You can feel it in the images contained in this collection. Tosh was killed eleven years later in a robbery attempt at his home.

Jeff also told me if I was lucky I might also interview the reclusive Bunny Wailer. Bunny was a bit more difficult to pin down than Tosh. As Jeff explained, Bunny was an "Obeah Man" — a man with powers. Jeff had been advised by Tommy Cowan, a local music-scene heavyweight, (a singer, promoter and manager) that the best way to reach Bunny was to travel to a local town square, find a special tree and "meditate" for an interview. He also said we could call him. But Bunny had no phone. We did both. We traveled to the tree and meditated. Jeff also literally 'called' him — shouting out his name. Bunny did not appear. But when we returned

the next day to the town square, on the off-chance that a second try might work out, Bunny was there waiting. He looked at Jeff with a smile and a memorable twinkle in his eyes. "You called?" he said.

The Bunny interview went well. I had learned my lesson. I refrained from smoking ganga with him. I'd been warned that a couple puffs and the whole day would disappear on you. But someone did tell me, "don't leave the island without trying some ganga tea" — a brew-like concoction made from the explosive local weed. Kim's photos of Bunny sizing me up, answering my questions with the simple eloquence of a heavy dude, are particularly revealing. The mood and sense of Bunny's 'Obeah Man' power are clear in her images. You can also just about smell the pungent aroma wafting from his trademark pipe.

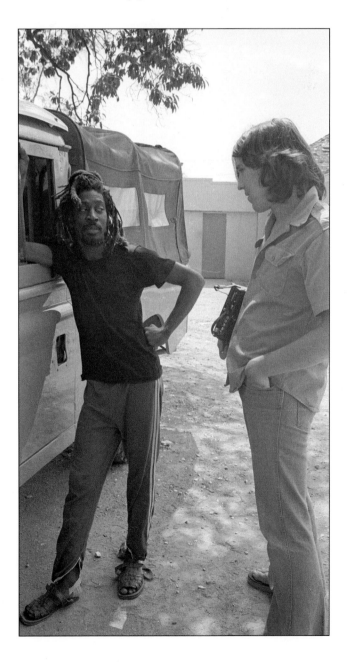

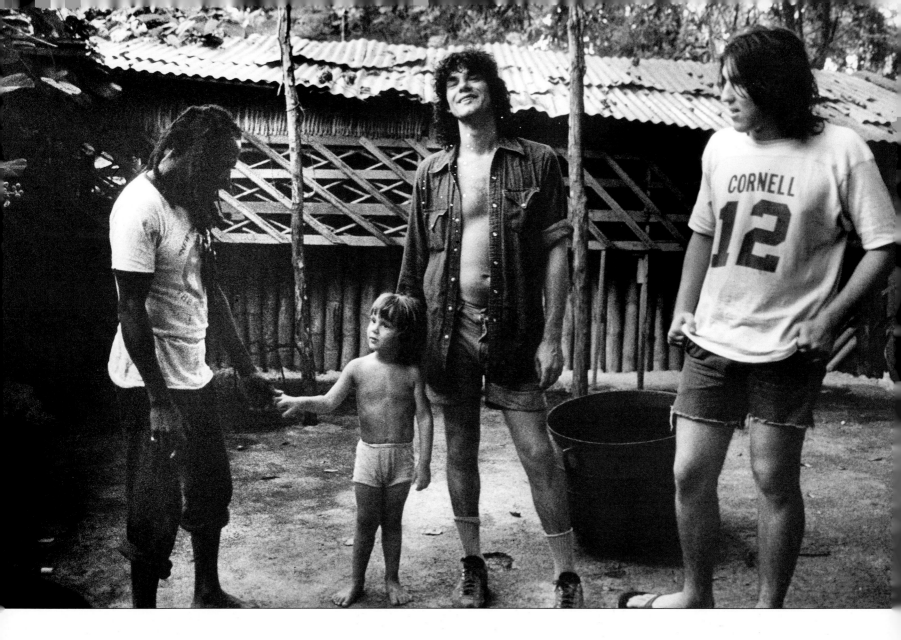

The news came that Bob Marley had decided to spend one more day in New York City. No problem. This was certainly paradise, and another day sounded like just the right idea. We visited James Bond beach, played with Ry (who had acquired the Jamaican nickname 'Ras Kitty') in waterfalls, and I was able to feel the power of how a young family could operate — all stuff I would bring to my own future relationships and experiences in child-rearing. We even visited Marley's house — where he wasn't — and spent the afternoon hanging out in his open-air bedroom. In the weeks after we left, there would be an assassination attempt on Marley in this very house. Marley survived, and I would write up an account for *Rolling Stone*. But on this day there was only peaceful solitude. Marley had some special bud in a wooden box by his bed. We assumed his hospitality would include inviting us to roll a joint from his personal stash, so we did. And though I still can't believe I risked this, I later smuggled some of the seeds from that box back to California. "These are Bob Marley's seeds, from the stash he kept by his bed!" I proudly gave

them to a stoner friend, who grew the seeds into tall plants and arranged a special party to sample the results. With Marley's music blasting, joints were rolled and the transplanted ganga from his own stash was finally sampled in the hills of Laurel Canyon. The transplanted weed had no potency. It was a lesson Marley himself might have shared — indigenous magic is often not meant to travel, particularly to LA.

The adventure continued. We visited studios, record stores and small homes, interviewing musicians and producers as we went. Like Seattle in the late 1980s, you could feel the eyes and ears of the world starting to turn their way. There was no music like it, anywhere, and all things seemed possible… including exactly what did happen. This was the music of the future. The strains of what we heard then are still present today in much of the music and the beats that thump across the musical landscape of the new millenium. But this was the real 'ting' — this was music borne out of personal strife, faith and, sometimes violent, streetlife. All still in its infancy, all captured in Kim's photographs.

We even dropped in on the Jamaican proprietor Bongo Sylli, who lived in a woven house. And yes, he served us that ganga tea. I tried a sip or two. The first sip took about three seconds to travel to the center of my skull. For the rest of the day, I was in the Jamaican version of the classic 1960s psychedelic-exploitation film *Psych Out*. Only Jeff and Kim could tell you what happened next. I'll have to check the proofsheets.

Bob Marley, by the way, never did meet me in Jamaica on that trip. He stayed in New York. He had been nominated for a key accolade for Don Kirschner's short-lived Rock Awards. Marley had a 'vision' he would win Artist of the Year. Finally, I had to return home while Marley waited to attend the ceremony in Manhattan. I had a bagful of cassettes filled with these powerful interviews and more, and of course we had our memories and notes and Kim's photos and my tape recordings of our rare conversations, all conducted at a pivotal point in modern music history. And Marley never did win that award — Peter Frampton did. The real prize, of course, is that everything happened exactly as it was meant to. Our trip was a beautiful portrait of that movement, starring the key players just outside Marley's white-hot spotlight. His effect, their music, their faces and their souls remain timeless, all vivid and electric to this very day. It was the beginning of a revolution, and a pinnacle in a treasured relationship with the Walkers. So breathe it in. Put on a copy of *Rastaman Vibration*. Read Roger Steffens' words and Jeff's recollections. Feel the music. And through Kim Walker-Gottlieb's camera, you'll see nuttin' but the trut'. Thank you Jeff, Kim, and Ras Kitty. Here's to you, and that front row seat to history.

Cameron Crowe
2010

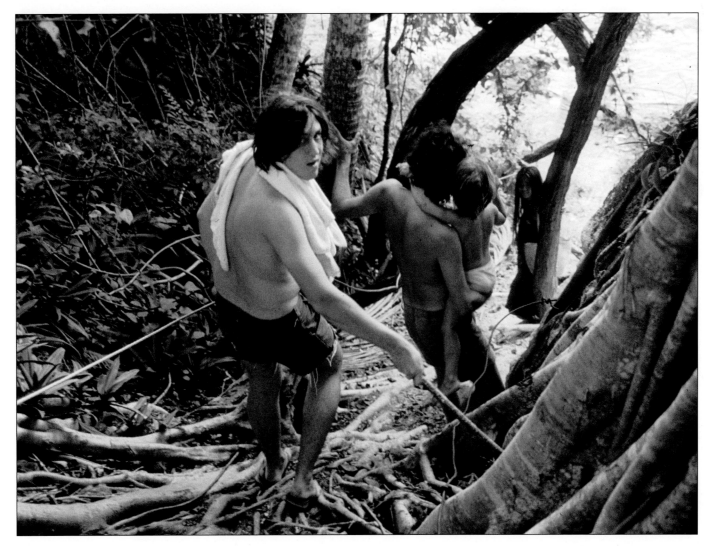

Left: Bongo Sylly, Orion "Ras Kitty," Jeff and Cameron, 1976. Above: Cameron Crowe navigating the bush in Jamaica with Jeff and Ry, 1976.

INTRODUCTION

Jeff Walker

In the summer of 1972, I was offered the opportunity to edit a new magazine called *Music World* by a publisher who had the crazy idea that if you had enough advertisers, you could give a magazine away for free. Then, it was a revolutionary idea ahead of its time. Now, it's common to walk into a store or cafe and be greeted with a wide choice of free publications. After our first meeting, the publisher — Harvey Miller — was most concerned over one thing: the photographer he wanted desperately to hire wanted to shoot a Cat Stevens concert at the Santa Monica Civic Auditorium the next night and he asked me if I could possibly get her a photo pass at the last minute. At that point in my fledgling career I was lucky enough to have a friend at A&M Records (Cat's label) I could call and managed to get us tickets and a photo pass for this photographer — named Kim Gottlieb.

Kim had been shooting a wide spectrum of music, film, political and literary figures for a few LA-based underground papers and I had seen some of her work in a local underground paper called the *The Staff* and was especially impressed by her pictures of Jimi Hendrix. But when I opened the door to my tiny one room apartment in the DeMille Manor on Argyle Avenue in Hollywood that night to greet her, I certainly had no idea I was about to meet my future wife.

So, Kim shot Cat Stevens that September night and I got the gig at *Music World* and over the next few years she photographed every interview I did and every concert I covered and her work appeared in *Music World*, *Rolling Stone*, *The Staff*, *LA*, *Feature*, *Crawdaddy* and *People* magazine among others. Frankly, as an interviewer, I could not have asked for a less obtrusive photographer as my partner. I always loved that Kim needed next to no prep time and was able to get some great shots no matter what the physical or lighting limitations might have been. Everything she shot was essentially on the go, as it happened. I can't remember a single time when we actually had a photo session in a studio or a controlled environment.

Whether as a magazine editor or a publicist, I was always blown away by Kim's work and, frankly, her eye. Her proofsheets were masterpieces of economy. Choosing the right shot was difficult, simply because every shot was worth considering. I've seen many photographers at work and many just keep clicking away, assuming that there will always be a gem on any given proofsheet. Kim waits for every shot and her ability to catch one magical moment after another was — and still is — kind of uncanny. And the moments she did capture, whether portraits, performance, on-set or candid shots at an interview were often very revealing and unique. Her portraits of Jimi Hendrix and Andy Warhol among others capture sides of those legendary artists not really seen anywhere else. Oddly enough, in both cases she captured these two legends with almost beatific smiles, marking quite

a change from the normally intense Hendrix and the equally enigmatic Warhol.

Kim went on to photograph an amazing cross-section of cultural icons of the late twentieth century — Andy Warhol, Jimi Hendrix, Dr Spock, Ray Bradbury, Tom Waits, Woody Allen, Joni Mitchell, Joan Baez, Gram Parsons, Rod Stewart, Jerry Garcia, Pink Floyd, Philip K Dick... and of course, Bob Marley.

By late 1974, Kim and I were married, our son Orion was a year old and we would be about to embark on the adventures in Jamaica you will see documented in this volume — and meet the legendary reggae artists whose music would soon be introduced to the world by Island Records.

I came to be at Island in 1974 after a year at *Music World* and another breaking into the music industry at United Artists Records as their west coast publicity coordinator. I had heard that the great UK-based Island Records was about to launch an independent US label and as a major fan of the wide array of unique music being put out by Island at that time — including Nick Drake, Fairport Convention, Richard Thompson, Sandy Denny, Roxy Music, Traffic, Steve Winwood and of course the landmark first two Wailers albums, *Burnin'* and *Catch-a-Fire*, I sought out Island founder Chris Blackwell during a trip to the UK and essentially just asked for a chance to be their director of publicity when the time came. Much to my amazement, several months later I got a call from Charley Nuccio, the President of Island USA, offering me my dream job. *Natty Dread*, The first Bob Marley and the Wailers album Island released in the States was getting a lot of attention from critics and fellow musicians, but the main audience for Bob (and reggae in general at that time) was white college kids in the northeast. Frankly, we had our work cut out for us. In spite of wide and adoring coverage in the press and media, getting mainstream and black radio stations to play reggae was an uphill battle during the disco years.

Knowing we had the classic *Bob Marley and the Wailers... Live* album on the horizon, as well as the incredible soundtrack for *The Harder They Come* and debut albums by Toots and the Maytals, Third World, the Heptones, Burning Spear and Max Romeo among others, it made sense to plan an advance trip to Jamaica so I could meet our roster of artists and interview them for their official bios. And of course I'd take Kim along to photograph everyone and come back prepared to unleash reggae on the world.

When the "Dream Concert" at Kingston Stadium on October 4, 1975 featuring Bob Marley and the Wailers opening for Stevie Wonder was announced, it seemed the perfect opportunity for such a trip. Not only would we meet and interview everyone we could, we would also get to see Bob perform and witness what would be the last reunion of the original Wailers, with Peter Tosh and Bunny Livingston.

After a few weeks of (literally) driving all over the island, during which many of these photos were taken, we returned to LA and presented a selection of photos to Chris Blackwell and Charley Nuccio for use in our press campaigns. I still remember Chris becoming visibly impressed as he looked closely at one photo after another and finally looked up at me and said in a vintage Blackwellian back-handed compliment... "You know, Jeff, these photos are really very good and I just thought you were bringing your wife along to take some snaps."

The "snaps" featured here in Kim's first book were taken between 1974 and 1976 during several visits to Jamaica and two US tours by Bob. It features a number of iconic or legendary photos, such as the *High Times* cover of Bob and the moment he met George Harrison in the dressing room of the Roxy after Bob's first performance there.

Even more important are the casual, more intimate photos of Bob, Tosh, Bunny, Toots, Lee Perry, Ras Michael, Burning Spear, Leroy Sibbles, Jacob Miller, Perry Henzell and many, many others.

There have been a lot of beautiful photograhy books by wonderful photographers covering parts of Bob's career, but no one had the access to these artists this early in their careers that Kim had, and even fewer were invited into their homes. Maybe it was because these artists knew we were there to work for them, not as members of the press... or maybe it was because they were simply comfortable with Kim shooting at will, but I think that their trust and intimacy comes though in these photos.

This book captures all of the major personalities who were behind this remarkable era in music history in a way that has never been seen before. Most of what you are about to see hasn't been shown anywhere in over 30 years.

It's been a long time coming, but I couldn't be happier that the vaults have finally been opened.

Jeff Walker
National Director of Publicity
Island Records 1974–1977

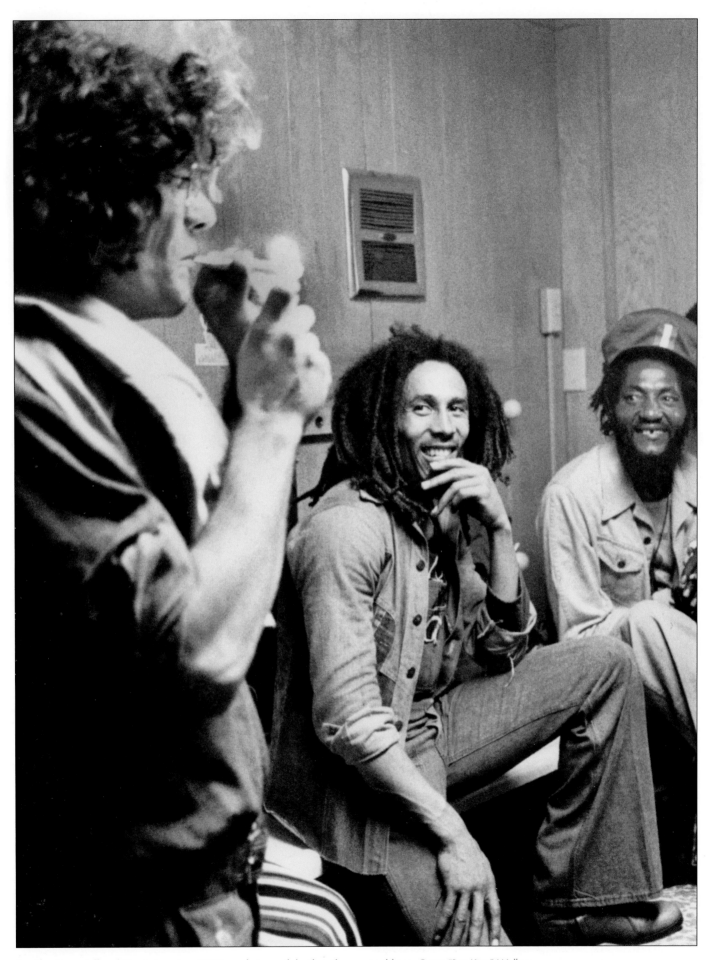

Previous Page: Jeff and Kim in Jamaica, 1976 — photograph by their three year-old son, Orion "Ras Kitty" Walker.

Above: Jeff lights a spliff backstage at the Roxy as Bob and Seeco look on, 1976.

KIM GOTTLIEB-WALKER AND THE GOLDEN AGE OF REGGAE

Roger Steffens

High above Hollywood, in the leafy hills of the legendary musical incubator, Laurel Canyon, photographer Kim Gottlieb and her husband, writer and publicist Jeff Walker, have spread their kitchen table with stacks of photos, contact sheets and thick folders of color slides. It is impressive evidence of a lifetime of devotion to documenting major moments of the musical (and, as we shall see, political and cinematic) culture of the past four decades. Kim is sharing her biography and some of the engaging stories behind the images. During the 1970s, she was privy to some of the signature figures in Jamaican music, encountering them in what we now know as the Golden Age of reggae. Her keen eye helped create many of the most unforgettable images by which these legendary artists are best known all these years later.

Her philosophy is "decisive moment" photography. "Moments," she explains, "that are a true reflection of the subject. I don't see photos as automatically being the truth, because it's just the way light is reflecting off a surface. To be able to get a decisive moment that actually does reflect the essence of the subject is the goal."

Kim shares her birthday with Bob Marley, born two years to the day after the reggae icon, on February 6, 1947 in Philadelphia, during the biggest blizzard the city had ever

seen. Before Kim was born, her mother took psychology classes at Brooklyn College with Abraham Maslow, "So she raised me to know that I could do anything I wanted to do, a very positive upbringing. We moved when I was three to Buffalo, to Fort Worth, Texas, at five, and then to Long Beach, California, at seven, and I've been a California girl ever since."

An early feminist, she claims to have "no major influences except my mom. I'm not an artist," she insists modestly, "I'm a documenter. But I do love the pre-Raphaelites, who appeal to my fairytale nature. I love their clarity. My mother, Blanche, was more of an influence than anyone because she taught me about light. She said, 'Look at how it strikes bone structure, and how it emanates from people's eyes. She had worked as a photographer's assistant before she met my dad."

Kim began her college education in Berkeley in 1964, remaining there as a psychology major for a year and a half before transferring 400 miles southward to UCLA to major in film. "I had my mother's 35mm fixed lens still camera with me at Berkeley. I photographed Joan Baez and others during the Free Speech demonstrations. This whetted my appetite for journalistic shooting. I've been a 'Lady of the Canyon' since 1977, and before that a

Berkeley girl. If the film major at UCLA didn't work out, I figured I'd just go back to being a street chick in Berkeley."

Back down south, she became even more politically committed. "I used go to the LA draft board on induction days, to try to talk them out of going to Vietnam and while on my film teacher, Bill Kerby's, camera crew covering the summer of 1967, I shot the famous Peace March that turned into a police riot at Century City on 8mm movie film. I got thrown down a hill by the cops, directly into the area where people were being beaten with billy-clubs and was rescued by an anonymous person in the crowd, who scooped me up into the throng. That night, Bill Norton, the future director, came up to our reassembled film crew and Kerby said, 'Man, you shoulda seen Kim, how she kept shooting.' And Bill Norton said to me, 'Gottlieb, you got balls of steel.' The best compliment of my life!"

A confirmed hippie, she attended many of the seminal events of the times, often as a part of Bill Kerby's masters thesis film crew. "At the Summer Solstice celebrations in Golden Gate Park we were guests of the Grateful Dead. I was even photographed at Monterey Pop with Bill, who was wearing a flag shirt, in the *Time* magazine "Hippie" issue. I was the most junior member of his master's thesis film about the events of that "Summer of Love", and I was shooting old-fashioned double width 8mm. If you did not split the film into its two lengths of 8mm, you would have 16mm with two images on each side — you could see two images at once, and never knew what would be opposite. I shot The Who on Saturday night destroying their instruments, and kept winding the film back, with multiple images of the smashing — very colorful and very violent. The next day I shot the second half of the roll with Ravi Shankar, perfectly symmetrical, as he sat unmoving except for his fingers on his sitar and flowers being tossed up from below the frame. One side is West, with The Who smashing their instruments in neon multiple exposures, and the other side is East, very still, peaceful and meditative. Bill yelled with excitement when he saw it for the first time. I hope it made it into his final cut." "While at UCLA I started photographing for the local underground press, for *The Staff*, an outgrowth of the *LA Free Press*. Bill Kerby used to do interviews for them so he could get free tickets to concerts."

During Jimi Hendrix's first foray into the City of Angels, Kim shot him for an interview he did with Bill at a Sunset Strip motel. Kerby writes in the book *Classic Hendrix*, "Jimi loved Kim, he thought she was the cutest thing in town. She was gorgeous, quite beautiful. He couldn't take his eyes off her — maybe that's why it wasn't a good interview, because he had his mind on other things. So Kim took the photos and one of them, the one of Jimi smiling really cutely, caused a bit of a stir when it was published because no one had ever taken a shot like that of him before."

Kim recalls "I also shot Jimi again backstage at the Shrine Auditorium, which marked my start in covering rock 'n' roll and other music, which started me on the path that led to meeting Jeff. Later for *The Staff*, I shot Andy Warhol, plus assorted authors and politicians, so I had a substantial portfolio of cultural icons and musicians by the time I met Jeff."

"Jeff and I have been a great team for a long time," observes Kim. "He had been an actor in the 1960s, featured in the free-love, encounter-group classic film *Bob and Carol and Ted and Alice*. We met September 30, 1972, and our son Orion ('Ry') was born August 24, 1973. We met over the formation of *Music World*, a free magazine. The publisher, Harvey Miller, thought that, as with the radio, the magazine should be free to the readers, supported by advertising and distributed in music stores. Miller hired me as photo editor and chief photographer, and considered Jeff for editor. I wanted to shoot a Cat Stevens concert, and Jeff said he could get us in. He managed to get two seats, one in the first row for me and one in the second row for himself and afterwards we went to his little apartment in the DeMille Manor on Argyle Avenue and talked until three in the morning. I told him I wasn't interested in dating; three days later he told a friend at RCA that he was going to marry me. We worked for a year at *Music World*, and because the magazine was free, we could put anybody we wanted on the cover — unknowns like Tom Waits, Jesse Colin Young, whoever we wanted. Unfortunately, Harvey Miller was both publisher and ad manager, and couldn't devote enough time to ad sales, so the magazine only lasted a year."

In late 1973, after the mag folded, Jeff went to work for United Artists records and a little over a year later, Island asked him to join their US label.

As Jeff recalls: "Before those jobs, though, I was a rock writer and reviewer and I really loved the first two Marley LPs on Capitol. I later heard that Chris Blackwell was

planning to launch a US Island label and talked my way into an appointment with Chris during a trip to London and pitched to be considered for his head of publicity. We had a very good meeting and several months later label president Charley Nuccio said Chris asked him to call me, and I was offered the job... the job of a lifetime, literally. Bob Marley and the Wailers' *Natty Dread* was our first album, with the promise of other incredible reggae acts that we were launching over the next year — the Reggae Got Soul campaign.

"Soon after, there was the final reunion of the original Wailers trio, Bunny, Bob and Peter, as part of Stevie Wonder's October 4, 1975 Dream Concert in Kingston, followed by Bob's 1976 tour to support his only top ten album in America ever, *Rastaman Vibration*.

"I spent 1975 reintroducing Bob as a solo act. Despite all the raves, his sales were low. We probably had more magazine covers and newspaper stories versus sales than anyone else ever. But we always had a problem finding black support for Bob, despite our constant efforts. In July 1975

he appeared on the *Manhattan Transfer* show and Kim shot him for a *High Times* magazine cover, but the national black magazines *Ebony* and *Jet* gave Marley very little coverage. It was impossible to get airplay, except on college and progressive rock stations. We were trying to create a new market for this music, and many other unique Island acts like Brian Eno, Sparks, Chieftains, Richard Thompson.

The couple's initial excursion to Jamaica was centered around the Stevie Wonder's Dream Concert. Jeff was amused that "Peter Tosh defiantly smoked herb on stage in front of cops, and backstage too, surrounded by cops. Columbia Records had just signed Tosh, and Chris and Charley gave me permission to be Peter's publicist as well. It made good marketing sense since we were putting out Bunny Wailer's and Bob's records concurrently. With Peter signed to a major US label, it helped to solidify our reggae campaign, especially with the Wailers reunion promised for Stevie's concert. So I suggested to Chris that Kim come with me, and we could meet all the other artists whose records we were putting

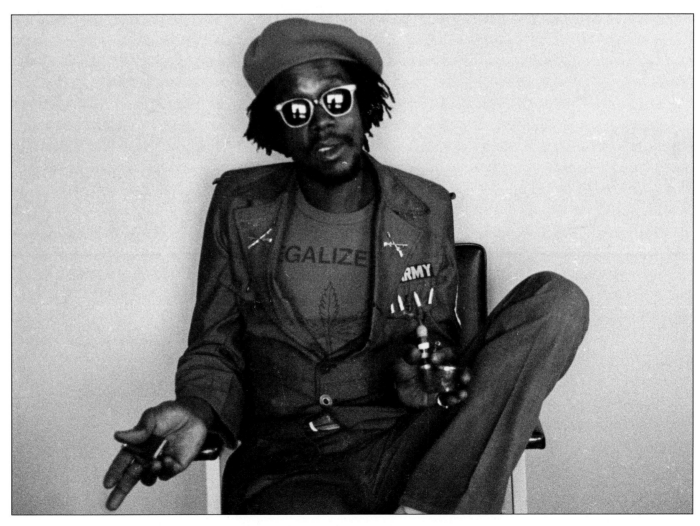

Above: Peter Tosh in Jamaica, 1975.

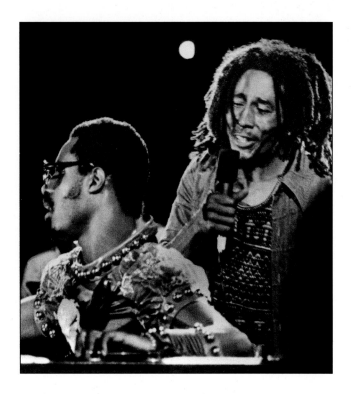

out, who needed bios and photographs for them. Kim was a well known underground photographer at this point. "The Dream Concert had an incredible vibe." Jeff continues, "When I got there early for the sound check, the cops were arriving to begin their evening's work, and I entered the National Stadium in the midst of them. Jimmy Cliff was going to play, and Jacob Miller and Inner Circle. The crowd was electric with anticipation. Peter sang his banned song, 'Legalize It,' and was the night's most interactive performer with the audience. The reunion of the Wailers was a very big deal among their home town crowd. I was very aware of the opportunity of getting Stevie and Bob together, and wanted to film it, but was turned down, so the only shot Kim got of that historic handshake between Stevie Wonder and Bob Marley was from the stage while the meeting took place on the playing field far below. Stevie and Bob performed 'I Shot the Sheriff' together during the encore but there was no video shot. The only record was the single photo Kim was able to get. Because of this incredible lack of foresight on the promoter's part, I really pushed for a film crew the following year when the fateful 'Smile Jamaica' concert was announced."

During the days leading up to the show, Kim set about documenting many of the major stars in the reggae firmament. As Kim remembers: "I'm easy to get along with, so people were comfortable with me. They knew I was there to help their music. Ironically, no one

but Bob gave me a hard time. Bob was just very 'soon come', pretty elusive at times. I shot Peter Tosh prior to my scheduled session with Bob. We were having a wonderful time, so we were with him a little longer than we thought we would be. And when we got to Bob's 20 to 30 minutes late, Bob was about to go off to play soccer. He wouldn't wait because they only had a few hours of daylight left, and took off in the car with his friends. I was standing there weeping as they drove away, and I could see his friends gave him a hard time. So I returned on Saturday and Bob graciously gave me the day to hang out and shoot whatever I wanted."

"No other photographer would have put up with what she did, going on those Jamaican assignments," Jeff remembers. "But it was amazing being around Bob's yard. It was like having a private concert, where you could hang out, smoke a spliff and listen to all this incredible music as it was being created. Then driving all over the island, just me and Kim, and believe me, driving on the left side (British-style) on narrow winding roads right out of *Dr No* took tremendous concentration. We went to Tommy Cowan's headquarters, then out to Chela Bay, and to Jack Ruby's place on the north coast, saw Burning Spear out in the bush. Peter Simon, Stephen Davis and I went to a grounation, an all night celebration of rasta, performed by Ras Michael and the Sons of Negus. We drank (bull's) blood tonic with Lee Perry as he played new tracks for us, hung out both Marley and the Heptones' recording sessions at Harry J's, sipped ganja tea and mushroom tea with Perry Henzell at his beautiful home and had the privilege of staying at the Blackwell mountain estate at Strawberry Hill where the amazing Agnes served saltfish and ackee for breakfast with a chocolate tea I still dream about."

It would seem that Kim had heard some amazing music in her time. "Actually," she corrects, "throughout my career, when I'm shooting, I'm not hearing anything. All my concentration goes into my eyes, and literally everything else shuts down. I can't tell you what the music was like at all the incredible shows I attended, or what the artists said during interviews. I was also shooting really cheap RGB movie film — it gave you color negs from which they made positive slides. The black and white tri-x, 400 asa, I often pushed to 1200 or 2400. My first real camera was a 35mm Pentax, from 1966 followed by my Olympus OM1, with a 50 or 85. I only had one camera at a time. I shot with whatever film I had on hand. I am not a technical shooter

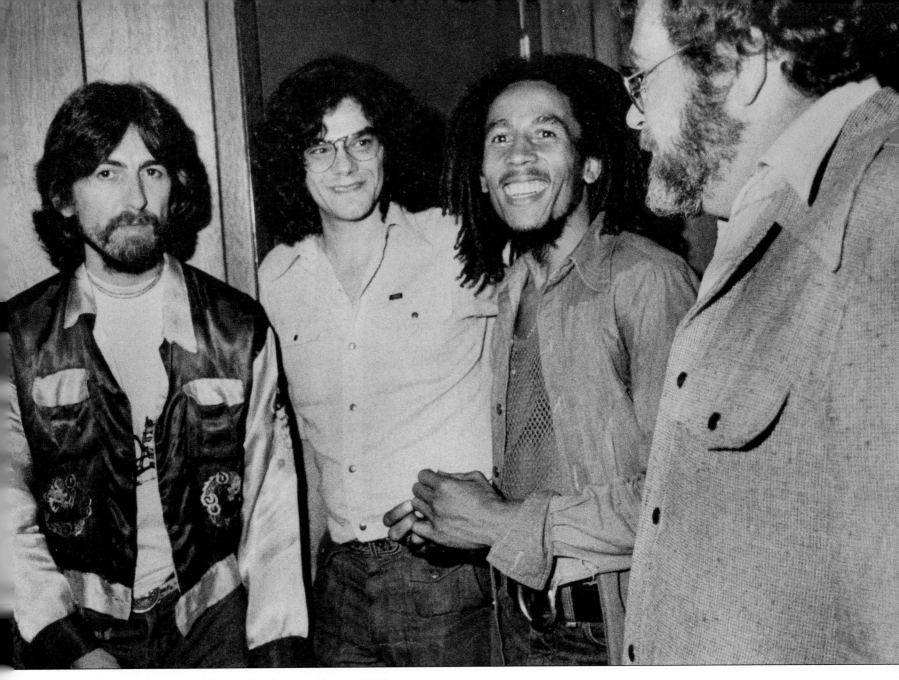

Left: Stevie Wonder and Bob Marley, the Dream Concert, 1975.

Above: Jeff introduces George Harrison to Bob, with Island president Charley Nuccio on the right.

— as far as I'm concerned it's magic that the moment that I'm seeing ends up on a piece of film. I tried to make every shot count," she agrees, "I sometimes stood with the camera up to my eye for hours at a time. But what a rush when the shot happens and you know you've got it! Everything was natural light. Even when I posed people I put them in places where the light was naturally beautiful. When I shot interviews, I would place the subject in the best light available before the interview began. Bob got so used to having me around, that it was like I wasn't even there."

According to Jeff, "Nothing got printed without Bob's approval. I showed him everything first. Chris Blackwell actually once told me that I was the only white man Bob trusted. I don't know how accurate that is, but it was great to hear and truthfully, we had a very good relationship and

I did everything for Bob that I ever promised." And unlike many other photographers who were kept on a short leash, Jeff says, "Bob always just let Kim shoot him."

With a wry smile Kim adds, "I have the world's worst memory. My pictures are my memory." Jeff laughs, readily agreeing and pointing out that Kim's short memory is probably the secret to their long marriage.

Those memories, photographic and otherwise, include the tumultuously received Roxy shows that Marley played to super-star fans at Sunset Strip's fabled Roxy nightclub in 1975 and 1976. Jeff has distinct memories of them. "We had George Harrison in 1975, and Ringo in 1976 at the Roxy. Charley Nuccio got George to come backstage and I got to introduce them... a true once-in-a lifetime moment! Bob was excited, you could see it in his eyes."

THE GOLDEN AGE OF REGGAE

The mid-1970s witnessed the most explosive outward growth of Jamaica's musical innovations, with A&R executives, record collectors, journalists, photographers and newly minted fans flooding the island, looking for the next big thing. By this time, the influential film *The Harder They Come* had been hand-carried by its director, Perry Henzell to 42 countries, in each of which a local fan base formed, eager to acquire more of this compelling music. International labels saw a huge potential, and rushed to sign the cream of the crop of Jamaica's home-grown, self-proclaimed 'stars.' Most had a decade or more of experience in Kingston's studios and dance halls, their talents honed by a hyper-critical local audience that could often be brutal in their responses to those they deemed less than worthy of public attention. Plus, they had years of material that had only tiny exposure, providing the initial albums released by Virgin, Island and Columbia among others, with artists' 'greatest hits.' It was a surefire way to create a dynamic audience.

How, wondered North America aficionados, could such a marvelous body of music exist, just a couple hundred miles from Florida, and not have been revealed previously? So many ineffable sounds to catch up on. So many styles to investigate — ska, rock steady, reggae, along with the proto-rap of 'toasting' and dub. There was also so much money for the conglomerates to cash in on — or so the thinking went then.

Jamaica's 300 years as a British colony had insured that it would be exposed to a wide variety of foreign influences. Tourists were drawn there throughout the twentieth century from all over Europe. Entertainment in the island's hotels was provided by bands of virtuoso musicians who could essay German oom-pah rhythms as easily as the mambo or tarantella. It wasn't until the late 1950s, however, that a unique local style was invented, called ska, a rollicking double-time beat that embodied elements of jazz, New Orleans, Cuban and r&b. The newly independent government in 1962 turned to professionals like bandleader Carlos Malcolm, instructing them to consciously create a truly Jamaican style that incorporated local folklore, Biblical citations, and the rural burru and pocomania drumming of the island's bush-based beliefs.

Ska received a brief flurry of attention in the States, due to Jamaica's participation in the New York World's Fair in 1964. Its pavilion there featured Jimmy Cliff and the society band of Byron Lee and the Dragonaires, putting a tuxedo on what was essentially a musical innovation given voice by down-pressed and impoverished 'sufferers.' Both Atlantic and Warner Brothers records tested the waters, but the music failed to make much of an impression on a public then mesmerized by the Beatles and the British invasion of the American pop charts.

In 1966, a new sound emerged on the Isle of Springs, thinned down and eschewing the large horn sections employed in ska. It was called 'rock steady' and its reign lasted a mere two years. Harmony groups, especially trios, came into the fore, and the lyrics became less generalized, often dealing with specific events in the ghettoes of western

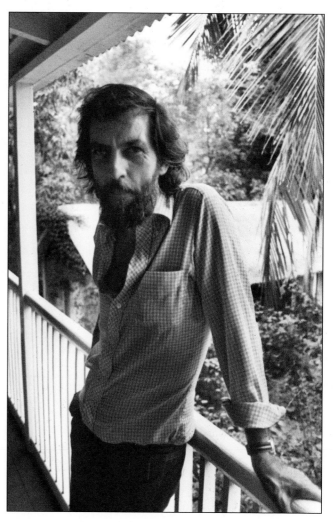

Above: Perry Henzell, director of *The Harder They Come*, at home in Jamaica, 1975.

Right: Charley Nuccio and Chris Blackwell.

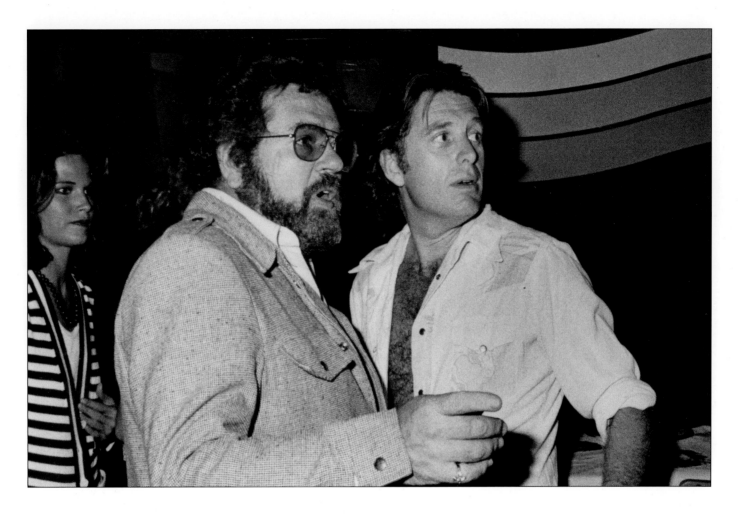

Kingston, from which most of the local artists emerged. Rude boys, slum dwelling 'bad bwois,' were praised much in the way Mexico's drug lords are heralded today in narco corridas.

Virtually all of Jamaican music is based on the primal engine of life, the heartbeat; it is only the tempo that changes as styles evolve. The influence of the island's home-grown rastafarian hymnal began to be more widely felt in reggae, as compositions like "Rivers of Babylon" gave praise to the Ethiopian Emperor Haile Selassie I, whom rasta believed to be a re-incarnated Christ. The new beat, based on that of the healthy human heart at rest, surged powerfully to the fore in 1968, in effect beginning what we now call the Golden Age of reggae.

In America, Justin Hides and the Dominoes repeated the success of Jamaican songstress Little Millie Small's ska raveup, "My Boy Lollipop," with 1969's surprise top ten hit, "Israelites." Soul singer Johnny Nash charted several times with songs written for him by Bob Marley, whom he had signed to his JAD label in 1968 as both singer and composer. But none of those songs, including the massive blockbuster "I Can See Clearly Now" was ever labeled as 'reggae.'

Britain played a major role in its worldwide spread. The UK had paved the way for masses of Jamaican immigrants to come to the mother country to solve the manpower shortage (caused by the Second World War) in the 1950s. This created a large audience hungry for the sounds of home in the ghetto areas of London and the Midlands. Entrepreneurs like the Jamaican upper class visionary Chris Blackwell imported the best works of the island's producers, establishing scores of UK-based labels that were essentially re-issue companies. Until 1973, however, the music was considered "novelty tunes," throwaway one-offs that occasionally found a home on British charts, often bawdy songs like "Big Bamboo" and Max Romeo's "Wet Dream."

Two things that year gave a newfound respect to reggae — an uncompromising film of ghetto badness called *The Harder They Come* and its provocative soundtrack, along with the Wailers' *Catch A Fire* debut album on Blackwell's Island Records label. Marley's ennobling paean to the proud and poverty-stricken, "No Woman No Cry," became one of the UK's top singles in 1975. A live album, recorded that year at his first solo concerts at London's Lyceum Theatre, was hailed as one of the best ever in any genre. Coming hot on the heels of his debut solo

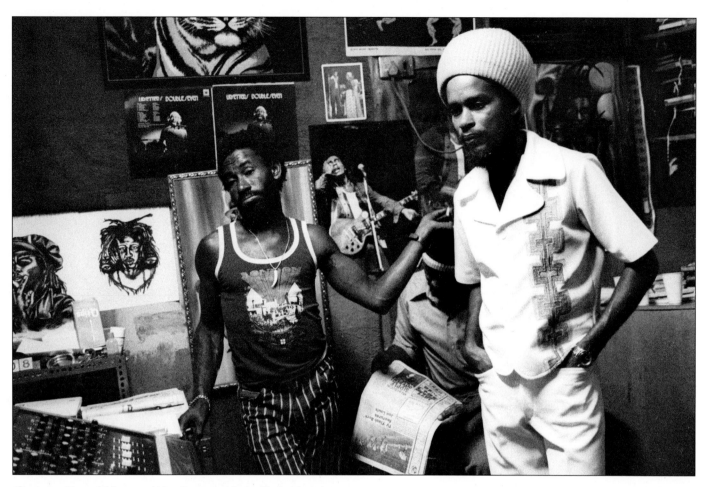

Above: Lee "Scratch" Perry and Max Romeo inside the Black Ark studios.

collection, the fiercely militant *Natty Dread*, the records' successes made Marley a mainstream star. His former mates, Peter Tosh and Bunny Wailer, would soon follow with enthusiastically received masterpieces of their own.

Eric Clapton had a crucial role to play as well. His million-selling number one cover of Marley's poke-in-the-eye-of-authority, "I Shot the Sheriff," alerted the world to the compositional power of the rasta poet and performer. Jazz master Herbie Mann followed shortly with a hit instrumental album called simply *Reggae*. Children of Britain's Jamaican immigrants began forming their own UK-based groups like Aswad, Matumbi and Steel Pulse, broadening the sensibilities of the music's concerns. Radio began adding shows devoted entirely to the genre.

As international attention focused on the fecund creativity of Jamaica's innovators, the most exciting period of the Golden Age dawned. Consider the movers and shakers of the genre who released much of their finest work in the mid-1970s, the period in which Kim was shooting: Toots and the Maytals' soulful *Funky Kingston*, *Reggae Got Soul* and *In the Dark*; the ethereal Mighty Diamonds' all-killer, no filler *Right Time*; Burning

Spear's wrenching *Marcus Garvey* and *Man in the Hills*; Ras Michael and the Sons of Negus' haunting rasta grounation ceremony, *Dadawah*; Marley's incomparable *Live* (at London's Lyceum) and his only US top ten, *Rastaman Vibration*; *Dread In A Babylon* by proto-rapper U Roy; madcap producer/performer Lee "Scratch" Perry's *Super Ape*; soul/reggae pioneers' eponymous *Third World*; the debut solo albums by Wailers' alumni Peter Tosh and Bunny Wailer — *Blackheart Man* and *Legalize It*, not to mention Tosh's highest critical success, *Equal Rights*; newly enlightened Max Romeo's *War In A Babylon* and Junior Murvin's punk anthem *Police and Thieves*, both produced by Lee Perry; *Hit the Road Jack* by lanky rapper Big Youth, whose front teeth were studded with red, gold and green jewels; Justin Hinds and the Dominoes' folky *Just in Time*; the Heptones' Perry collaboration *Party Time*; and Culture's prophetic *Two Sevens Clash*. Together, this music provides the perfect soundtrack to this book.

Reggae's international assault was led by all of these classic recordings, each of them released internationally, making the music far easier to come by for the general

public. Reggae's listening audience was moving beyond the ethnic enclaves of Brooklyn, Brixton and Birmingham and into a white market, characterized in the US by a nearly all-white college age audience intrigued by the inside-out rhythm and inventive patois slang. As major upstart indie labels such as Island and Richard Branson's Virgin went into a signing frenzy, it was this segment of hip white youth that became the target audience. The African-American market seemed strangely impervious to Caribbean protest music, and it received almost no airplay at all on r&b stations, whose deejays were notorious for airing only what they had been bribed to play. (It wasn't until the day of Bob Marley's death, May 11, 1981, that most American black stations played their first Marley tracks!) But by the 1980s, Jamaican immigrants in the South Bronx had introduced the sound system-toasting style to the disaffected American youth, and rap was born. The bare drum-and-bass sound of Jamaican dub versions, the instrumental flip sides of nearly all the island's 45s, helped the techno form of sonic manipulation, originally practiced in the late 1960s by Lee Perry and King Tubby, to become a hugely important part of late twenieth century popular music. Marley and his peers brought consciousness back to rock and roll, after a dead-end period of glam and disco. Jamaican 'toasters' were transmogrified into Japanese, African, Polish and South American rappers, forever changing the face of pop.

And so it was against this background that Kim would travel to Jamaica not just as an observer, but as an insider. Thanks to her husband's budding relationships with the heaviest dreads of the time, she was allowed into their homes and hangouts in ways that most other investigators were not. The resulting pictures, many of the best of which appear in these pages, produced images that were eagerly collected and displayed around the world — and sometimes acted as a guarantee of personal safety. In 1976 a second trip to the Isle of Springs was arranged, this time with son, Ry, in tow. Their return to the chaotic streets of Kingston was inauspicious — at first. "We got accosted at the bus station," recalls Jeff. "There was a huge billboard of Bunny Wailer's debut album, *Blackheart Man*, which we wanted to document, and two gigantic guys came over to us demanding to know 'Who are you? CIA?' I said, 'We're Island Records, this is Kim Gottleib.' 'Oh, Kim, we know Kim. She's ok, mon'.

THE ARTISTS

"Scratch" — born Hugh Rainford Perry — was perhaps the beating heart of the Golden Age of reggae in this crucial year of its history, when dozens of major artists were creating the finest work of their careers. Known by many names — Lee Perry, the Upsetter, Pipecock Jackson — his Black Ark studio had opened two years earlier in Washington Gardens, one of the city's quieter residential enclaves. The modest cement block studio, hardly bigger than a garage, stood behind his house, which bore parti-colored murals honoring the major figures in rasta — Haile Selassie and Marcus Garvey, as well as Scratch himself. Here he stirred an aural cauldron containing a babble of bats, banshees and babies mixed over interstellar dub tracks. A veritable Outsider Art museum, the diminutive Perry's domicile was a madhouse of graffiti layered upon even more graffiti, (Perry suffered from graphilalia, the irresistible compulsion to cover every surface available with visual word salads), dangling baby dolls and holy pictures, juju bags and fetid "holy" water, scattered among tape boxes marked "Shit," "Piss" and "Fuck," themselves strewn across the cement floor of a tiny back room he labeled his "Thrown Room."

The activities on this cramped site went on practically 24/7, and their sonic excrescences were a critical factor in reggae's international acceptance. Perry's bizarre antics, both professionally and privately, were a prime draw for the profusion of hangers-on surrounding his studio — hustlers, rudeboys and the merely talented. It was their demanding, cramping presence that led the unpredictable producer to torch the Black Ark in 1980 in an intoxicated fit of madness, leaving its roofless hulk in ashy ruins right up to the present time.

During the Golden Age, along a narrow driveway to the right of Perry's front house, one might encounter veteran Max Romeo who at the turn of the decade had shaken up the British censors when his single, "Wet Dream," crashed its way into the UK top ten, despite being banned from airplay. Claiming it was about a leaky roof, Romeo turned his slack reputation around as he climbed aboard the Protest Train in a scorching Scratch-produced 1976 album of fiery prophecy called *War Inna Babylon*. Or one might find the sky-soaring alto vocalist, Junior Murvin, warming up his pipes with

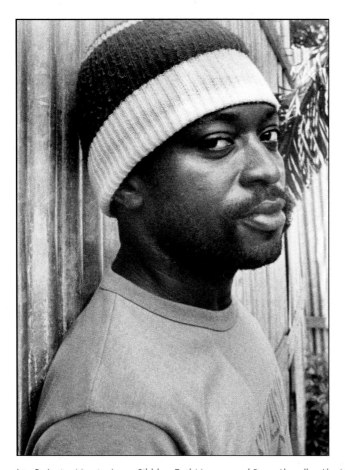
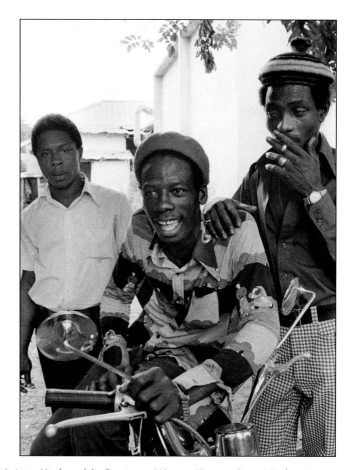

L to R: Junior Murvin, Leroy Sibbles, Earl Morgan and Barry Llewellyn (the Heptones), Justin Hinds and the Dominoes, Winston "Burning Spear" Rodney.

"Police and Thieves," a lament that these two types of gun-totin' dudes weren't really that different after all, "with their guns and ammunition." His ethereal plaint soon became an anthem for youthful protesters in the streets of London and elsewhere, even covered by punk idols, The Clash.

Frequent Black Ark visitors also included the towering Leroy Sibbles along with Barry and Earl, his compatriots in the Heptones. Some of that key trio's best work was laid with Perry at the controls during this period. Leroy had been the lead singer of their hit-making harmony group, as well as the bass player for Coxson Dodd's Studio One house band in the 1960s. Their "Book of Rules" is considered one of the all-time great Jamaican 45s, based on an old inspirational poem: "Each is given a bag of tools, a shapeless mass and a book of rules." Scratch gave the Heptones a newly muscular sound on their "Party Time" LP collaboration, and renewed their reputation in the process. Eschewing earlier, bawdy material like "Fattie Fattie," which sang of their need for "a fat girl tonight," they now caught the political wave of the 1970s, especially in their accusatory condemnation of top-ranking politricksters, "Mr. President."

Jamaica was alive with partisan fervor as the Walkers arrived. The antagonistic Socialist Prime Minister, Michael Manley, was about to run for a second term, campaigning with fervent and inciting Marxist rhetoric. He had befriended neighboring Cuba, much to the increasing chagrin of the fading, fear-filled Republican regime in Washington. Along with Kim and Jeff came Cameron Crowe, then a precocious journalist for *Rolling Stone*, eager to beat the bushes for the roots of reggae, alongside the writer and photographer team of Stephen Davis and Peter Simon, whose reportage would lead to the ground-breaking book, *Reggae Bloodlines*. "It was Cameron," said Kim, "who christened Ry, 'Ras Kitty,' because our son loved cats so much."

Other professionals followed, music business execs and talent scouts, most notably Jeff's boss, Chris Blackwell and Chris' chief competitor in the counterculture, Richard Branson — heads, respectively, of the Island and Virgin labels. These men would meet with local producers like Jack Ruby, who took his bad boy name from the murderer of Lee Harvey Oswald and was reputed to be involved in very dangerous dealings on the island's north coast. Ruby introduced them to groups like Burning Spear and

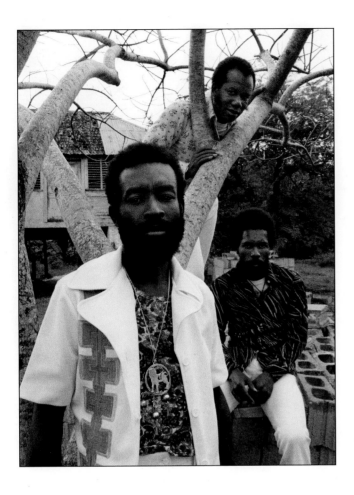 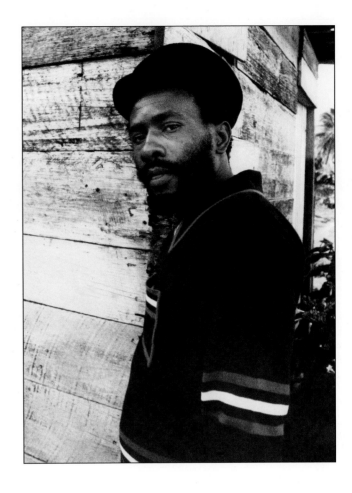

ska pioneers Justin Hinds and the Dominoes. Hinds had released a reported 70 singles between 1964 and 1966, many of them huge sellers. His 'country reggae' style was a smooth amalgam of rural folk wisdom and ancient Biblical aphorisms, of which "Carry Go Bring Come" was among the most successful examples, rediscovered successfully in the early 1980s by the emerging two-tone revival groups in the UK. "I photographed Justin Hinds by Dunn's River Falls on the North Coast beach in *Dr No* where Ursula Andress got out of the water in her bikini and met James Bond," says Kim. "Today it's even called James Bond Beach. It's below the Lion's Den, a hand hewn straw and wood rasta B&B, built on 'capture land' by a rasta artist named Sylvester Ivey, who was known as 'Bongo Sylly.'"

Marcus Garvey's most significant musical advocate, Burning Spear, represented the quiet but explosive power of the Man in the Hills. He hailed from St Ann, where Kim photographed him, the same parish which had been home to Marcus Garvey, Bob Marley, as well as Harry Belafonte. Leader Winston Rodney's nickname became the name of his mid-1970s trio as well. His anguished, cave-deep vocals were voluptuous chants, each of his albums a long and continuous hypnotic riff, designed to take one to what Australian writer,

Michael Thomas, called the "psychic rapids of Upper Niger consciousness." His deep baritone echoed with cries from the past, dark carnal nights of captivity. He would go on to become one of reggae's hardest working touring acts until his semi-retirement in 2008, dispensing an album a year of soulful and spiritually satisfying musical sacraments.

In his way, "Jah Spear" was continuing in the paths of rasta originators like his forerunners Count Ossie and the Mystic Revelation of Rastafari, who had played for the rasta god, Haile Selassie I, on his triumphant royal visit to Jamaica a decade earlier. This was music as divine linkage, a path to the vibration of the creator, based on the Nyahbinghi drum, which represented the beating of a healthy human heart at rest. This foundational form's other main exemplar was Ras Michael and his Sons of Negus band, a floating lot of roots musicians who rejected the life of colonial submission and "ignorancy." Instead, they preferred to lead an "I-tal," or natural, life, ideally in the bush where they could grow their food and smoke their herbs in peace and carry on profound reasonings in 'grounations.' These rasta sessions of intricately argued theological discussions and praise could often go on for days.

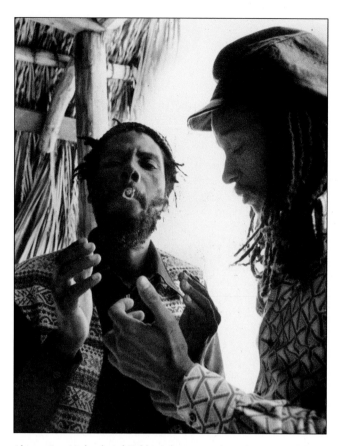

Above: Ras Michael and Kiddus I share a smoke in Jamaica, 1975.
Below: Toots Hibbert of Toots and the Maytals in Southern California.
Right: Third World (L–R: Cat, Richie, Carrot, Ibo, Bunny & Willie).

Singer and herbsman Kiddus I moved among these bredren, and went on to fame as a star of the 1980 Jamaican film, *Rockers*. His striking, pale countenance was ideal for Kim's black and white investigation. At the same time 'toasters,' those who would be called rappers today, were on the ascendant. Dominating sound system clashes, they free-styled over echoing 'dub' tracks, raw instrumentals mixed to minimal dimensions that cracked a hole in the universe. Dillinger was a particular local favorite, whose work was gaining prominence abroad. His track, "Cocaine" had become number one in Holland. The story goes that at that time he was living in New York. The Dutch record label's owners wanted desperately to mount a tour with him in Holland, but no one could find him. Eventually he was discovered in a lunatic asylum in New York City. He had been walking the streets one night when a policeman stopped to ask him some questions. When the cop couldn't "penetrate the patois," he thought Dillinger's thickly accented speech was the raving of a madman, and confined him for observation. Bailed out, he went on to musically conquer several European countries with his witty brand of rapping.

Another producer and studio owner whose career had contributed significantly to reggae's international acceptance was Harry J (for Johnson). His then-current album with the Heptones (co-produced by American Danny Holloway) was called *Night Food*, their first to be released in the US, for Island Records, with interior photos by Kim. At the start of the decade, his production of Nina Simone's classic "Young, Gifted and Black," as sung by Bob [Andy] and Marcia [Griffiths], hit England's top five, becoming a UK perennial.

Among the groups making their flashiest moves concurrent with the Walkers' exploration of the island, were Third World and Jacob Miller and Inner Circle. Third World's charismatic lead guitarist, Stephen 'Cat' Coore, had been a member of the initial lineup of Inner Circle, whose core (in more ways than one) was the Fatman Riddim Section. These were two sumo-size brothers, Roger and Ian Lewis, who were joined by the equally bulky and witty figure of Jacob Miller. They appeared in Jeremy Mare's brilliant, non-pareil 1977 documentary *Roots Rock Reggae*, shot for British television, in which they revealed their song-writing prowess from conception to first public performance. Lead singer Miller was a ghetto hero, one of the main headliners at the gigantic "One Love Peace Concert," held in Kingston in April of 1978 to welcome

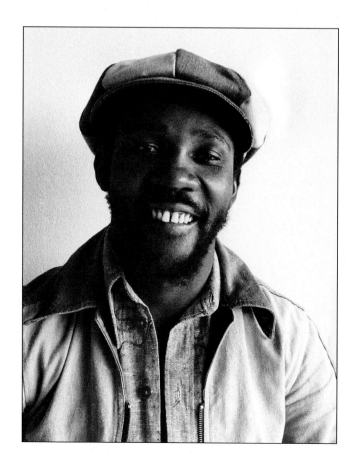

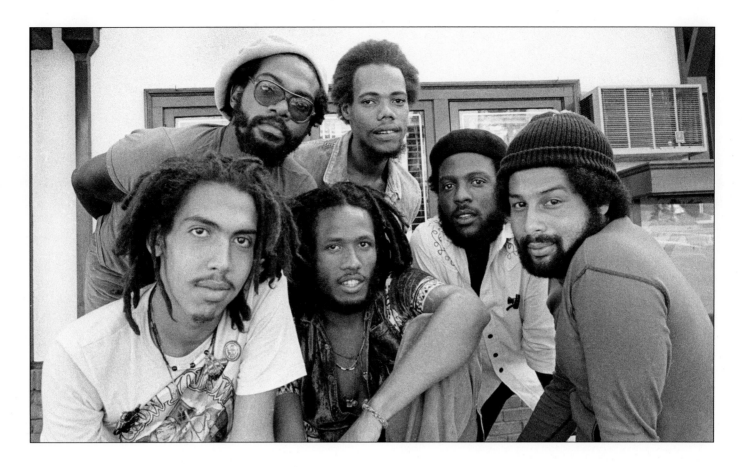

Bob Marley home from a 14-month exile after an attempt on his life, and to cement a fragile peace truce in the ghetto. By 1980, Jacob was more popular than Marley in their home country, and about to initiate a world tour with his friend Bob, which would have made reggae history. Sadly, that spring he died in an automobile accident, shortly after his return with Marley from a promotional tour of Brazil. You can seen him in the often laugh-out-loud funny *Heartland Reggae*, stealing a policeman's cap and dancing shirtless on a crude stage in the middle of a cow pasture in Savannah-la-Mar, Jamaica's westernmost parish. The film also includes much of his performance at the tension-filled Peace Concert. He's also featured comically in the rollicking, Robin Hood tale *Rockers*, set in the, sometimes treacherous, backstage world of the music business.

Toots and the Maytals, whose lead singer, the effervescent Frederick "Toots" Hibbert, was an early contemporary of Marley, Cliff and other ska-era hit-makers, also joined the Island Records roster in the mid-1970s. His irresistible songs, "Pressure Drop" and "Sweet and Dandy" had been a significant part of the million-selling soundtrack album to the movie that broke reggae worldwide — Perry Henzell's "The Harder They Come." His songs, like Justin Hinds', mixed the African-inspired

folklore of country people and the quotidian perils endured by ghetto sufferers, and won three first place awards in the annual Festival Song competitions. This did not stop the authorities from setting him up and arresting him on false ganja charges, leading to a 12-month stint in prison — and a hugely successful musical account of it in "54-46 Was My Number." In 2007, during a living legend tribute/ interview at the Rock and Roll Hall of Fame in Cleveland, Toots, who had recorded three differently titled versions of the song, announced to a shocked audience that, in fact, "54-46 wasn't my number. Me never have no number. Me just make it up." Jeff accompanied Toots when he and the Maytals opened for The Who on their 1975 American tour (by bus), and when Kim and Jeff encountered him in Jamaica, he was already an iconic figure there.

Third World became the 1970s soul platoon in reggae's multi-front invasion force. Cat Coore had been invited by Marley to be the Wailers' lead guitarist at the same time the different members were coming together to form Third World. Cat had studied the cello with Pablo Casals in his youth. In fact, the group's members were all well-educated uptown youth. Their goal was to be a bridge to US r&b, which had always been an important influence in Jamaican music, particularly during the island's mid 1960s rock steady period. They became known for their cover of "Now That

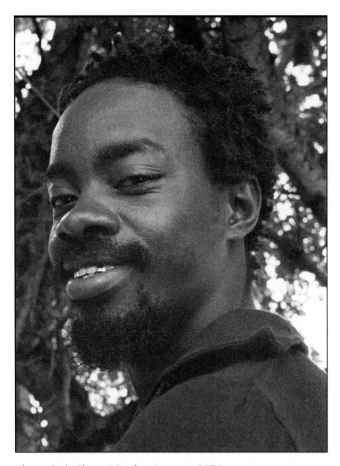

Above: Earl "Chinna" Smith in Jamaica, 1975.

Right: Peter Tosh in Jamaica, 1975.

We Found Love," and their own "96 Degrees in the Shade," radio-friendly tunes that were among the few Jamaican sounds to garner airplay on black American stations.

A popular gathering place for many of the more 'rootical' artists was the yard of Top Ranking Records' owner, the ebullient Tommy Cowan. "I shot Tommy with the Compton Brothers, Russell and Greg, who were well-known tennis players and close associates of Tommy and Bob Marley," remembers Kim. Cowan had been a member of the 1960s Festival Song-winning group, the Jamaicans, and would go on to produce a trio of childhood polio survivors, Israel Vibration, bringing them to international attention. In the 1980s he was an energetic host of the giant annual Sunsplash Festivals in Montego Bay, as well as on that event's worldwide tours. A member of the Twelve Tribes house of Rastafari, he was joined in it by a fascinating guitarist named Earl "Chinna" Smith. His nickname was a corruption of the word "tuner," garnered from his father who was an electrical technician. Rasta elders hailed him from his early teens as "Melchizedek the High Priest," because of the depth of his reasonings and his spectacular ability on the guitar.

He would eventually go on to be an important part of Ziggy Marley's touring band. But in that bustling year of 1976 he was actually a Wailer, backing Ziggy's dad, Bob, on his breakthrough world tour in support of the Wailers' *Rastaman Vibration* album. The record was a prime focus of Jeff's activities that summer, as head of Island Records West Coast promotion department.

The Wailers had started as a harmony group, releasing their first record, "Simmer Down," a scintillating ska scorcher, and instant number one, in the summer of 1964. The core of the group — Bob Marley, Peter Tosh and Neville Livingston aka Bunny Wailer — remained together essentially for the next ten years, trying everything in their power to reach an international market, with a particular (though unfulfilled) desire to reach the black audience in North America. They ran through three of the most important producers in Jamaica during that time: Coxsone Dodd, Leslie Kong and Lee Perry. When they signed a performing and writing contract in 1968 with soul singer Johnny Nash and his business partner, Danny Sims, they thought that their path was finally clear to conquer the US. Instead, Nash's versions of Marley's increasingly sophisticated compositions charted in the US, but the Wailers' own versions could never gain traction there. In late 1972, Sims sold their contract to Jamaican entrepreneur Chris Blackwell — and the rest is history. With 1973's dual punch of *Catch A Fire* and the Wailers' final effort as a trio, *Burnin'*, the group's critical success was assured. As they split apart at the end of that year, there followed a trio of spectacular critical and commercial successes, solo debut albums — Marley's *Natty Dread* in 1974, followed within the next two years by Tosh's *Legalize It* and Bunny's *Blackheart Man*. The reason that they had been hailed as the Jamaican Beatles became apparent, at long last, to the outside world — they were three men each capable of writing, producing and singing their own provocative, idealistic compositions. They appeared together a handful of times in Jamaica after the official breakup, onstage with the Jackson Five, Marvin Gaye and, in October of 1975, with Stevie Wonder at the National Stadium. As Kim and Jeff began their work with them, they were kings of the reggae world, about to take it by storm.

Peter Tosh had the most militant reputation, the Malcolm X to Bob Marley's Martin Luther King. He was often the victim of police brutality for his outspoken

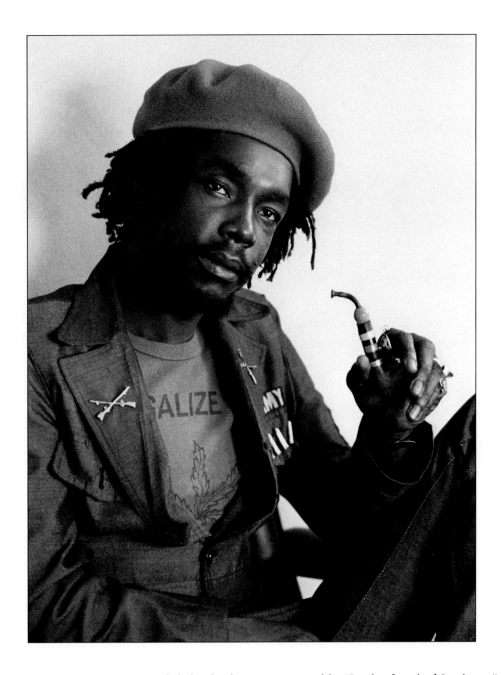

and sometimes riotous activities, once even left for dead in a jail cell. During the so-called "Walter Rodney" demonstrations of 1968, he commandeered a large bus, filled it with poor people from Trenchtown and drove it through the display windows of a downtown department store, which was promptly looted to the ground. He smoked herb in open defiance of the country's strict laws prohibiting it, and told the authorities, who he called "Babylon," that "Only Jah law is legal on this earth." A towering figure, he became a limber martial arts expert, and used the slashing movements as part of his stage show. Like Bob he was a country boy, raised in Savannah-la-Mar back in the bush, coming into town as a teen to seek his fortune. Songs he wrote for the Wailers included the incantatory anti-slavery anthem, "400 Years," but he also merged traditional calypso and mento sounds in

tunes like "Jumbie [zombie] Jamboree" and "Hoot Nanny Hoot," as well as spirituals in "Amen." During 1976, it was impossible to enter an urban club or a rural dance or zinc-fenced roadside bar, without hearing "Legalize It," which, for a while, seemed the defiant national anthem of the island's increasingly restive, rebellious population. Despite his sometimes off-putting demeanor, Kim found Tosh to be quite approachable, and "His sweetness impressed me, the way he was with Ry. But don't forget, we were there to help him with his career and Tosh very much wanted his music heard." In the old-fashioned town of Port Antonio on the northeast tip of the island, Jeff shot 8mm footage of Tosh on a pier jutting into the turquoise waters of the Caribbean, sparring with Donald Kinsey.

Neville O'Reilly Livingston, known as Bunny Wailer, was raised as Marley's brother from the time they were

Above: Seeco Patterson in Bob's backyard, 1975.

kids when Bob's mother moved in with Bunny's father. He was the most mysterious of men. His stern visage, threateningly deep voice and uncompromising embrace of the most arcane tenets of Rastafari, turned away many who sought contact. He had walked away from the Wailers in the spring of 1973, with his self-imposed exile back in Jamaica lasting 13 years. In his 142-acre spread of land, called 'Dreamland,' Bunny practiced "cultivation," and wrote a series of inspired albums that he refused to support with tours. Much of what Kim shot established Bunny's 'screw-faced' image, the baneful scowl that he and Bob used to keep others at arm's length — and preferably farther. Yet she was able to extract a lighter side too, a tribute to her ability to grab unexpected and fleeting moments of revelation.

After the Wailers trio dissolved at the end of 1973, Bob had retained the Barrett brothers, the former core

of Scratch's house band at the Black Ark, the Upsetters — Aston 'Family Man' on bass, and Carlton on drums. "Fams" played the bass melodically, like a lead guitar merged with rhythmic inventiveness. Carly has been widely credited as, if not the inventor, the most important exponent of the 'one drop' drum style. Newly solo, Bob added his early mentor, a gentle older dread named 'Seeco' Patterson, on percussion in the studio and as part of his touring band, keeping a taste of the Nyahbinghi within his ever-synthesizing sound. It was Seeco who had brought the Wailers to Coxsone's Sunday afternoon auditions twelve years earlier, and now he was a near constant presence at 56 Hope Road, the uptown estate that Bob had bought from Chris Blackwell to be at once his home, business office and studio. Marley's Tuff Gong label and corporation had great plans for outreach, and the bustle that filled the yard and out-buildings was

constant. Press arrived from far and wide, often being made to wait for days for interview time with Bob, which Jeff set up and coordinated.

Seeco worked closely with Bob's new manager, Don Taylor, as well. A rough-cut bi-racial orphan who had grown up on the docks and bawdy houses of Kingston, Don had become a personal assistant to Marvin Gaye in the States after a stint in the US Army. When Gaye played Jamaica, Taylor preyed on Bob's sympathies, reminding him that they both had endured love-starved youths as social outcasts because of their light skin, begging Bob to take him on as his manager. He underbooked the group, now known as Bob Marley and the Wailers, into foreign halls that were not big enough to hold all the hordes of fans desperate to see the band. This clever strategy often resulted in front page headlines as streets teamed with restless fans unable to get in to see the shows, sometimes verging on riots. Taylor's tactic paid off: within three years, Bob was headlining stadiums in Europe.

Jeff would go on to be an editor of the seminal *Crawdaddy* rock magazine, founder of the Thinking Cap Company and eventually become the pre-eminent genre publicist in Hollywood, specializing in science fiction, fantasy, horror, animation and comic book-based films. As well as studio liaison to the giant annual Comic-con in San Diego, he was also named one of the "50 Smartest People in Hollywood" by *Entertainment Weekly* in 2009 for his early recognition of the growing market and appetite for such films.

As for Kim, "My pictures seem to speak an international language. They got me into film work, and I went on to be a Hollywood unit still photographer, among the first women admitted to the International Cinematographers Guild. I was John Carpenter's unit production photographer on *Halloween*, *Escape from New York*, *The Fog*, and *Christine*. From there I went to work on *Cheers* for nine years and *Family Ties* for another five. I also shot pilots and episodes for *Star Trek: The Next Generation*, and *Deep Space 9*." She also worked with veteran comedian and actor, Bob Newhart and shot several episodes of *Steven Spielberg's Amazing Stories*. When asked about the difference between shooting actors and musicians her answer may seem surprising: "Taking pictures of musicians while they are performing is never any problem. But actors are very self-conscious, because if they're very into the moment it might not be flattering in the still. But, fortunately, the actors I've worked with know they can trust me."

Kim's access to these titans of reggae allowed her to capture some casually glamorous shots of them in private surroundings, like the classic cover shot for *High Times*. Her shots were used by record companies as their main publicity photos for a wide variety of performers, reproduced countless times in newspapers and magazines, on posters and t-shirts, and as raw material for fliers and advertising. They helped to legitimize the form and bring it to mainstream acceptance. Because she was privileged to be 'inna de red,' in the very epicenter of the reggae explosion at the moment of its Big Bang, her unforgettable images have become standards, crucial to the historic documentation of the movement's finest moments. They capture your attention instantly, and make you want to find out more about the person portrayed. In that way, they were a gift to the world. For attention brings understanding, which leads to love, and One Love is at the very heart of what Bob — and his colleagues — and rasta itself is all about. This book features those iconic shots as well as many others that have never been published before. For fans of that period in reggae's history, or those interested in music history more generally, these photos are a true treasure trove, making this period become vivid and vital once again.

Roger Steffens
March, 2010

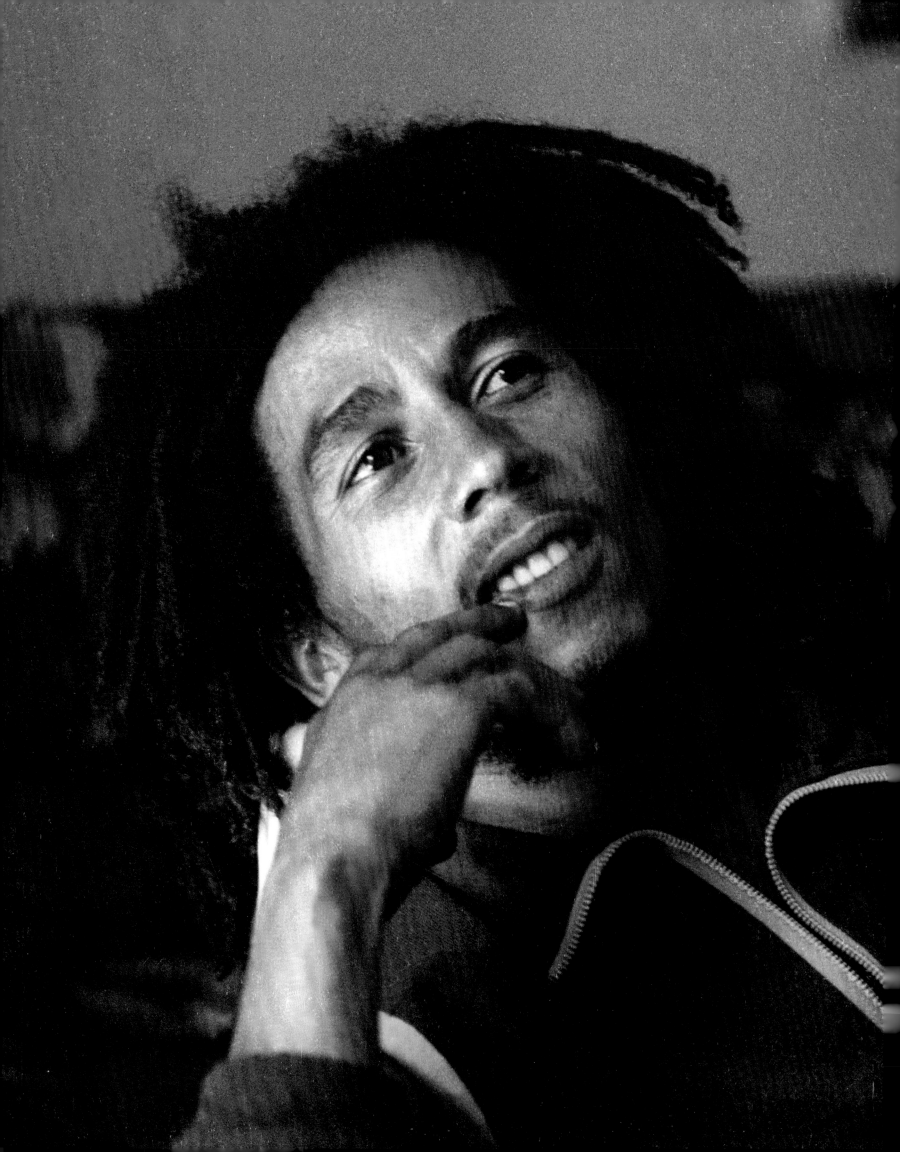

LOS ANGELES, JULY 1975

Jeff Walker

I first met Bob Marley in New York in June of 1975. *Natty Dread* had already been released to rave reviews and Bob and the Wailers had come to the shores of Babylon to play a series of dates in Toronto, Chicago, Detroit, Cleveland, New York, Philadelphia, Boston and the Bay Area, culminating in three (now legendary) nights at the Roxy in LA. I flew to New York to introduce myself to Bob and discuss with him and his manager, Don Taylor, what our publicity plans were for the rest of the tour. The three of us held a press conference at Jamaica House (the Jamaican Embassy) that week to introduce Bob to the New York music press and media.

Now, as someone with no formal education whatsoever in music, journalism or public relations, my basic approach to publicity has always been extremely simple — as a fellow fan. If I liked something, then others were bound to like it and all I had to do was reach them. And if some music was not to my own personal taste, I still knew that it would be to other fans and certain rock writers and all I had to do was find them. My approach was never about getting items in columns or pitching stories to people I had to convince. Instead, I've always sought out champions in the press or media who would be happy to cover something first. And once an artist started getting that kind of attention, from people who actually buy and recommend albums, the mainstream media would soon follow.

This was certainly the course we took for *Natty Dread* and this tour — shore up and grow our base in proven markets, continue to garner raves for the album and concerts and do local interviews when time allowed.

On the night of June 18, Bob was set to perform at the Schaeffer Music Festival, which was held outdoors at the Wohlman Skating Rink in Central Park. I first joined the band for the next leg of their tour that very afternoon. Walking out of the elevator onto the hotel floor where the entire Wailer family was staying in New York, I was immediately hit with two of the most distinctive and pleasurable scents you can imagine. The Wailers' traveling cook was preparing lunch and those wonderful smells shared the atmosphere with the familiar and intoxicating odor of burning ganja. I met the whole band at once then and basically just tried to settle in and stay out of the way until Bob was ready to meet privately. I also quickly learned that if you waited for someone to pass you a spliff, you could sit there all day. The herb was communal — if you wanted to smoke, you just had to grab a handful and roll your own.

I think it's pretty safe to say we were both feeling pretty good when Bob finally indicated he was ready to talk about the interviews and press coverage we planned for the remainder of the tour, so — as we would for most of our professional meetings — we stepped into another room for privacy. I don't want to say too much about my personal relationship with Bob. Most of our direct, professional interaction was in private, but he was always friendly, asked lots of questions and knew exactly what

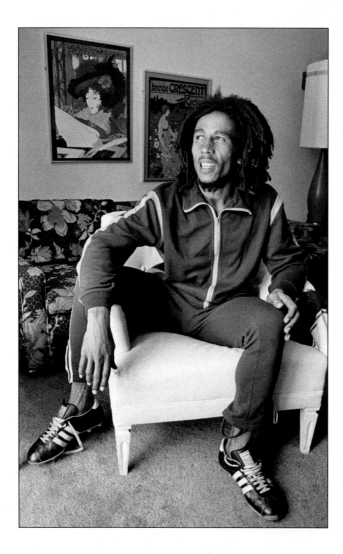 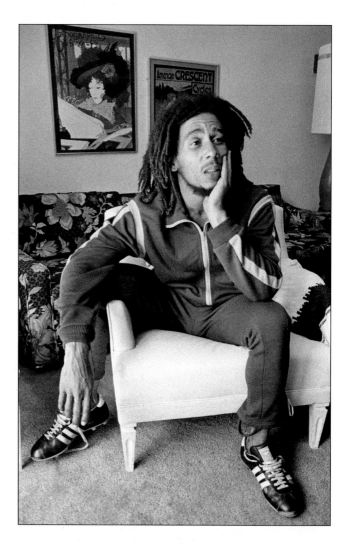

Previous Page, Above, Right: Bob doing press interviews at the Sunset Marquis in Hollywood, July 1975.

he wanted. I laid out everything we planned along the way and he agreed to everything he thought made sense. I always felt welcome and comfortable among the group at large and would have been very happy to just lie back, hang out and listen to the magic being created. But that wasn't my role.

I heard later from Chris Blackwell that Bob told him he trusted me and, aside from being very gratifying, I can say that the feeling was mutual.

Bob might have been late to a few interviews and embellished a few stories for particularly thick journalists and occasionally, if he lost patience, he could slip into a Jamaican patois so thick the interviewer could only nod and pretend to understand — but Bob did everything he agreed to do and was always pleased with the results. All of the important rock magazines, including *Rolling Stone*, *Crawdaddy*, *Creem* and *Phonograph Record Magazine* (PRM), wanted to talk to him and I proceeded to set up those interviews along the tour.

I also told him then that Island's president Charley Nuccio was one of the key people (at Capitol Records)

responsible for bringing the Beatles music to America and that he had been in touch with George Harrison, who would be coming to the LA opening night in a few weeks and that a photo of their meeting would be seen around the world. Bob nodded in agreement... "Yes mon, Ras Beatle!"

Bob was a pretty happy guy when they all got to LA. On July 10, they played to a star-studded crowd at the Roxy, including Bob Dylan, Linda Ronstadt and George Harrison for all three shows (and yes, we got that shot of them together and, as you can imagine, getting to introduce George to Bob was easily among the highlights of my life). Oddly enough, our musician reach out campaign had garnered another fan in The Manhattan Transfer's Tim Hauser and he invited Bob and the Wailers to perform two songs on their CBS summer replacement show, shot on July 12, 1975.

Bob also did several sit down interviews during the next few days. Bob's final Roxy gig on that tour was on July 12 and after a day off, the band headed off to London to play a few dates before returning to Jamaica.

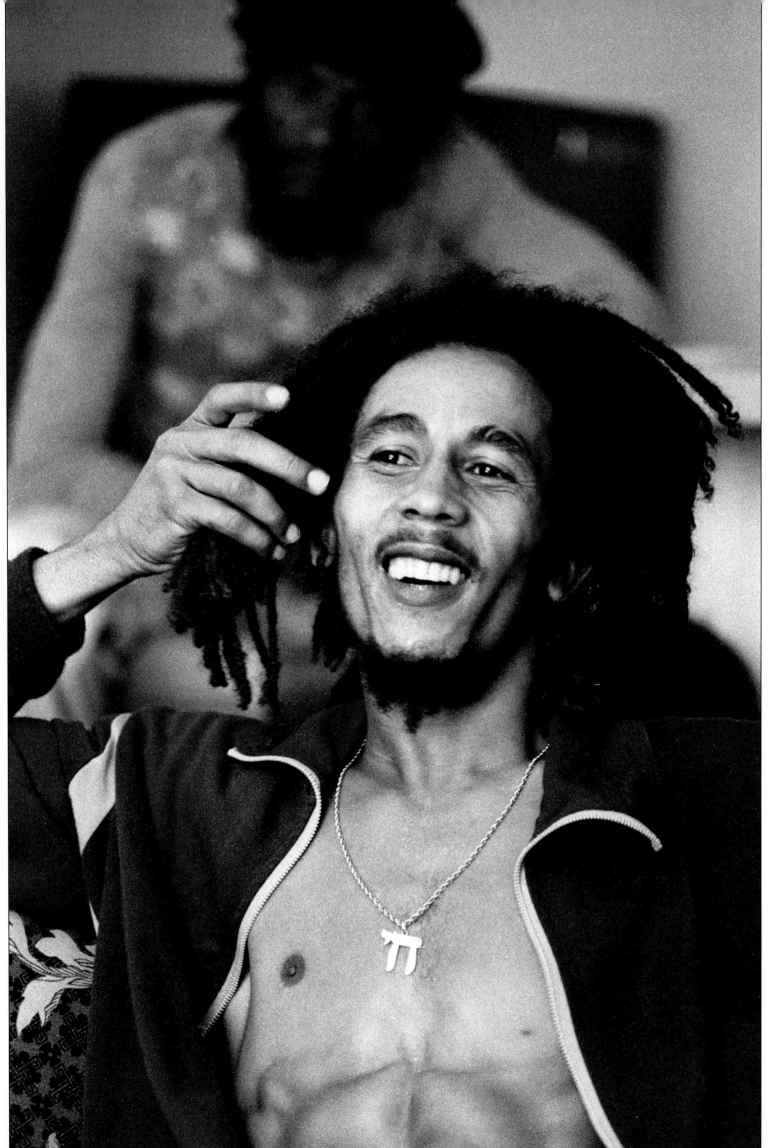

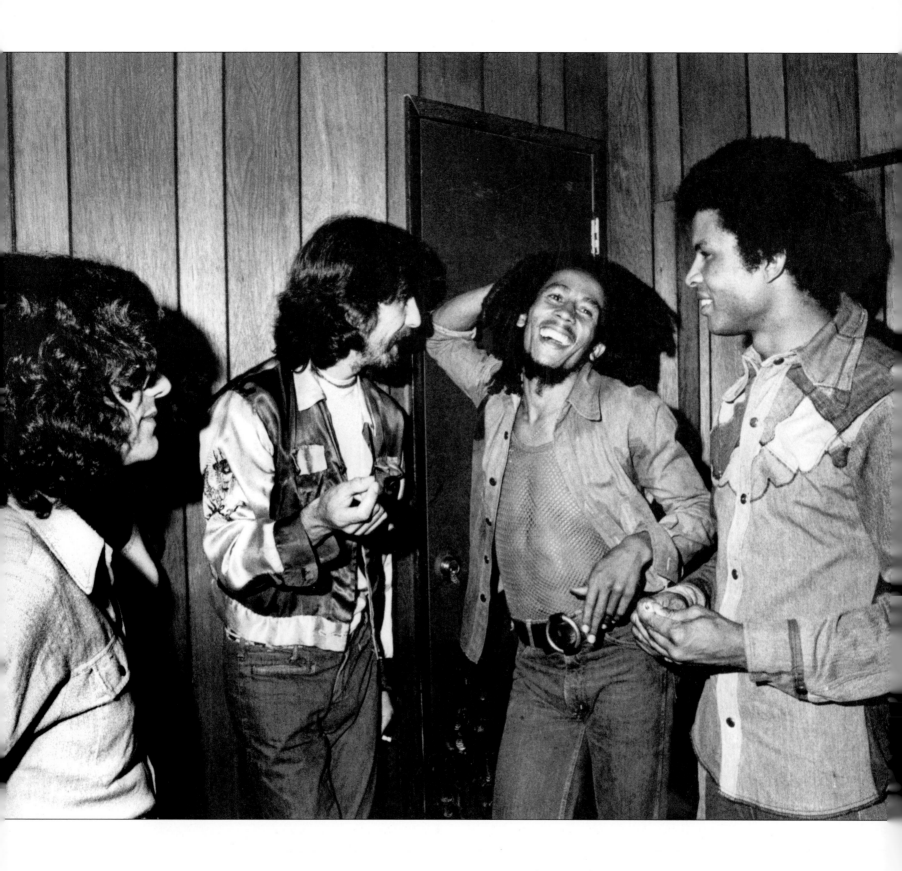

Above: Jeff, George
Harrison, Bob and
Bob's manager Don
Taylor backstage at
the Roxy, 1975.

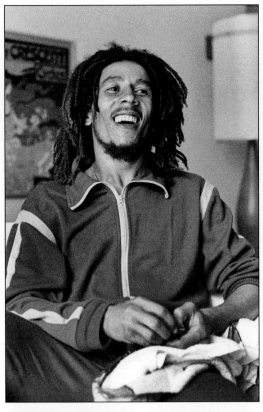
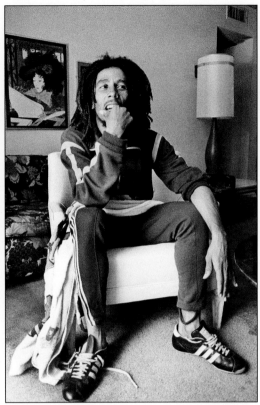
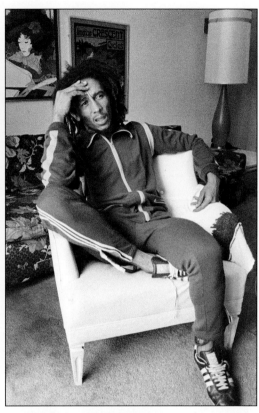
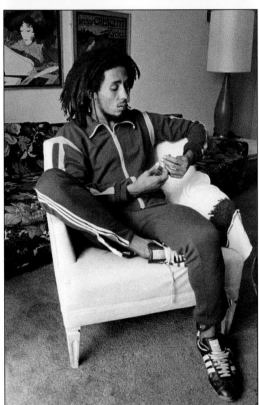
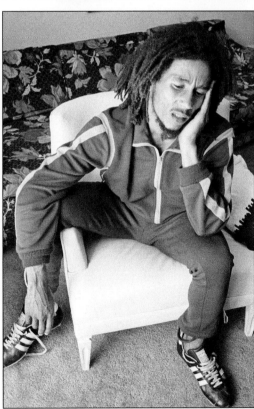
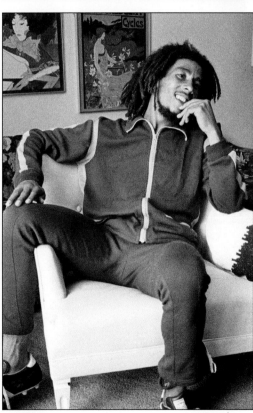

Above: Bob sitting for press interviews at the Sunset Marquis in Hollywood.

41

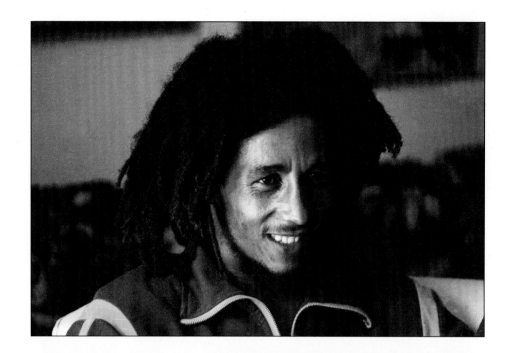

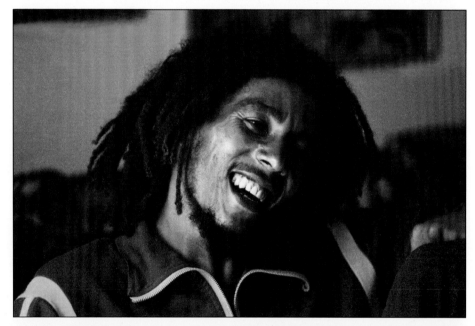

Right & Opposite:
Kim snaps some
candid photos while
Bob sits for more
press interviews at
the Sunset Marquis
in Hollywood,
July 1975.

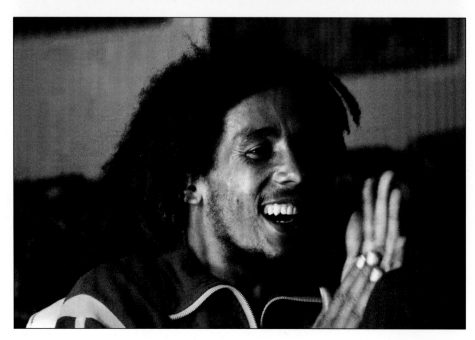

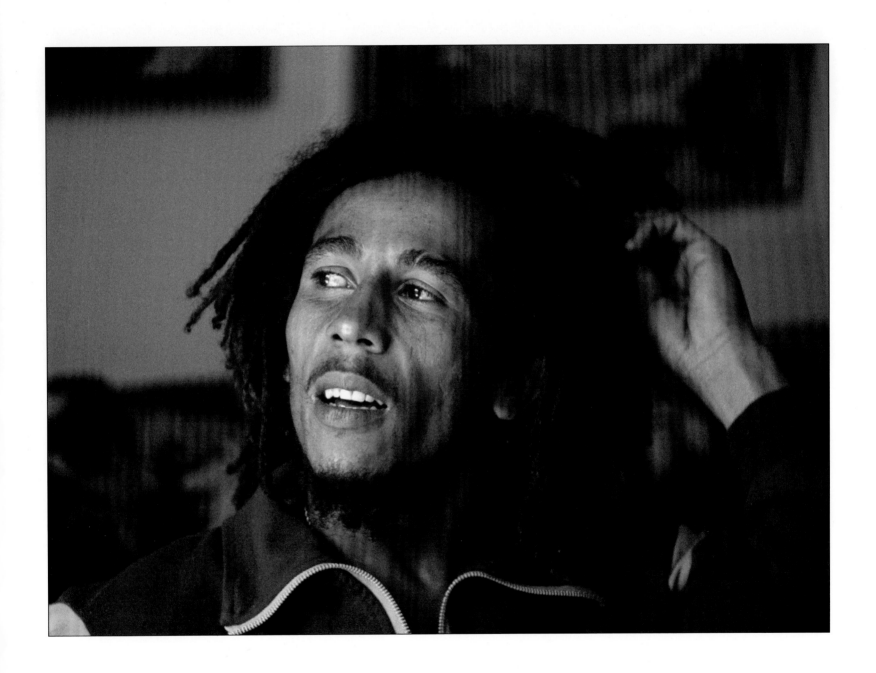

"MARLEY, NOW 30, IS BOTH STAR AND POTENTIAL POLITICAL FORCE IN VOLATILE JAMAICA, BUT, HIS LYRIC ASIDE, HAS NEVER SHOT A SHERIFF OR ANYONE ELSE. HIS TUNES DO BEAR MENACING TITLES LIKE "REVOLUTION" AND "BURNING & LOOTING," BUT HE DISCLAIMS CHARGES OF RABBLE-ROUSING: 'WE'RE NOT TALKING ABOUT BURNING AND LOOTING MATERIAL GOODS AND THINGS. WE ONLY WANNA BURN CAPITALISTIC ILLUSIONS.'" — LEE WOHLFERT, *PEOPLE* MAGAZINE, 1975

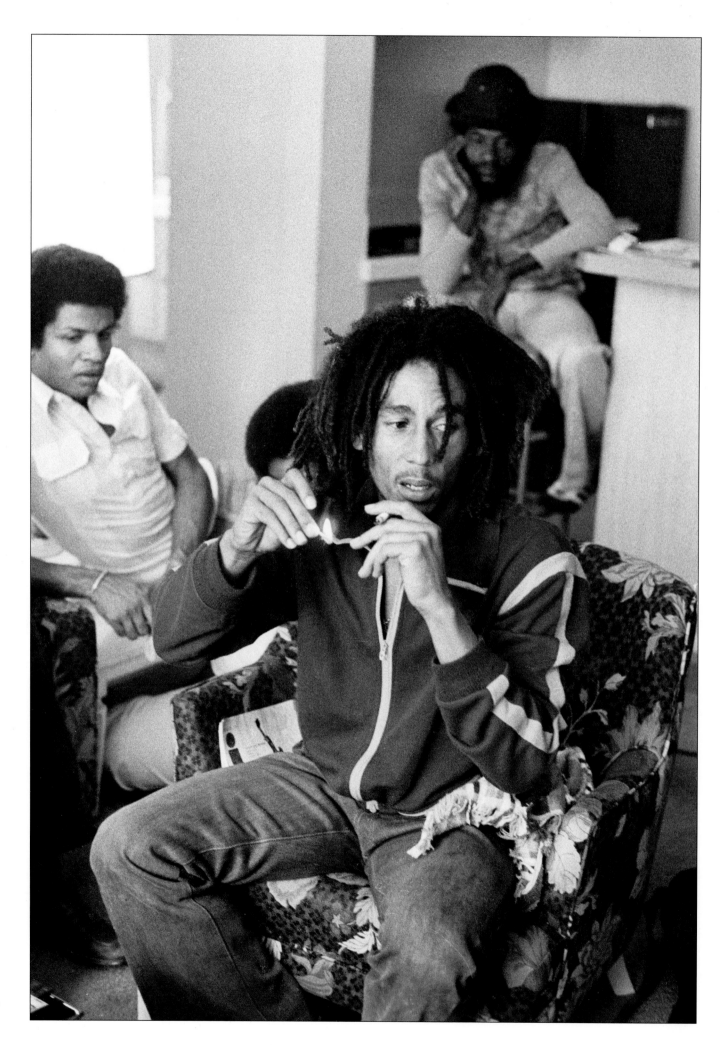

Right: Don Taylor,
Bob and Seeco
during press
interviews at the
Sunset Marquis in
Hollywood, 1975.

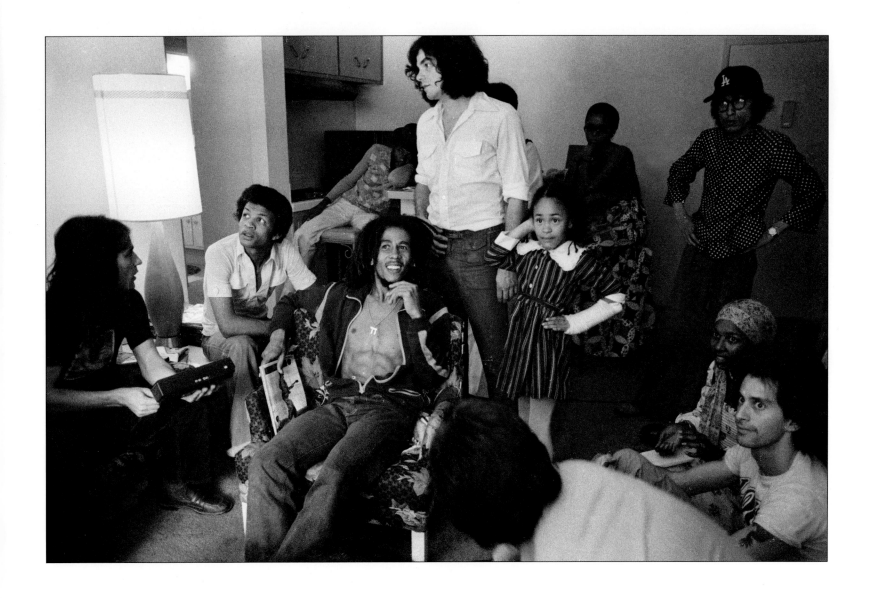

"IT'S LIKE ADDRESSING AN INSCRUTABLE BLACK PRINCE WITH A SPLIFF BETWEEN HIS TEETH. ONCE IN A WHILE, WHEN HE'S DRIVING HOME A PARTICULARLY URGENT POINT OR BREAKING INTO A HEARTY, ILLUMINATING SMILE, HIS FACE EMERGES FROM ITS RIGIDITY AND ITS SHADOW TO BECOME AN EXPRESSIVE INSTRUMENT. WHAT DOES COME ACROSS MORE IN HIS MELLIFLUOUS VOICE AND MOMENTS OF ANIMATION THAN IN ANYTHING HE ACTUALLY SAYS, IS A MERCURIAL MAN, SERIOUS ABOUT HIS WORK AND HIS LIFE, BUT WITH FLASHES OF ENTHUSIASM AND CONSPIRATORIAL HUMOR." — MITCH COHEN, *PHONOGRAPH RECORD MAGAZINE*, OCTOBER 1975

Above: Bob winds
up the interview
session a the
Sunset Marquis
in Hollywood,
surrounded by press,
band members
and entourage.

Right: Bob takes a minute to relax after being interviewed by the American music press in Hollywood's Sunset Marquis. He wears the 'Chai' character around his neck, the Hebrew word for 'Life.'

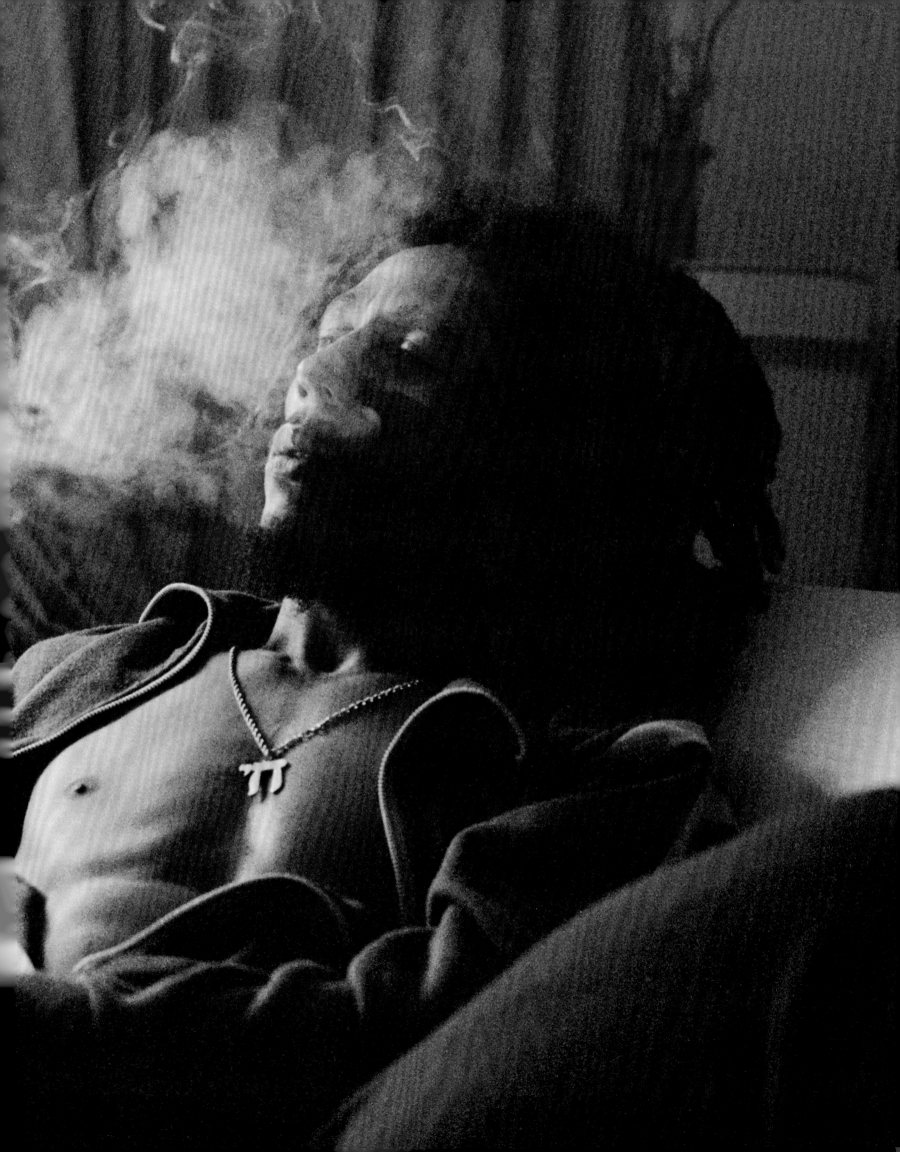

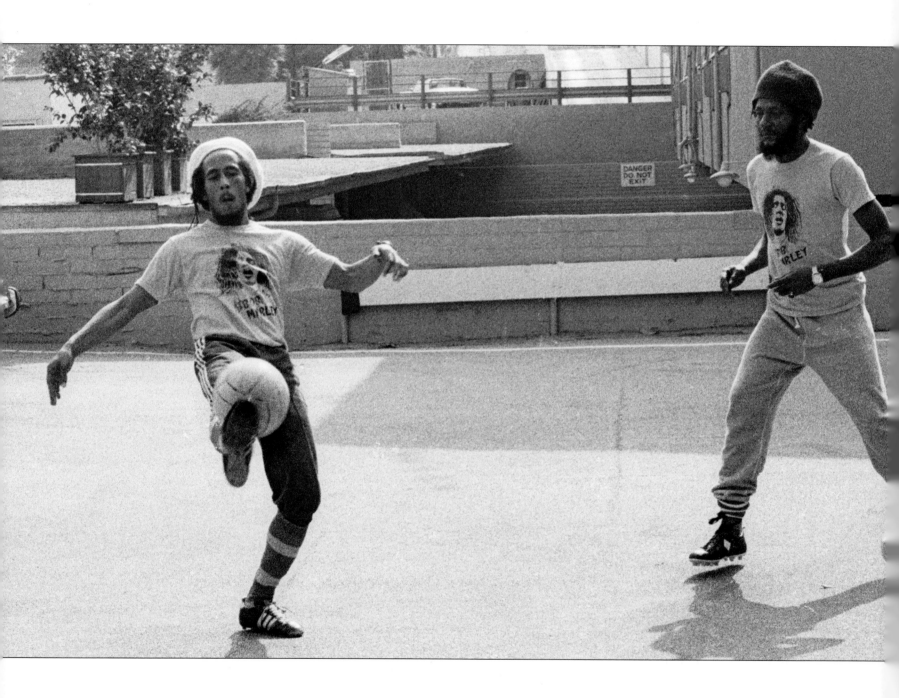

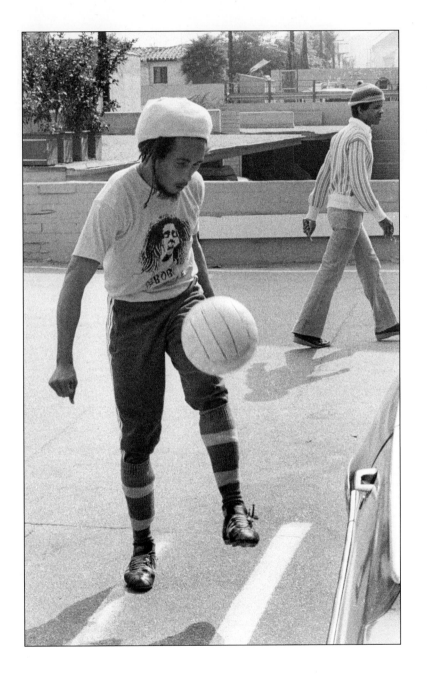

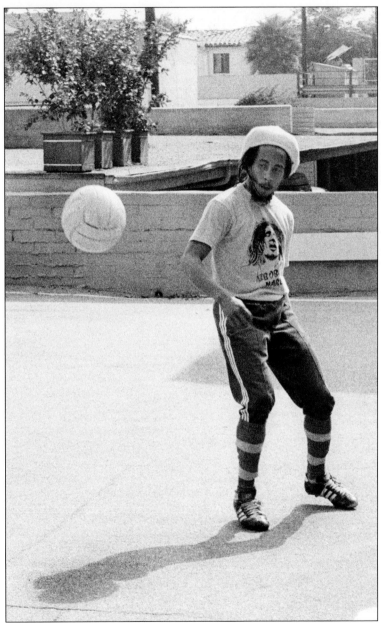

Above (L to R): Bob and Seeco get in some soccer practice in the parking lot of their West Hollywood hotel, 1975.

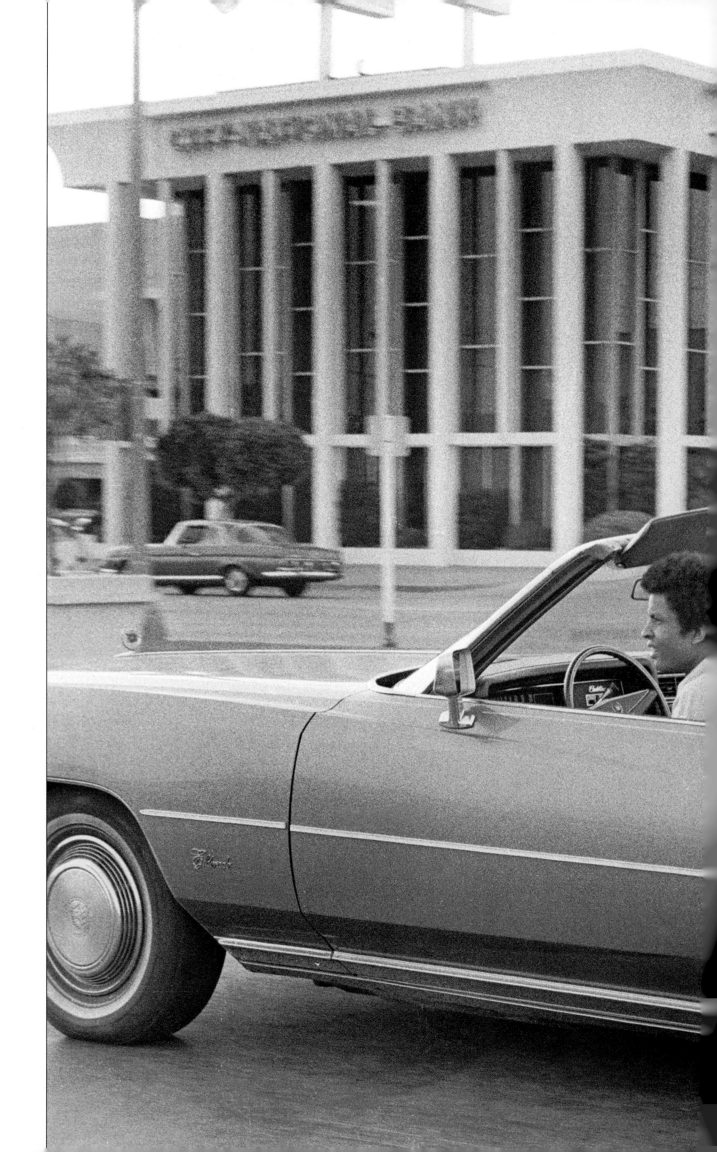

Right: Don Taylor drives Bob and the band to CBS Studios to record the *Manhattan Transfer* show, shown here at the corner of Beverly Blvd and Fairfax Ave in Hollywood with Carly Barrett, Seeco and band leader Aston "Family Man" Barrett in the back seat.

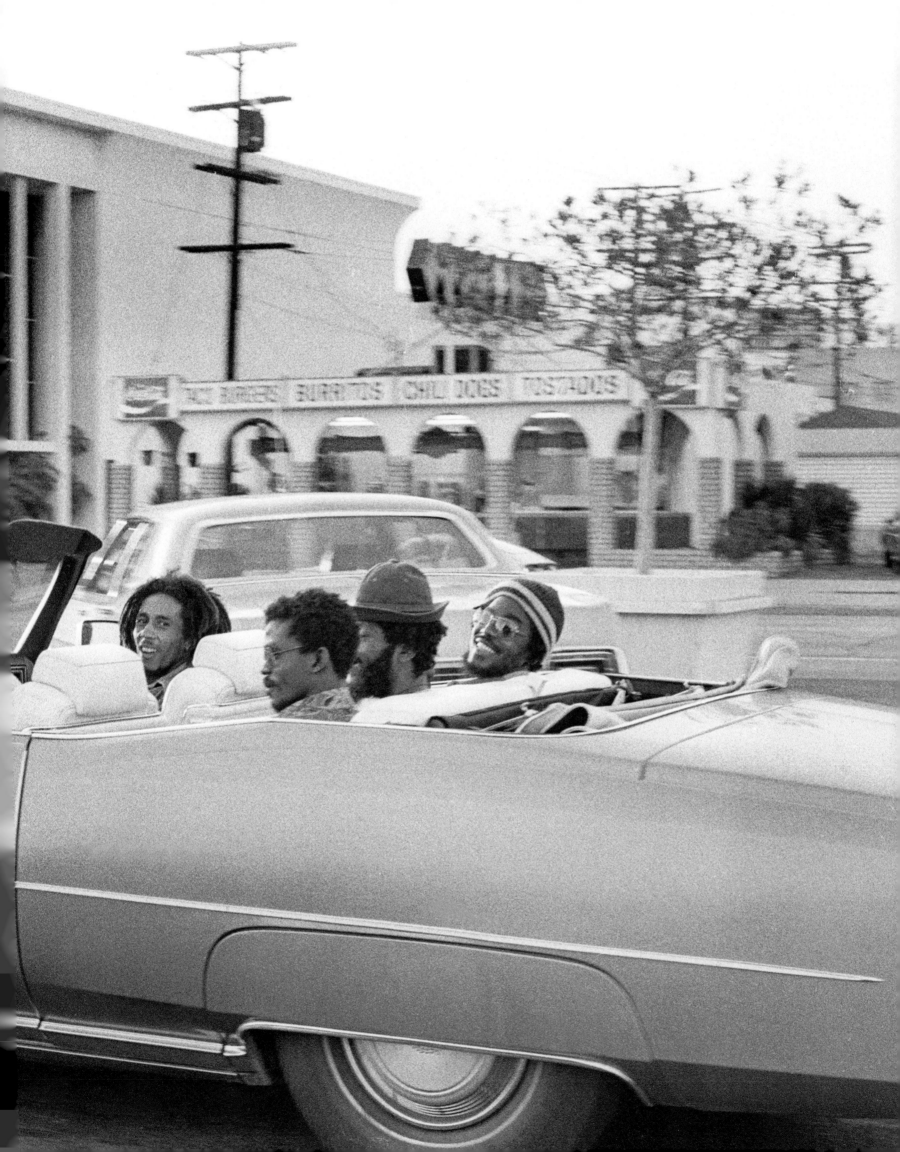

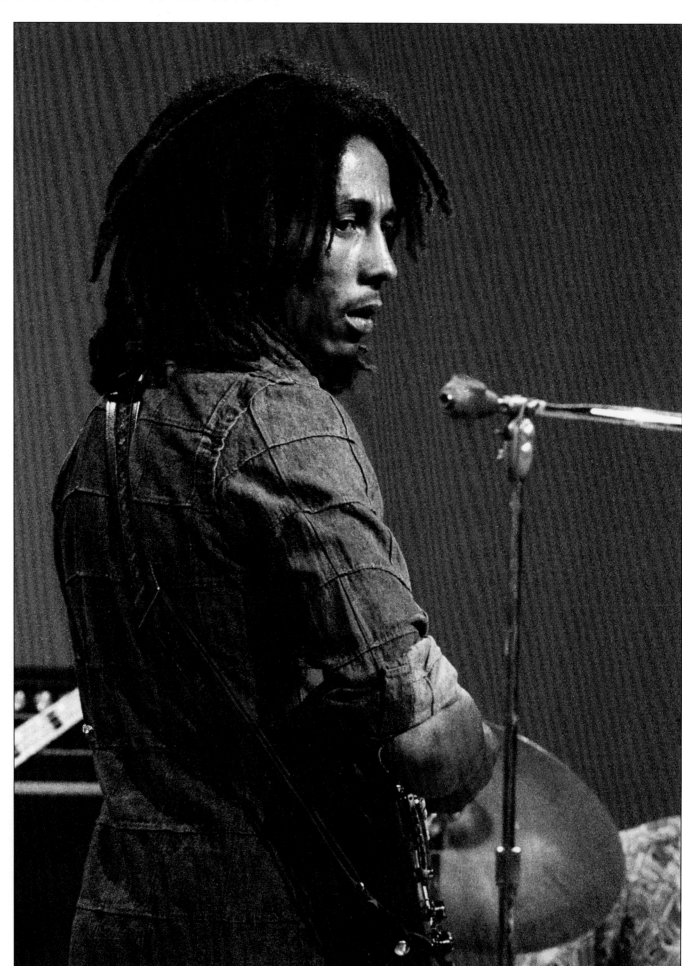

Right: Bob
preparing to tape
his first US television
performance on the
Manhattan Transfer
show at the CBS
studio, 1975.

Opposite: Bob
performs on the
Manhattan Transfer
show, with Rita
Marley, Judy
Mowatt (two of
the I Three) and
Bob. Lead guitarist
Al Anderson, is
just visible in the
background, 1975.

"SO THERE HE WAS ON THE TUBE, PLAYING FOR 20 MILLION PEOPLE. STRANGE THINGS HAD BEEN HAPPENING. HE WAS SCHEDULED FOR THE OPENING SHOW OF THE SERIES AND POSTPONED: ALMOST SCOTCHED ALTOGETHER. THE GROUP HAD TAPED TWO NUMBERS; ONLY ONE WAS BROADCAST AND THAT SONG, "KINKY REGGAE," WAS MADE ACCEPTABLE BY CLEVER EDITING OF MARLEY'S BODY LANGUAGE." — MITCH COHEN, *PHONOGRAPH RECORD MAGAZINE*, OCTOBER 1975

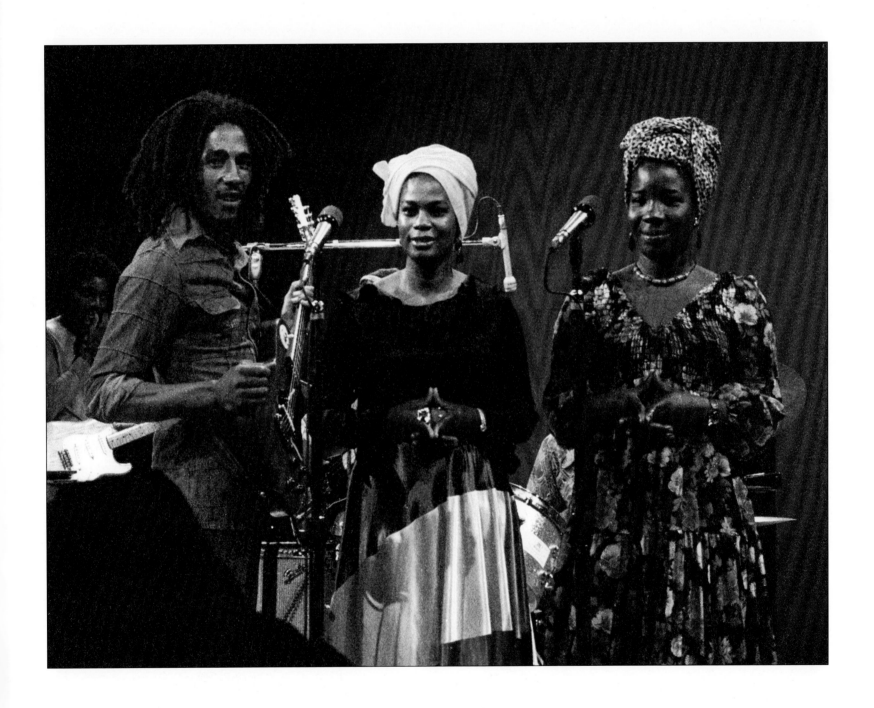

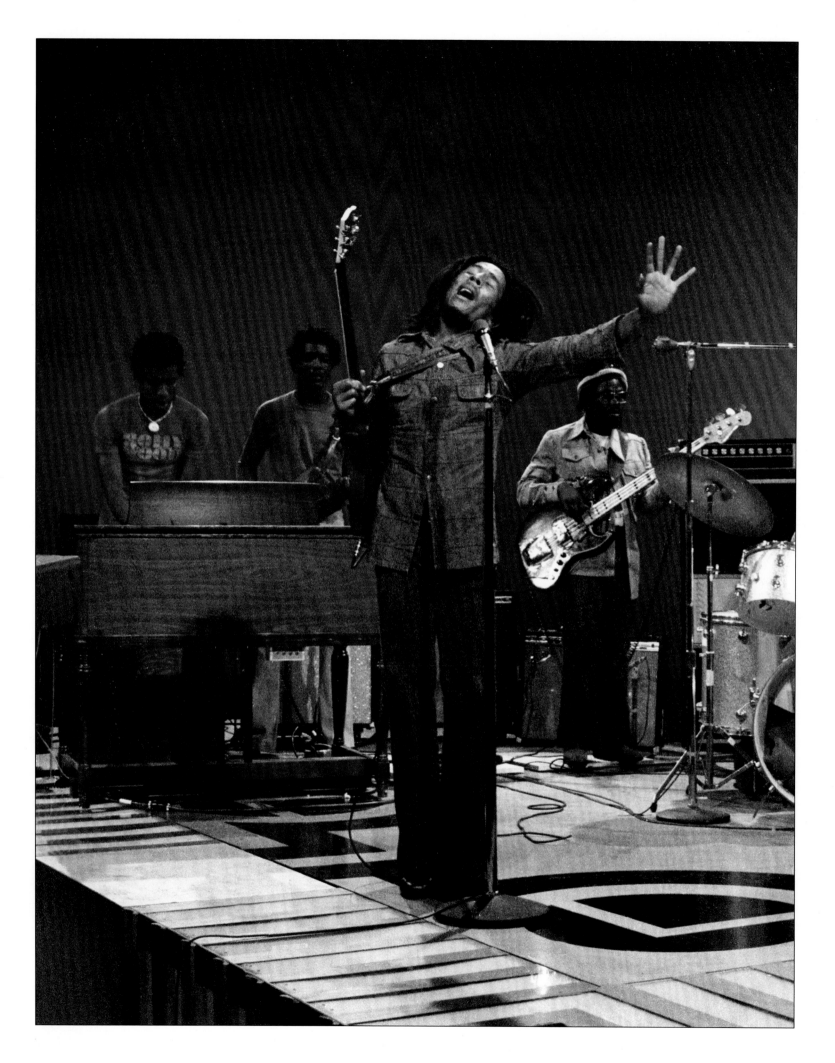

"HOW IRONIC THAT THE WAILERS SHOULD BE DISPLAYED FROM COAST TO COAST ON A STERILE SUMMER REPLACEMENT SHOW. THE *TRANSFER* CODDLE THEIR AUDIENCES WITH SLICKNESS AND A DASH OF CONDESCENSION. MARLEY, THANK GOODNESS, IS THREATENING AND PASSIONATE. IT WAS A CONTRACT THAT COULD NOT BE MISSED." — MITCH COHEN, *PHONGRAPH RECORD MAGAZINE*, OCTOBER 1975

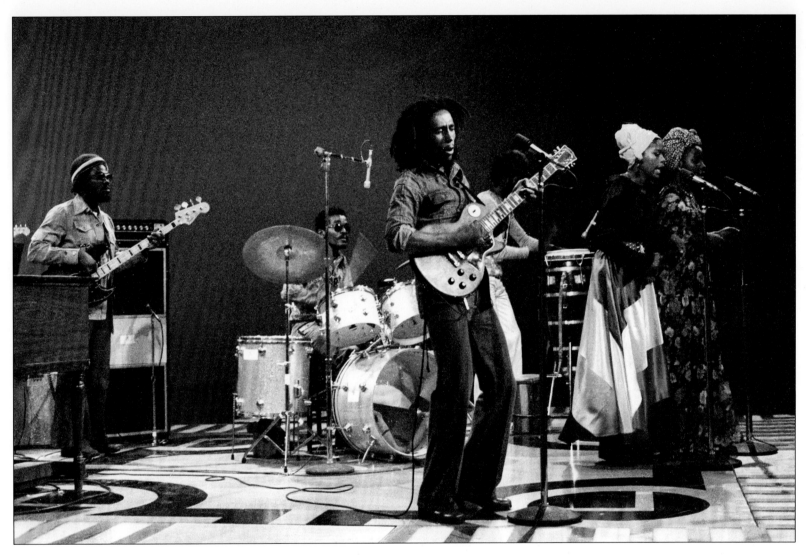

Left: Bob performing with Tyrone Downey (keyboards), Al Anderson (lead guitar) and Bassist, Aston "Family Man" Barrett visible in the background, 1975.

Above: Bob performing with Family Man, Carly on drums, Seeco on conga, Judy and Rita. Only "Kinky Reggae" was broadcast, though they recorded "Trenchtown Rock" in that session as well.

TOOTS AND THE MAYTALS

Right: Frederick "Toots" Hibbert, front man of Toots and the Maytals, 1976.

Opposite: Toots and the Maytals are considered legends of ska and reggae music. Their sound is a unique combination of gospel, ska, soul, reggae and rock.

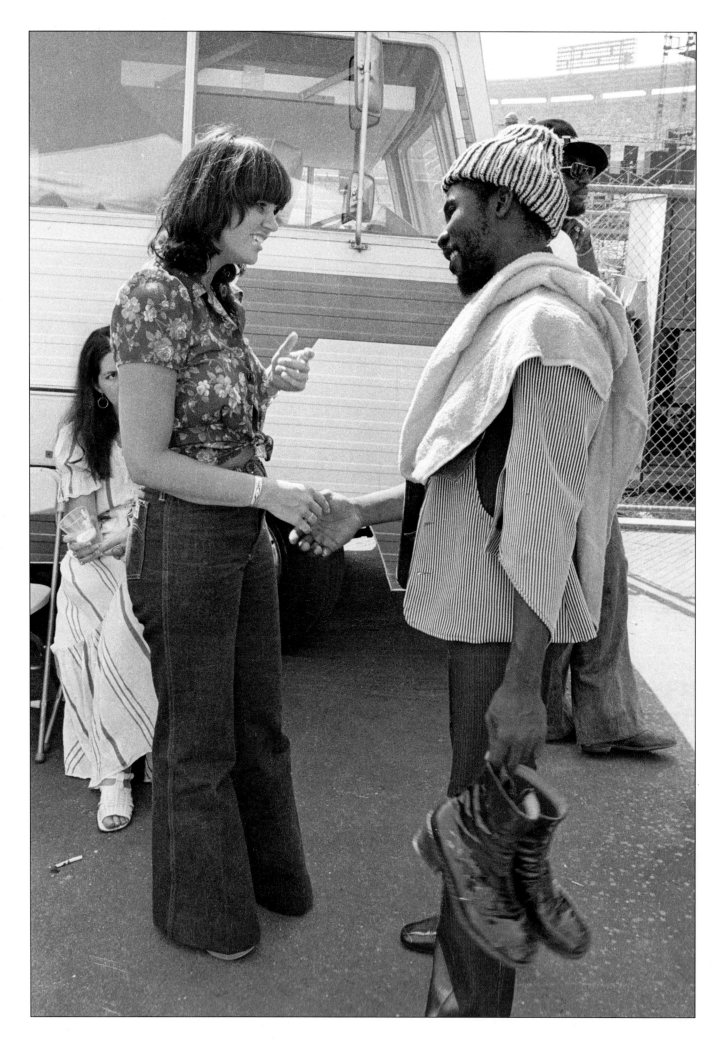

Right: Toots meets
Linda Ronstadt just
before his show in
Anaheim, 1975.

Opposite: Toots
relaxing in his
Winnebago at
Anaheim, 1975.

"IF MARLEY IS THE SULLEN SOURCE OF SORCERER OF HELLFIRE, THE APOCALYPTIC SOUL REBEL, THEN TOOTS HIBBERT IS THE EBULLIENT PREACHER MAN, A DELIVERER OF JOY. TOGETHER, THESE TWO RASTAS, WHO CONSIDER EACH OTHER BRETHREN, ARE SO DISSIMILAR AS TO CREATE ALMOST A REGGAE DIALECTIC, A DARK AND LIGHT SIDE OF THE JAMAICAN MUSICAL EXPERIENCE." — MITCH COHEN

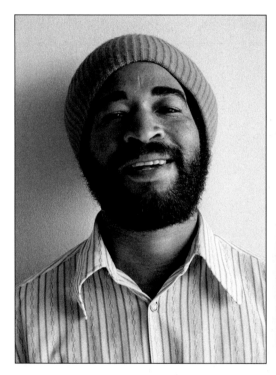 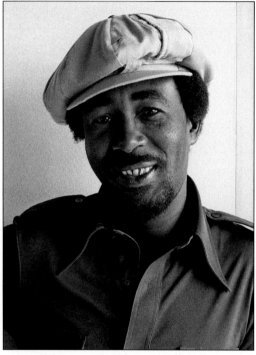

 RECOMMENDATIONS
Toots (Hibbert) and the Maytals: Bam Bam; Sweet & Dandy; Pressure Drop; Six & Seven Books; 54-46 Was My Number; Funky Kingston

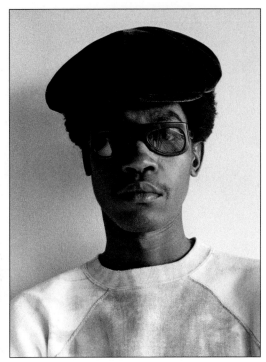

Above: Kim lent a
hand by shooting
passport photos for
Toots and the Maytals,
from left to right:
Ansel Collins (organ),
Nathaniel "Jerry"
Mathias (singer),
"Hucks" Brown,
Henry "Raleigh"
Gordon (singer),
Paul Douglas, and
Rad Bryan.

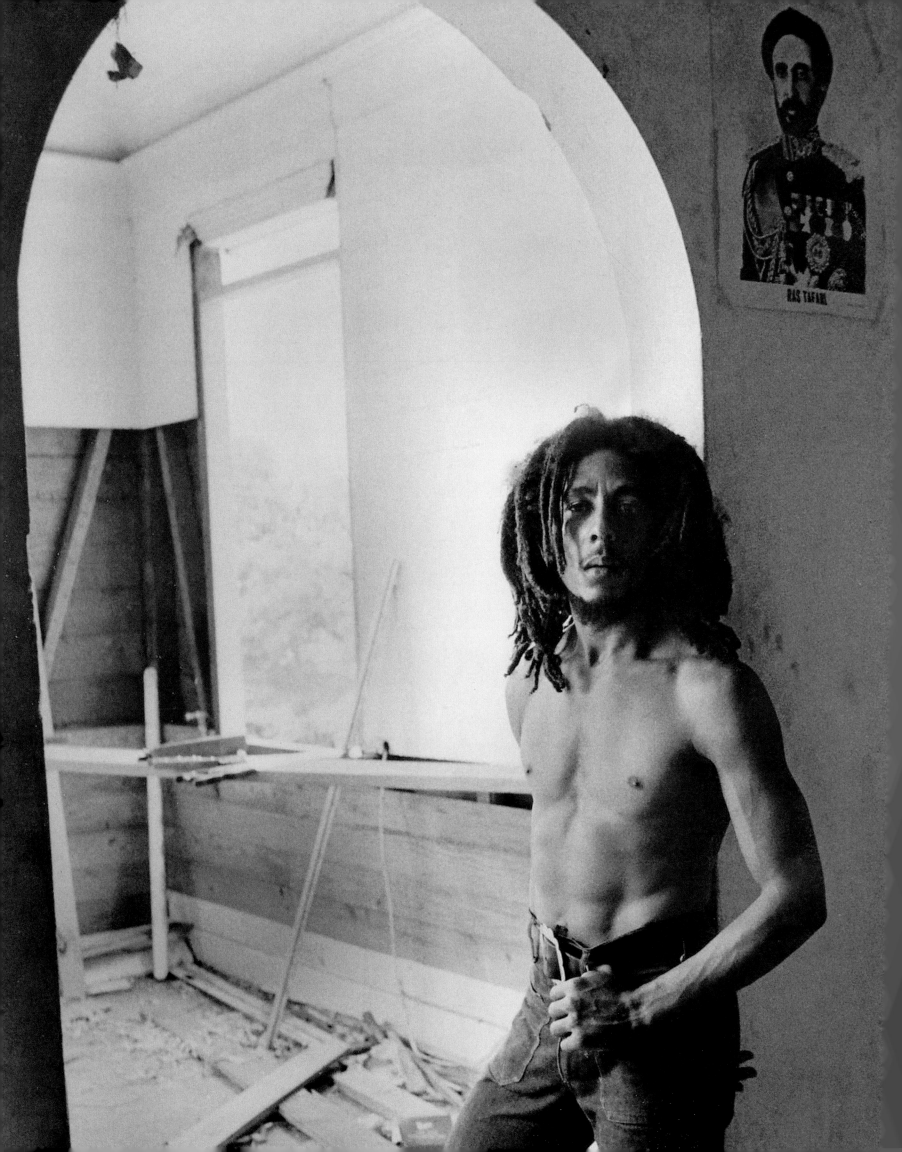

JAMAICA, OCTOBER 1975

Jeff Walker

There have been any number of biographies of Bob Marley and histories of reggae. This is not one of those books.

This book is meant to simply be a snapshot of a brief period in the history of Jamaica and, frankly, rock & roll, that produced one of the greatest poets and songwriters of the twentieth century. The period from 1974 to 1977 is arguably the key creative era in Bob Marley's life and the albums produced during that time, (*Natty Dread*, *Live*, *Rastaman Vibration* and *Exodus*), have all become true classics.

The Bob Marley you will see portrayed in these pages is the man who created those albums, along with his amazingly talented group of colleagues and contemporaries. Just as the Beatles were at the forefront of the British invasion, followed by an almost unbelievable array of other great rock & roll bands, Marley amd the Wailers were at the forefront of a similar wave of great reggae musicians and songwriters all coming out of this small island nation in the Caribbean at the same time.

Bear in mind that although at this point in the history of Island Records it had just launched its own independent label in the US — two landmark albums by the Wailers (*Burnin'* and *Catch-a-Fire*) had already been released in the States on Island when it was distributed by Capitol Records. Those two key albums, along with Johnny Nash's "I Can See Clearly Now" and Eric Clapton's cover of Marley's "I Shot the Sheriff" helped set the stage for the adventure Kim and I were about to embark on when we first

went to Jamaica to gather all the material and information necessary to introduce and hopefully build a larger audience for reggae in the United States. Most importantly, Island was in the midst of introducing Bob Marley as the leader of his own lineup of the Wailers, without his longtime mates Peter Tosh and Bunny Livingston.

While we were there, it was our mission to meet as many of the artists and producers as possible and to become as familiar with the world they came from as we could during the six weeks we spent driving all over Jamaica. Even though I worked for Island, it didn't matter whether or not a particular artist had been signed by us — there was always a chance that we would be signing them or that another label would and that it would only be common sense to interview and photograph everyone we could. The photographs in this book represent a wide array of the great reggae artists of that era, no matter what label released their music.

Although virtually all of Island's official publicity photographs were taken by Kim (and are included in this book), the vast majority of these pictures are being published here for the very first time. Whether it's the elusive and mysterious Marley himself, the fiery but very warm Peter Tosh, the mischievous Bunny "Wailer" Livingston, the sweetness of Inner Circle's Jacob Miller, the intensity of Burning Spear's Winston Rodney or the playfulness of Lee "Scratch" Perry, you will see those qualities vividly in these images along with never-before-seen candid photos of these artists and many others.

BOB AT HOME ON HOPE ROAD

Previous Page: Bob posing in front of the reconstruction underway on his home in Hope Road, also the headquarters of his new Tuff Gong company. Haille Selassie's image is visible on the wall behind him.

Right: Jeff recalls, "We got into Kingston earlier that day, checked into the Sheraton and than went over to Hope Road. I had brought with me a bunch of albums, promotional materials and press clippings to give to Bob and to discuss his coming tour."

Opposite: Kim is reflected in the mirror behind Bob, as she photographs him reading some of the press coverage Jeff brought from the US. "Bob was very pleased with the results of the US press coverage when I showed him all the magazines and papers that had published stories, interviews and reviews. This period just before and after the Dream Concert was probably the most relaxed and laid back I ever saw him. He was in the midst of writing songs for their next album, *Rastaman Vibration*, and rehearsing/ jamming with the Wailers in the studio out back. Music and herb filled the air and there was a tangible joyfulness around the house that day."

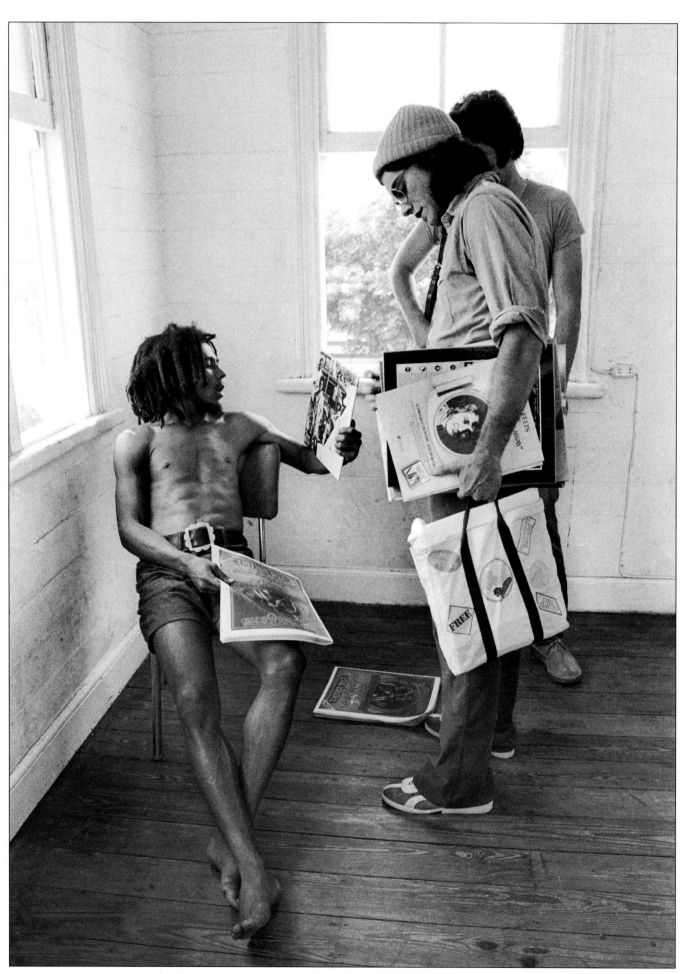

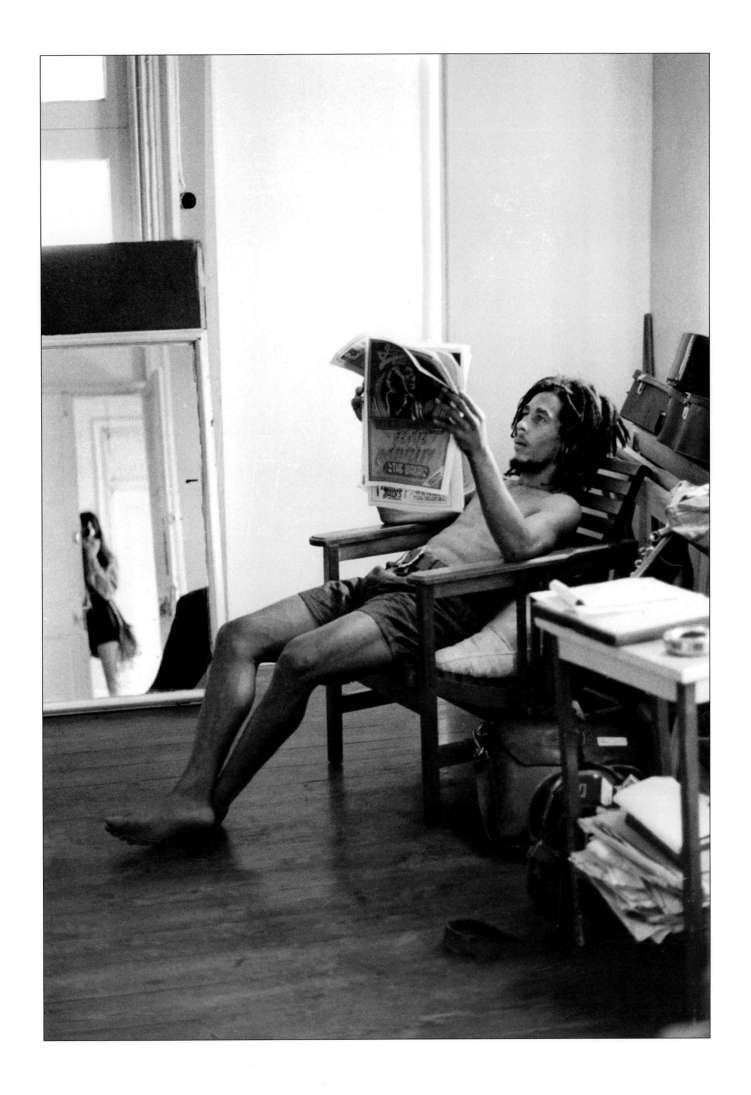

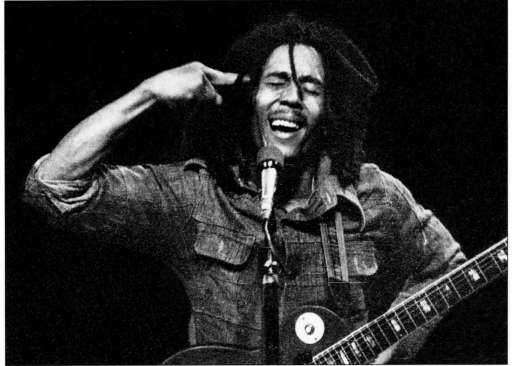

Opposite: Bob's manager, Don Taylor, with Bob's three-year-old son Stephen.

Left: Diane Jobson, Bob's lawyer, with Bob's son Robbie, reading the *Crawdaddy* article about Bob. Robbie is imitating his father's poses in those shots (pictured on this page).

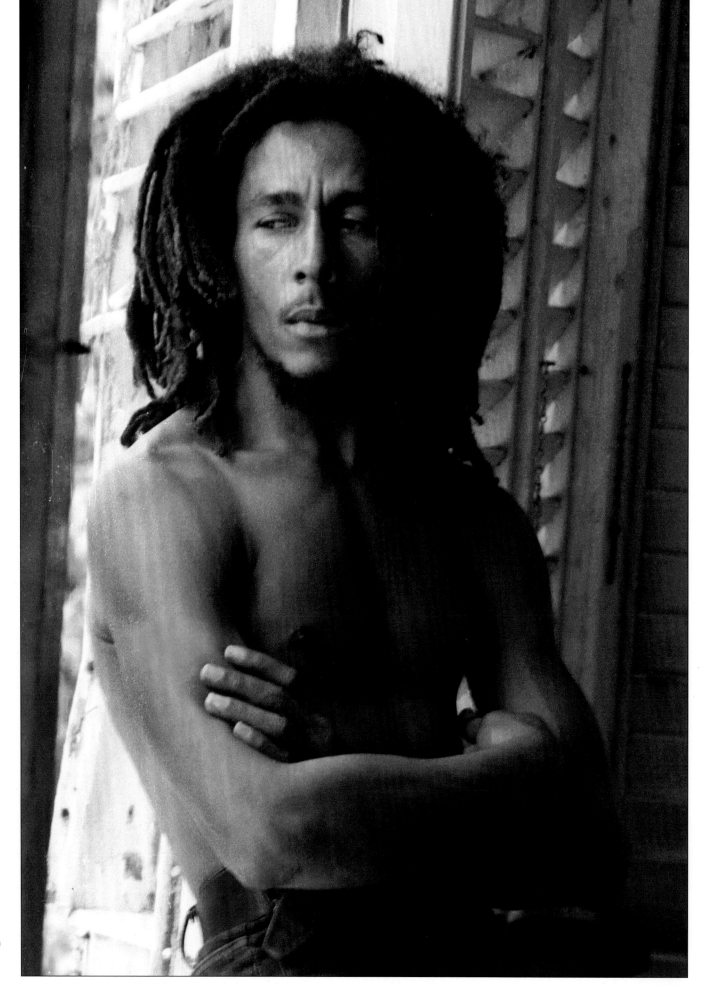

Right & Opposite: Kim recalls: "I had an appointment to meet with Bob at his home a day or two later to shoot some photos for consideration by *People* magazine, something that meant a lot to me professionally and which I had explained to Bob would be his introduction to millions of people in the US who did not yet know him, so I wanted him to think about what he might like to have in the photo with him when creating that first impression."

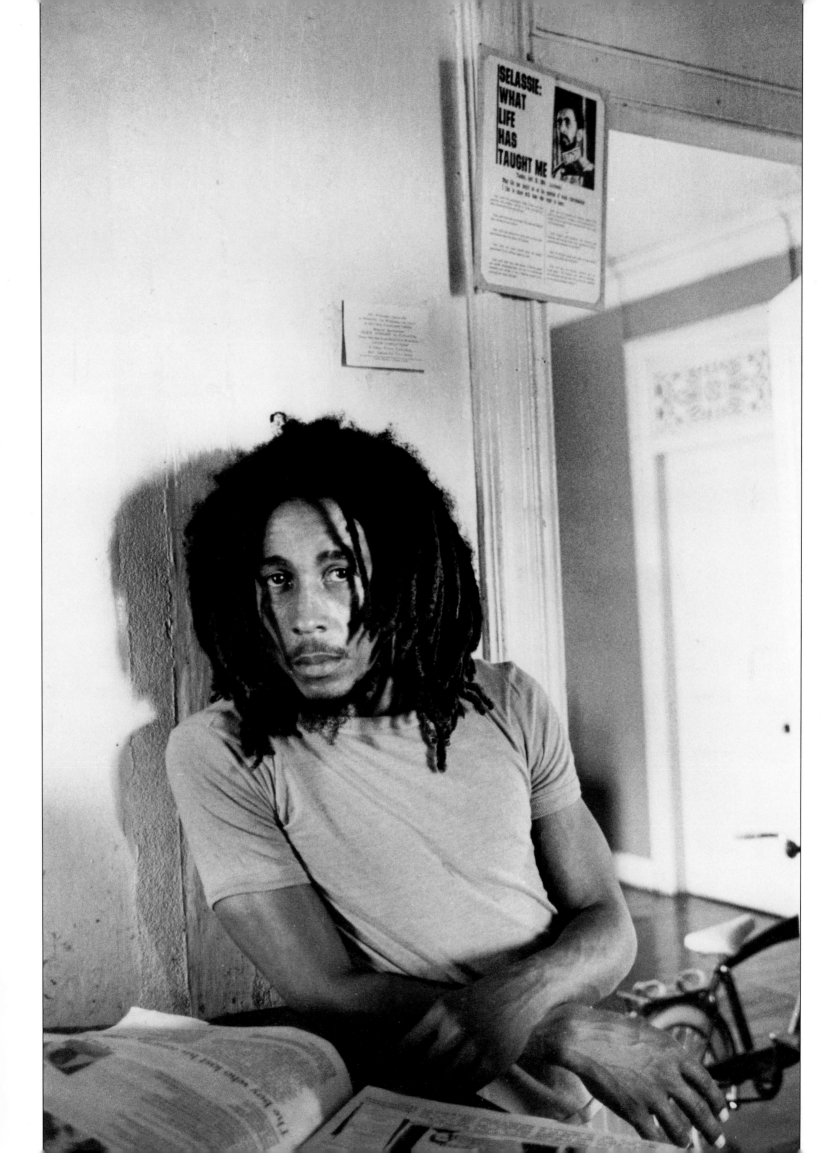

Right: Bob at home in Hope Road, with his best friend, footballer Allan "Skill" Cole visible in the background.

Opposite
Above Left: Bob's best friend, Allan "Skill" Cole.
Above Right: Reni, Bob's herbsman, with his dog Ringo.
Below: Bob, Skill and friends.

Kim recalls the circumstances around these photos well. "We had been shooting Peter Tosh earlier that day, who was wonderful, gregarious and cooperative and arrived at Bob's house on Hope Road about 20 minutes later than we had planned, which is not late at all by Jamaican 'soon come' standards, but Bob was just leaving to go play soccer with his friends and would not wait. Watching them drive away, tears began to well... and I think his friends may have given him a hard time about it because soon after I received an invitation to return on Saturday to spend the day.

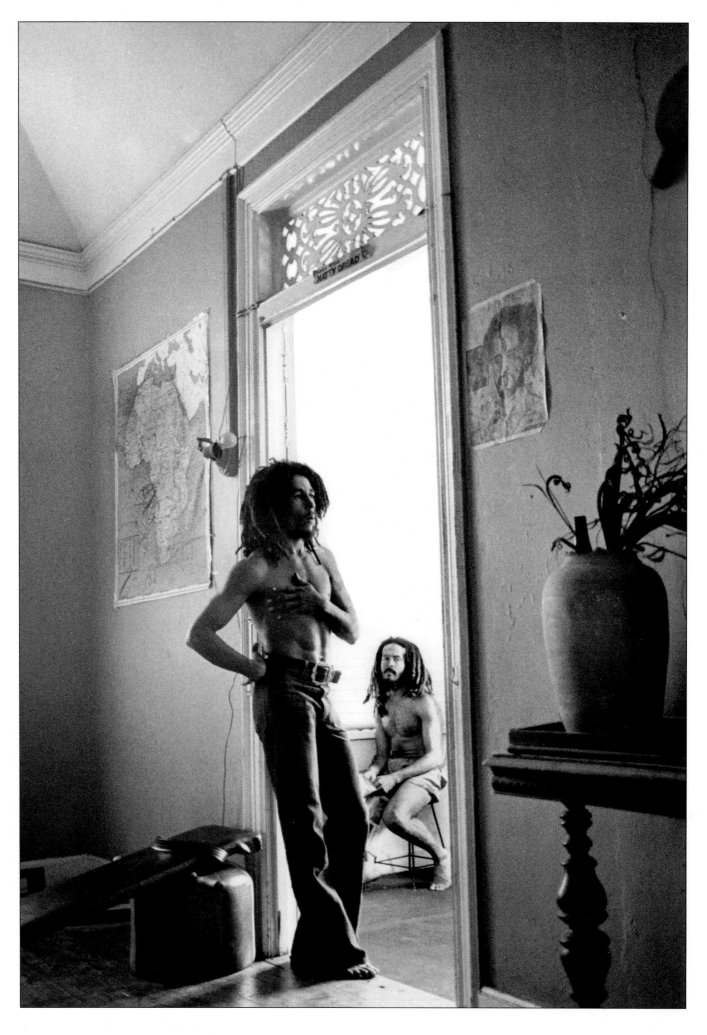

70

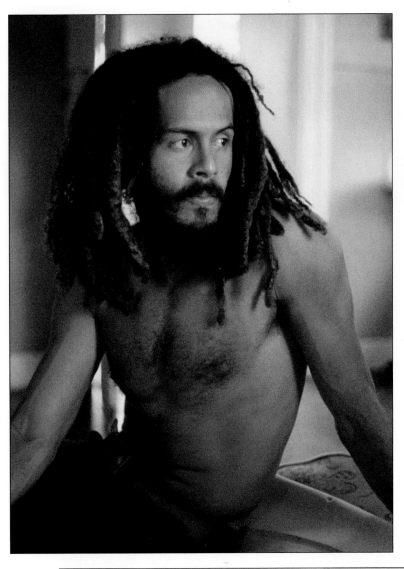

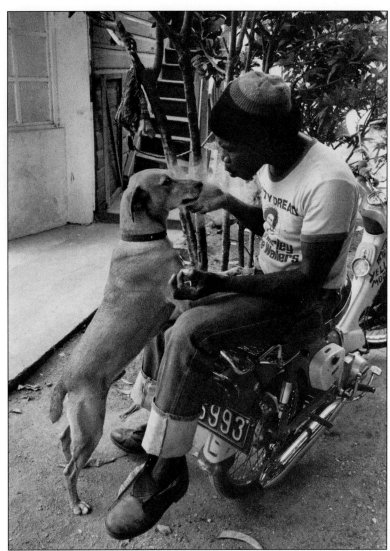

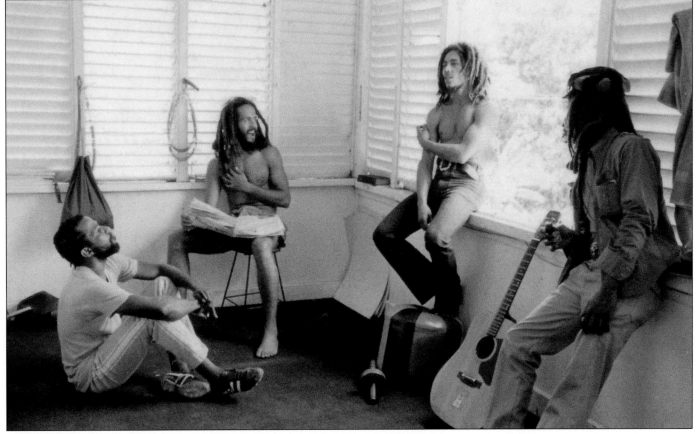

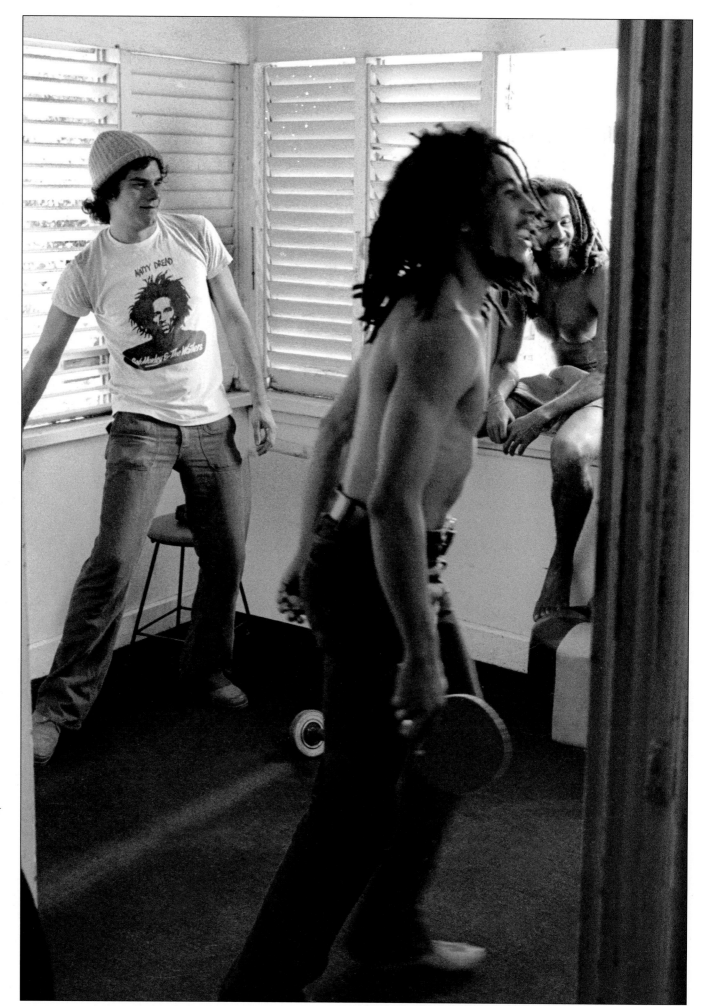

Right & Opposite: Bob at home, playing ping pong with friends. Skill Cole and Jeff Walker are visible in the background.

"When I returned two days later, I spent most of the day hanging out as Bob socialized with friends, played ping pong and briefly posed for me."

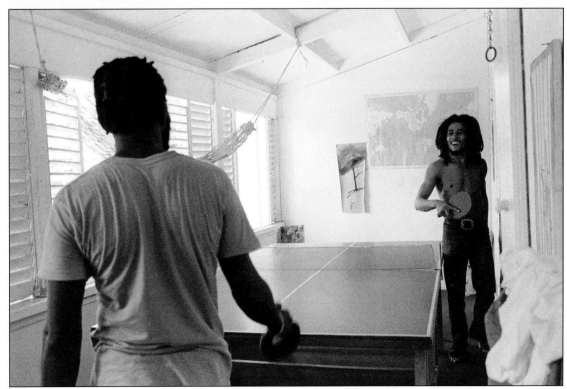

Left to Right: As Kim recalls: "I brought along some cardboard in the rasta colors to tape to the wall as a backdrop and had Bob stand in front of them. His expression was serious and distant for the first frame. I peeked out from behind the camera and said: 'You know, some of the people seeing these photos will be people who already love you' and he broke into a smile for the next two frames."

Above: Bob's uptown house at 56 Hope Rd, which he bought from Chris Blackwell.

Below: A truck in the Hope Road driveway with grafitti quoting a Marley lyric "Who Jah bless, no man curse."

Above: Bob's house was always full of friends stopping by, hanging out. On the right, Ras Reuben known as "Jawaye."

THE DREAM CONCERT

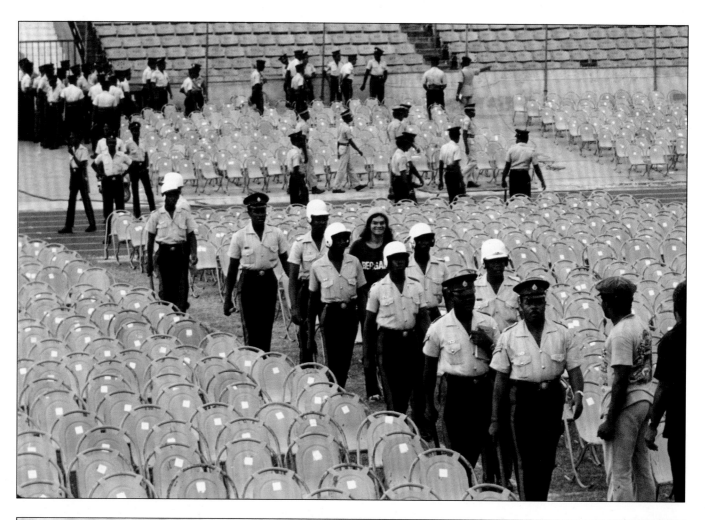

Above: Jeff is surrounded by police as he enters the National Stadium in Kingston to attend rehearsals for The Dream Concert, October 4, 1975.

Below: Neville Garrick (Bob's art director), Bunny Wailer, Bob, Lee "Scratch" Perry, Skill Cole and engineer Dennis Thompson all mill about during rehearsals for The Dream Concert, 1975.

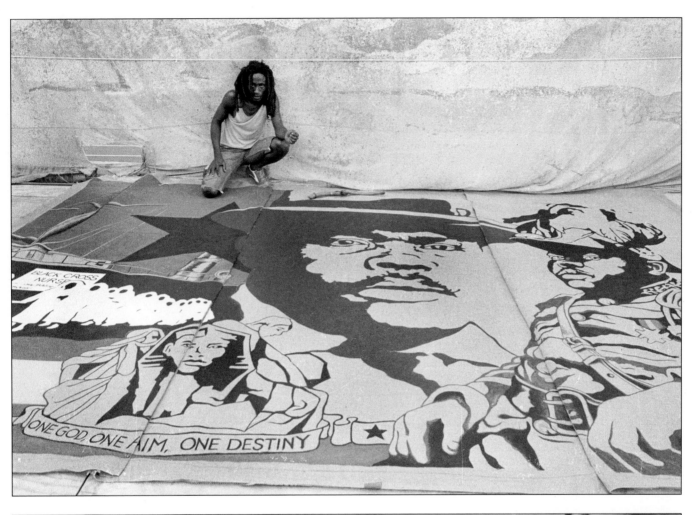

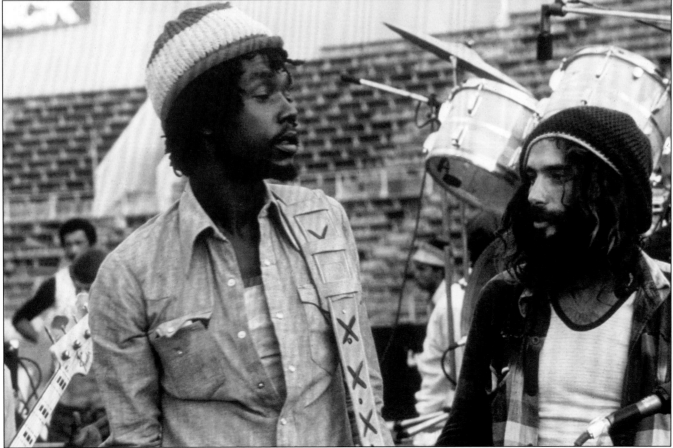

Above: Ras Reuben known as "Jawaye" with Neville Garrick's stage backdrop of Marcus Garvey.

Below: Peter Tosh and harmonica player Lee Jaffe at rehearsals for The Dream Concert.

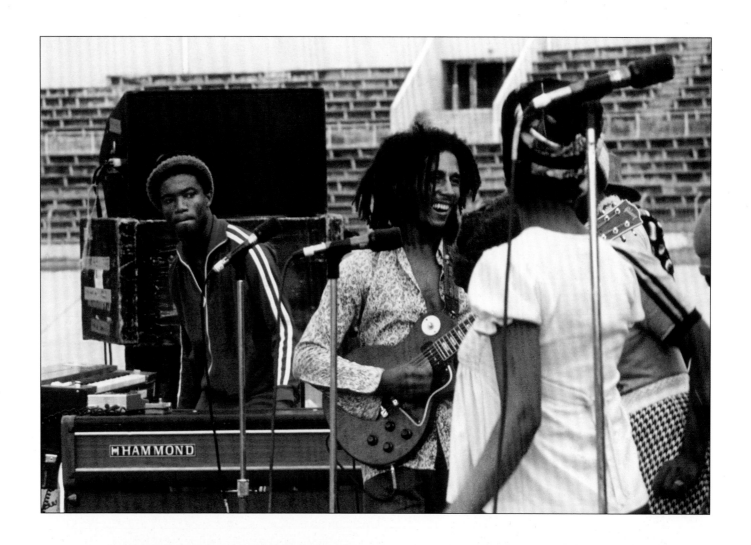

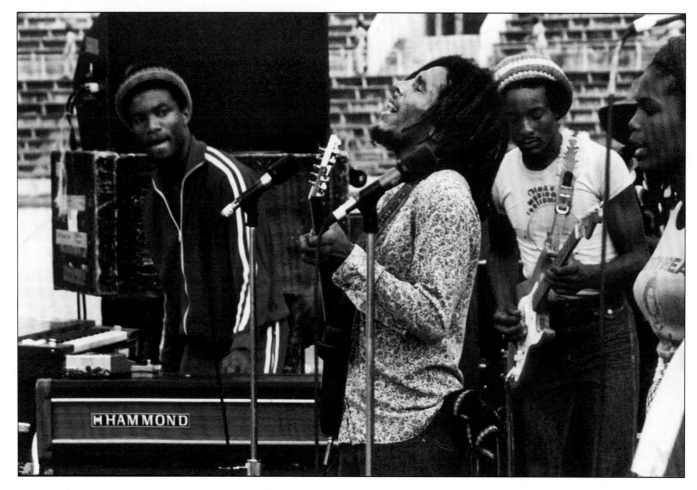

Above: Bob shares
a laugh with
Tyrone Downey, Al
Anderson and Judy
Mowatt at rehearsals
for The Dream
Concert, 1975.

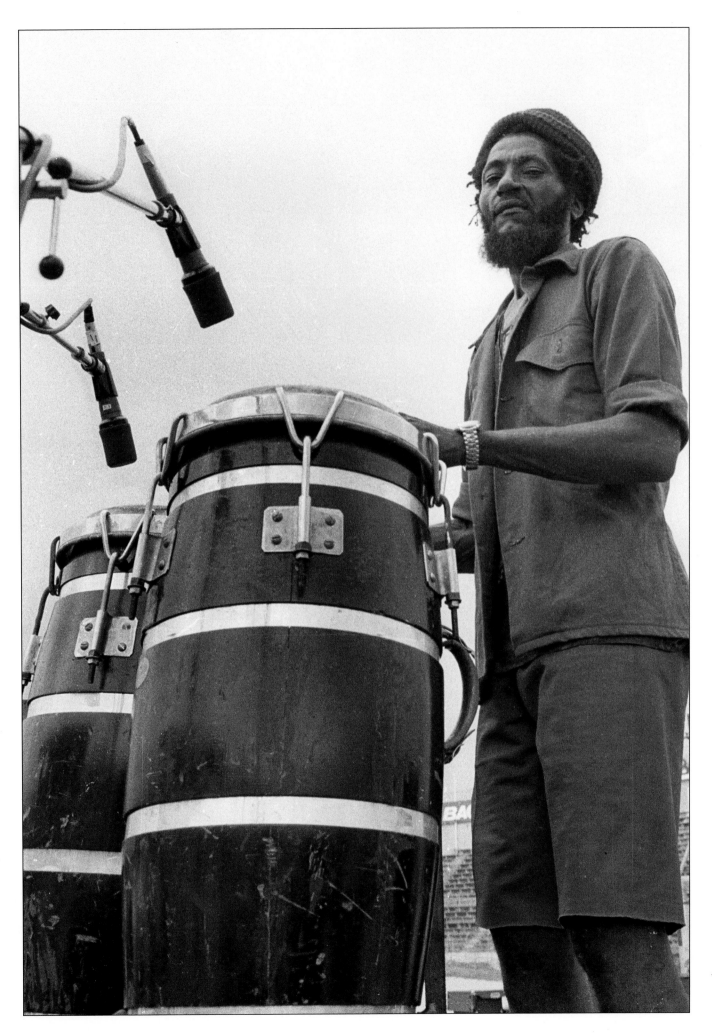

Left: Alvin "Seeco" Patterson rehearses on the bongos for The Dream Concert, 1975.

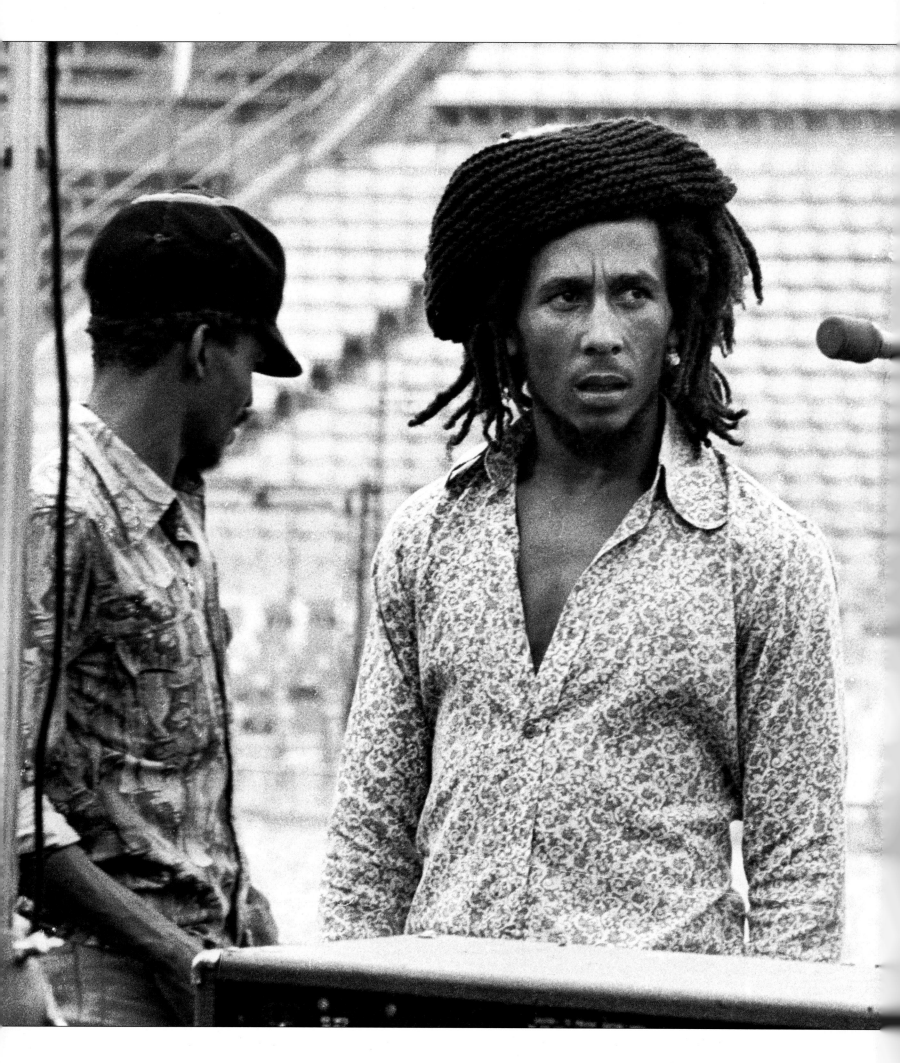

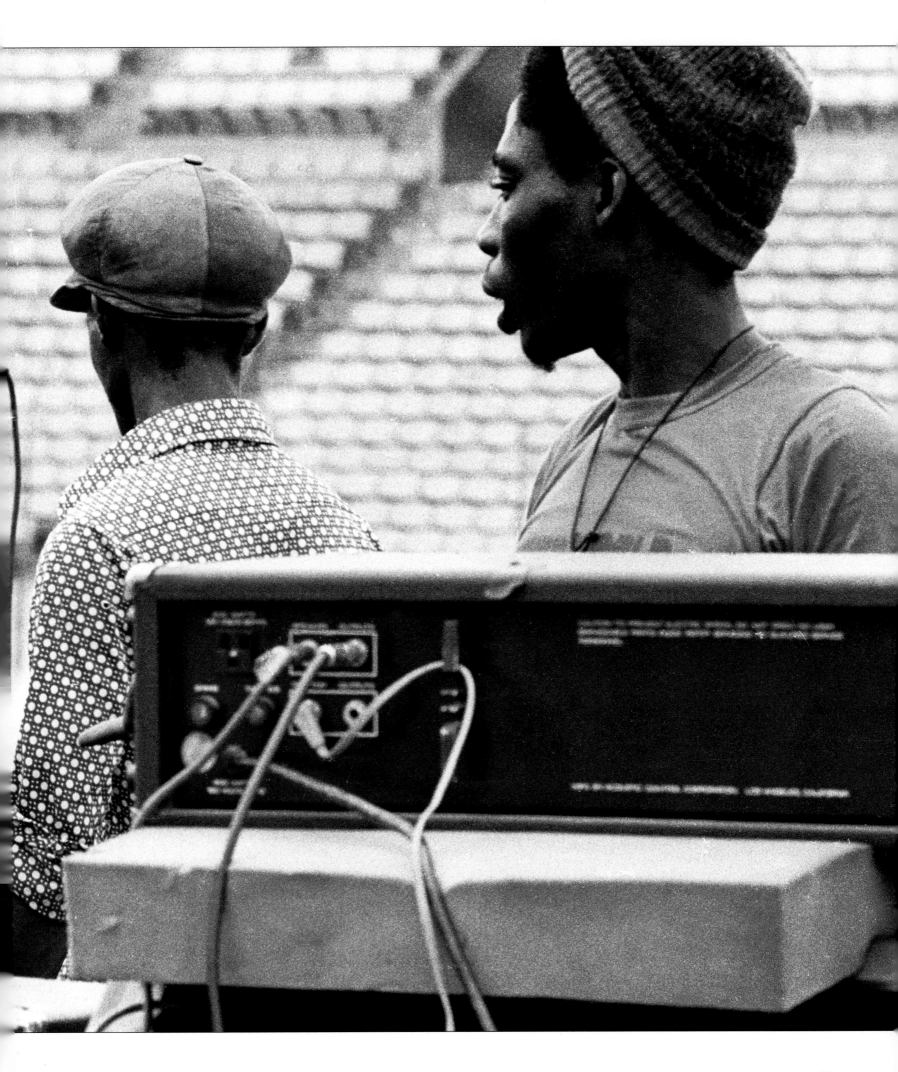

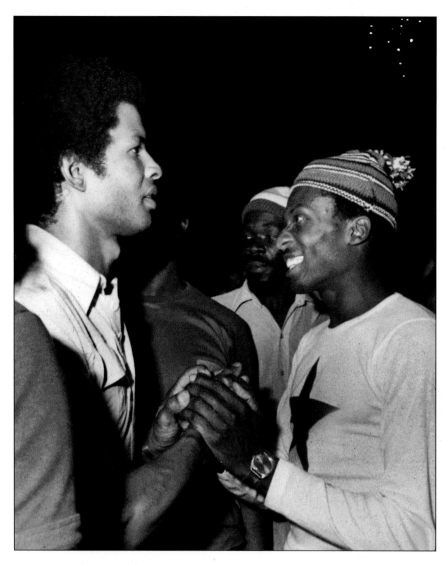

Previous Page:
Bob shoots a steely
glance during
rehearsals for the
Dream Concert.

Above Left: Jimmy
Cliff greets Don
Taylor.

Above Right: Diane,
Robbie and friends
wait for the concert
to begin, with
Jacob Miller in the
background.

Right: Bob heads
to the stage for
what will be the
final appearance
of all three Wailers
together.

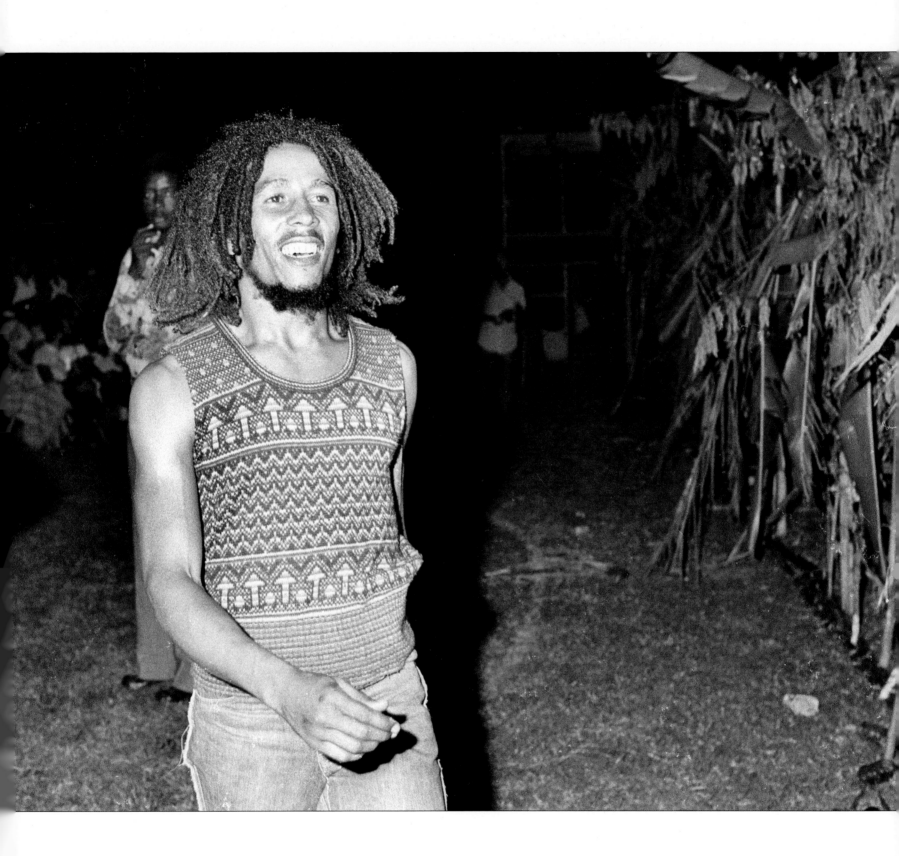

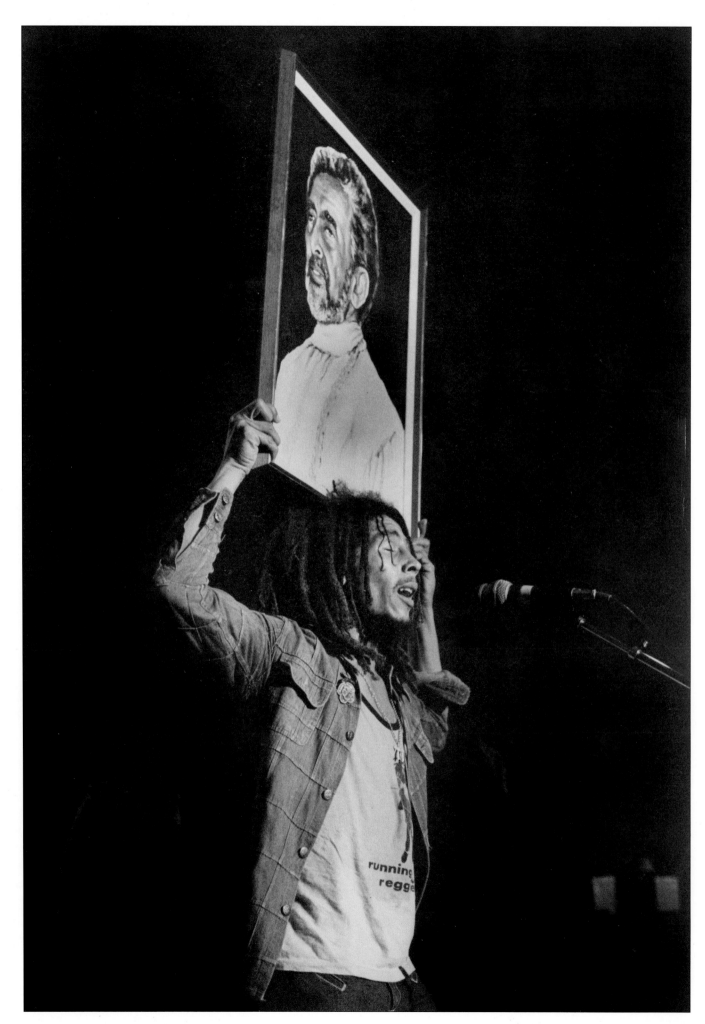

Right: Bob hoists a picture of Emperor Haile Selassie I, the Rasta God above his head during his performance at The Dream Concert.

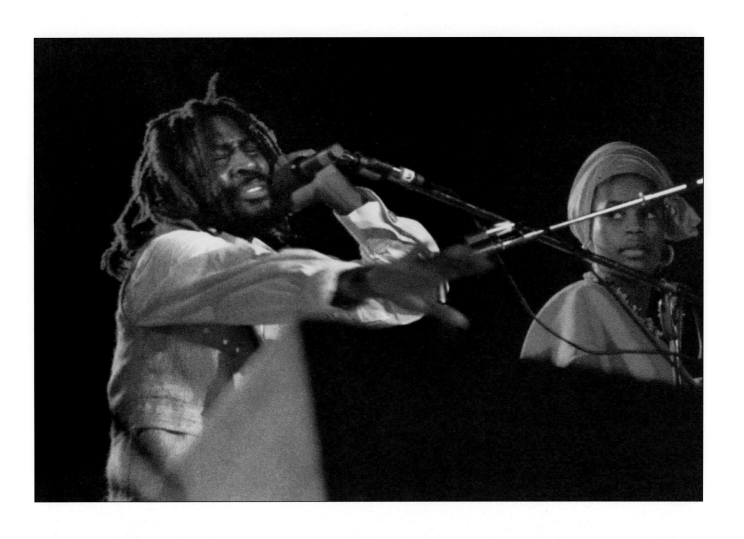

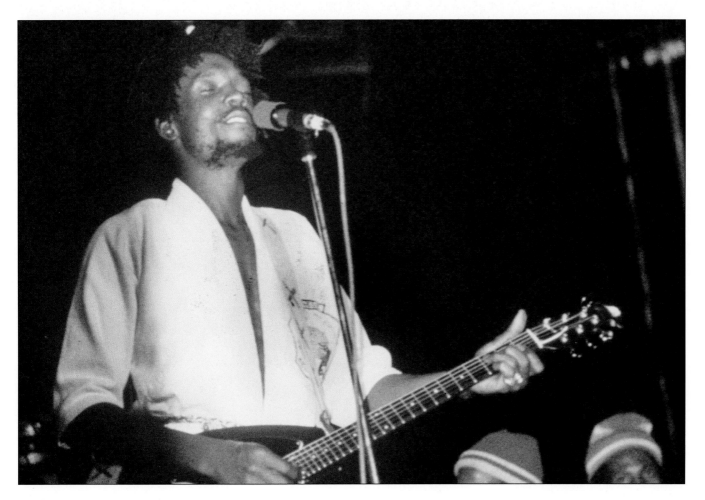

Above: Bunny singing "Battering Down Sentence" at The Dream Concert.

Below: Peter Tosh stirs the crowd with his performance of the banned song, "Legalize It" at The Dream Concert.

THE PRODUCERS

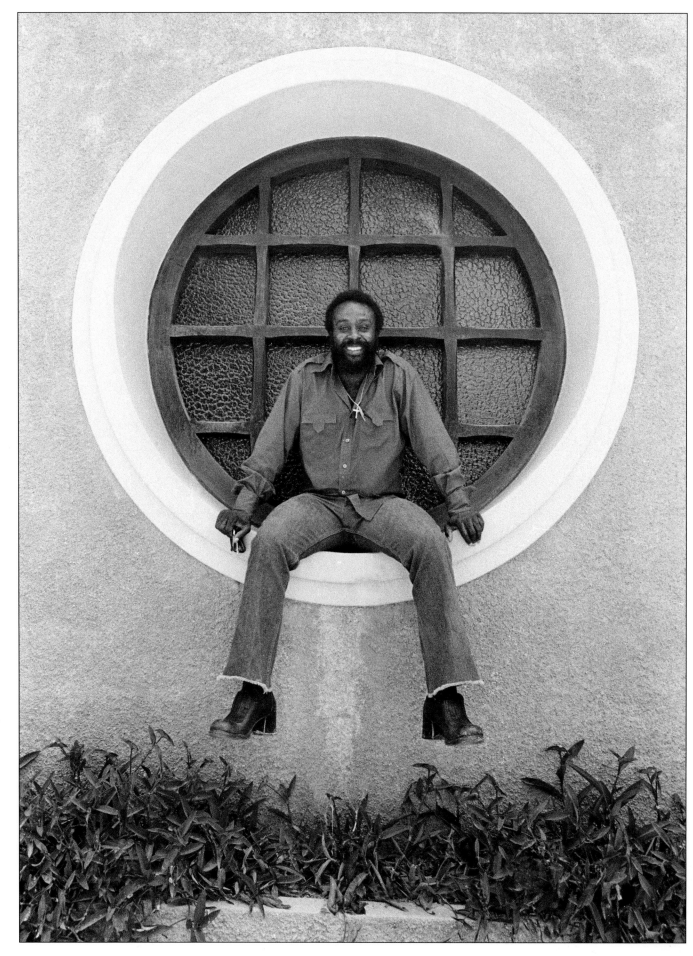

Right: Producer Harry J (Harry Zephaniah Johnson) provided the Kingston studio for several of Bob's 1970s Island albums including his only American top ten, *Rastaman Vibration*. He also produced the Heptones, Burning Spear, Ken Boothe, Augustus Pablo and Johnny Nash and his studio was the Jamaican hangout for the Rolling Stones, The Who and Grace Jones.

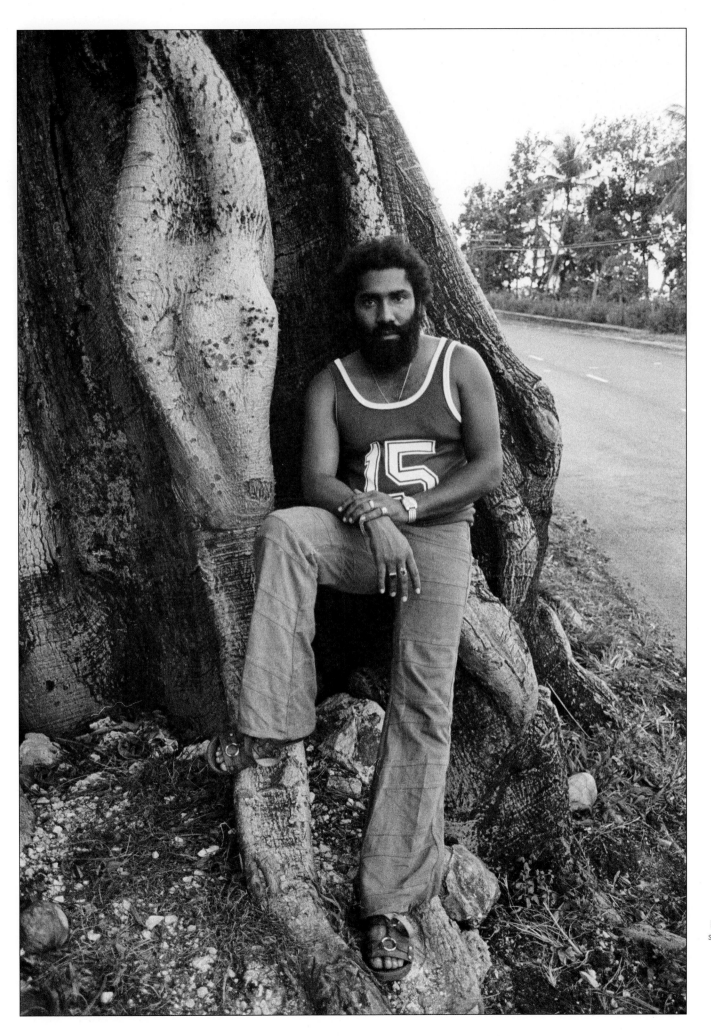

Left: Jack Ruby (Lawrence Lindo) was a north coast producer and sound system operator who recorded Burning Spear, Justin Hinds, the Heptones and Delroy Wilson.

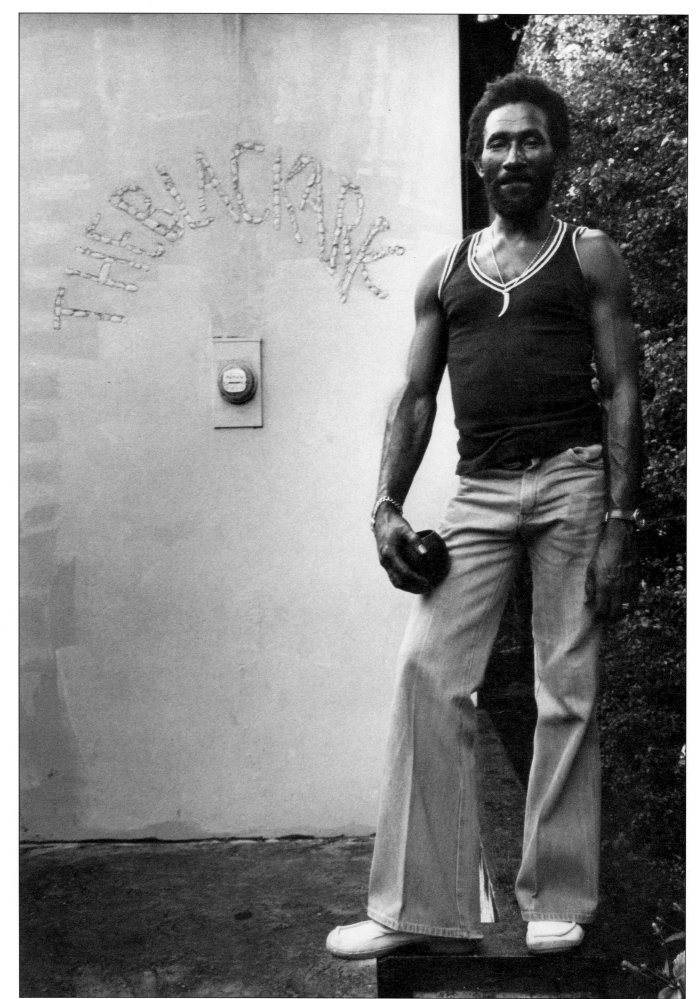

Right: Lee "Scratch" Perry was at the height of his powers in the 1970s. He opened his four-track Black Ark studio in 1974, recording major hits with Junior Byles, Max Romeo, Junior Murvin, the Heptones and Bob Marley. His groundbreaking dub technique utilized drum machines and phase shifters to create other-worldly sounds.

Opposite: Singer Max Romeo, Lee Perry, producer-singer Clancy Eccles and "Chinna" Smith. "The bass plays rock steady, the guitar plays ska, the organ plays Calypso." — Max Romeo describing reggae.

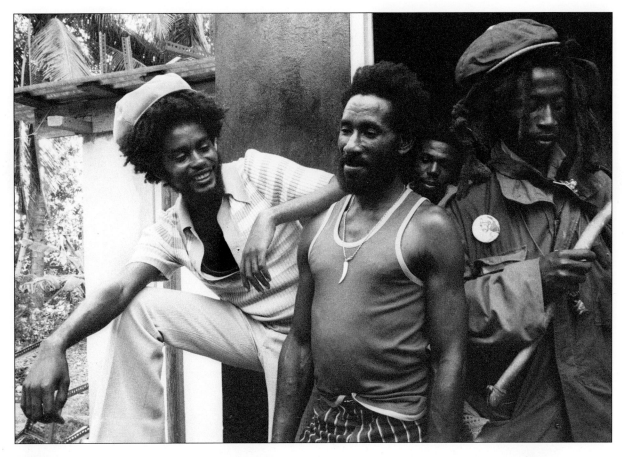

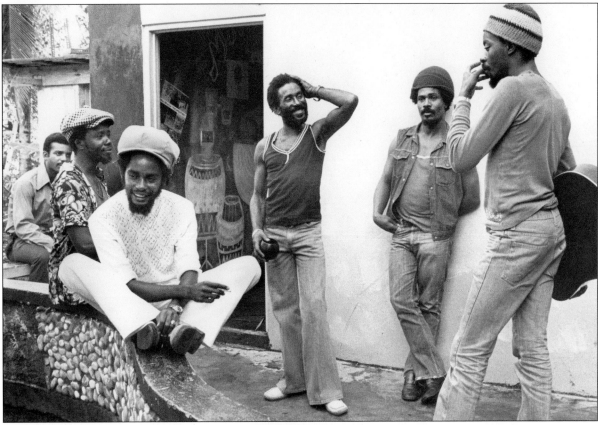

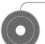

RECOMMENDATIONS

Lee Scratch Perry: Dreadlocks In Moonlight; People Funny Boy; Return of Django; Roast Fish & Corn Bread; Judgement Inna Babylon

Max Romero: Let The Power Fall; Wet Dream; War Ina Babylon; Babylon Burning

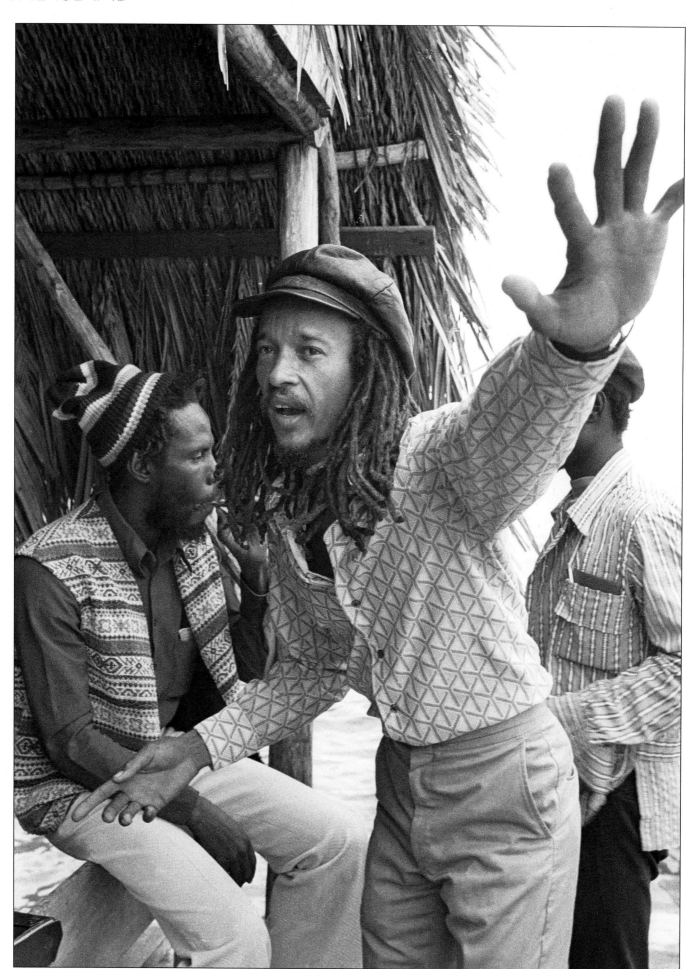

Right: Kiddis I is a highly respected underground singer who achieved international prominence for his role in the movie *Rockers*, pictured here in 1975 with Ras Michael in the background.

Opposite: Ras Michael is the best known exponent of pure nyabinghi spiritual reggae, pictured here describing his music and philosophy, 1975.

 RECOMMENDATIONS

Ras Michael & The Sons Of Negus: New Name; Holy Mount Zion; Birds In The
Treetops; None A Jah Jah Children No Cry

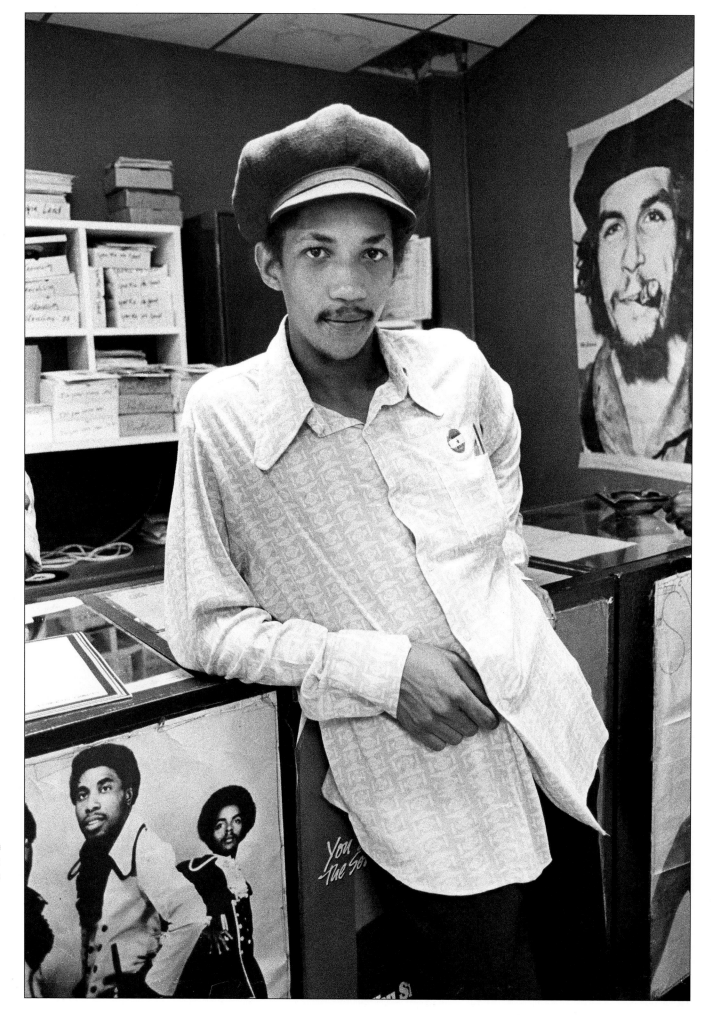

Right: Augustus Pablo transformed a child's toy melodica into one of reggae's most haunting instruments. He played with many of the major figures of his time and was also a successful producer.

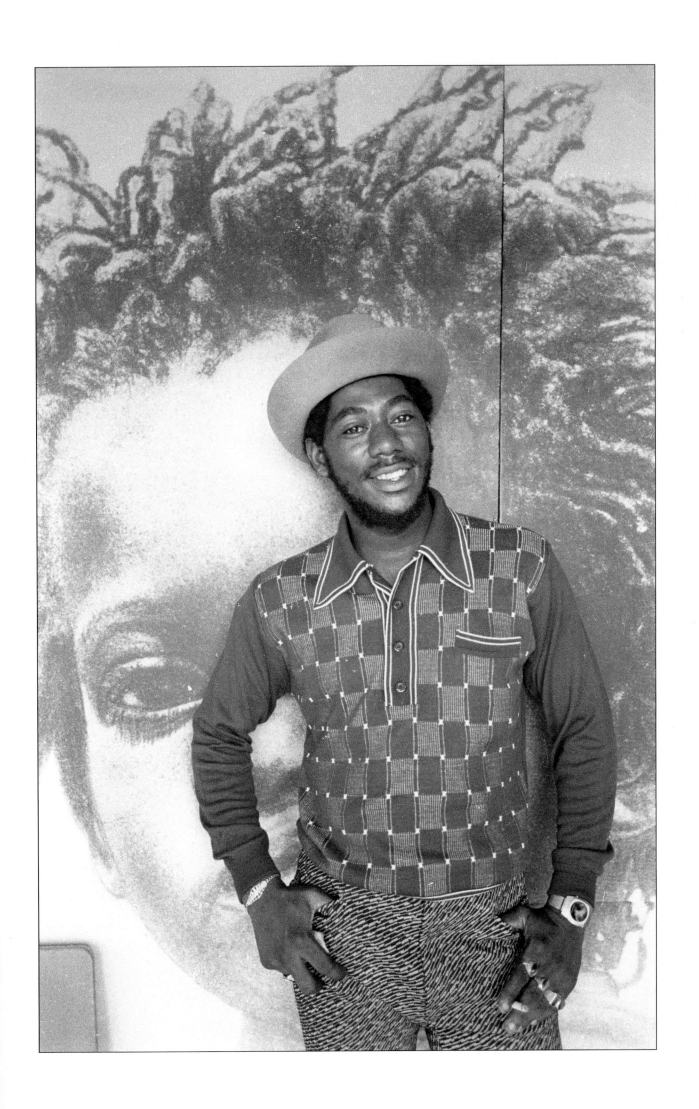

Left: Johnny Clarke was producer Bunny Lee's most prolific singer in the mid-1970s, as famous for his cover songs as for originals like "Blood Dunza."

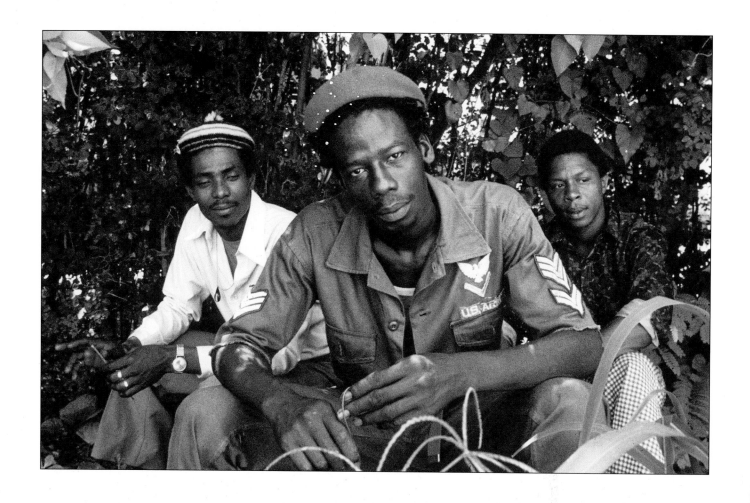

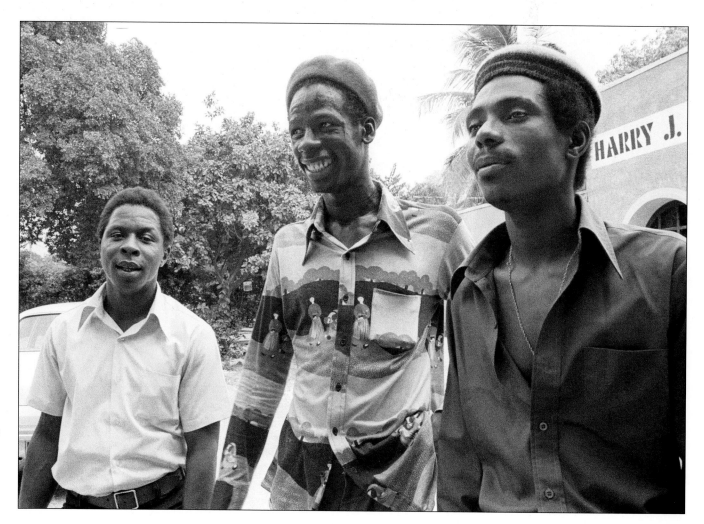

Right & Opposite:
The Heptones; Leroy
Sibbles, Earl Morgan
and Barry Llewellyn
pictured here in front
of Harry J's studio in
Kingston, 1975.

"THE HEPTONES ARE JAMAICA'S TOP VOCAL GROUP; THEIR MUSIC IS IN THE STREETCORNER SYMPHONY TRADITION OF SUCH GREAT HARMONY GROUPS AS THE PERSUASIONS AND THE DRIFTERS. THEY POSSESS THE SAME PASSION AND SOULFULNESS; THE SAME DEDICATION TO THE MASTERY OF SINGING HARMONIES. ONLY THE HEPTONES' PERSPECTIVE AND STYLE IS COMPLETELY DIFFERENT, DELVED FROM A BACKGROUND ON THE STREETS OF KINGSTON INSTEAD OF NEW YORK."— ISLAND RECORDS, 1975

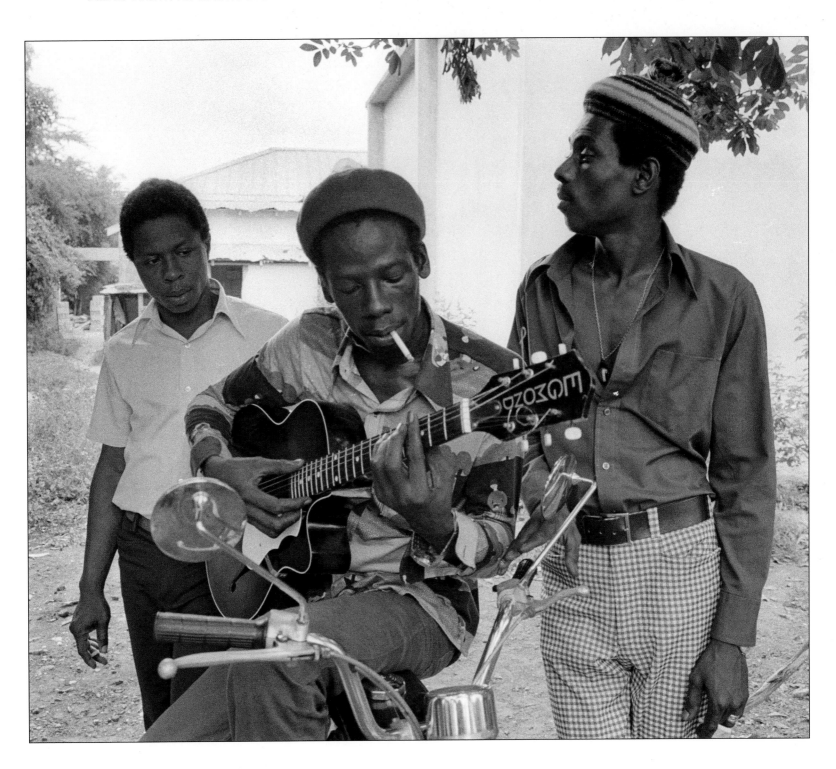

 RECOMMENDATIONS
Leroy Sibbles/Heptones: Ting A Ling; Fattie Fattie; I Shall Be Released; Book of Rules; Mr Presidents; Party Time

Right: Winston
"Burning Spear"
Rodney. His devotion
to the patron saint of
black repatriation,
Marcus Garvey, is
apparent on virtually
every album he has
made. His songs
are lengthy haunting
chants recalling
the days of slavery
and the hope of
salvation.

Opposite: Winston
Rodney "Burning
Spear" with Rupert
Wellington and
Delroy Hines.

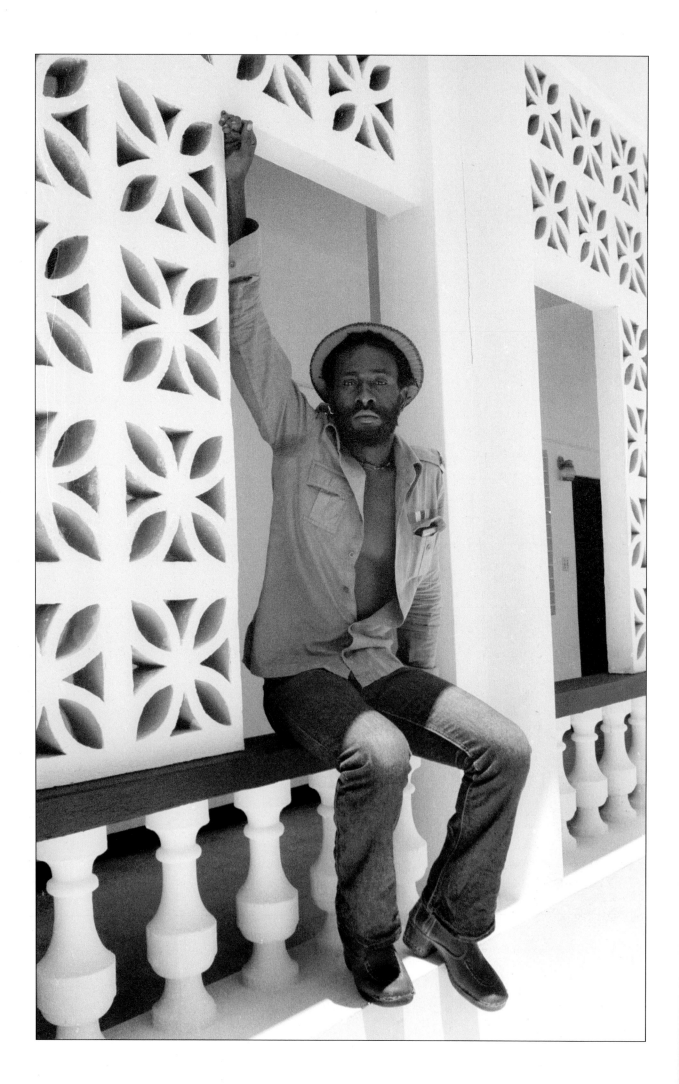

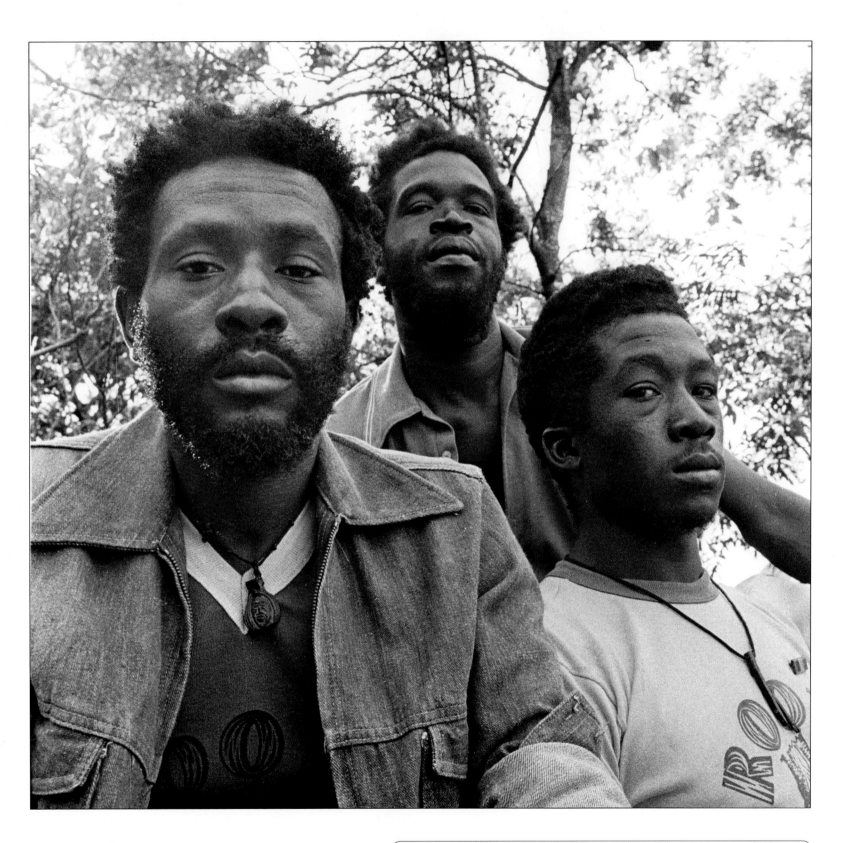

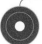 **RECOMMENDATIONS**

Burning Spear: Door Peep; Slavery Days; Marcus Garvey; Man In The Hills;
African Postman; Bad To Worse; Foggy Road

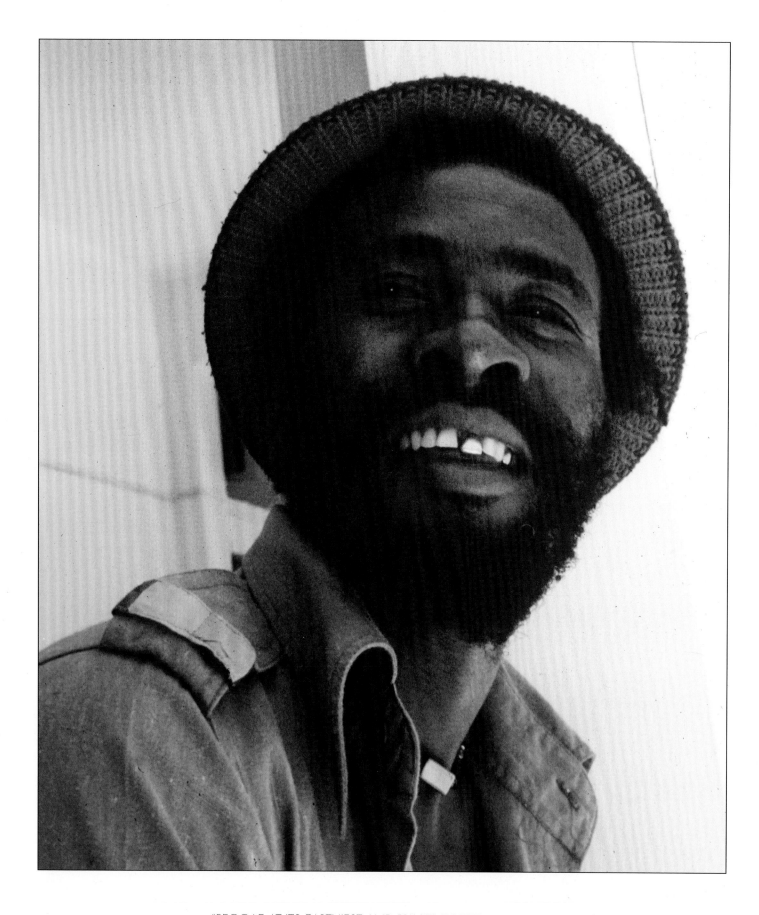

"REGGAE AT ITS EARTHIEST AND PRIMITIVE BEST" — *CASHBOX*

Above & Opposite:
Winston "Burning
Spear" Rodney
pictured here in
Jamaica, 1975.

"THE MOST EXCITING JAMAICAN ACT YET" — *CRAWDADDY*

"INTENSELY RHYTHMIC, CHANT-LIKE AND HYPNOTIC" — *PLAYBOY*

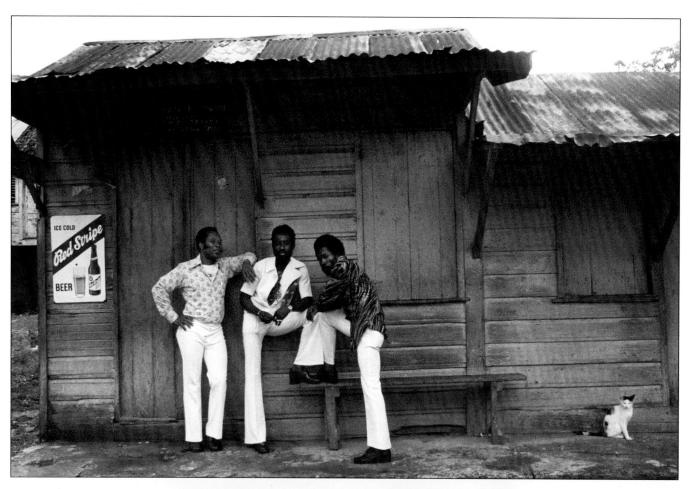

Above: Justin Hinds and the Dominoes, pictured here, gave reggae its rural voice, mixing proverbs and parables in hundreds of releases. Their mid-1970s Island albums brought them an international audience. Justin's influence was crucial to the success of the 'two-tone movement' of the early 1980s. His selfless charity resulted in his neighbors referring to him as "Jesus." Keith Richards idolized him and recorded two albums of rasta spirituals called "Wingless Angels."

Opposite: Justin Hinds pictured here in Dunns River Falls, Ocho Rios, Jamaica, 1975.

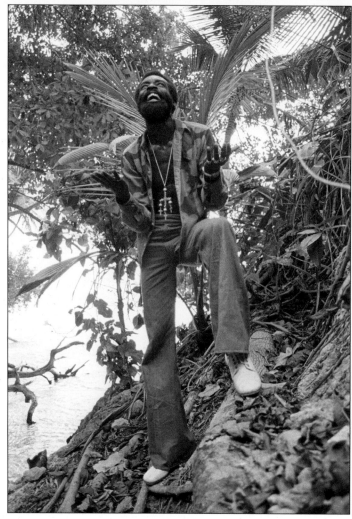

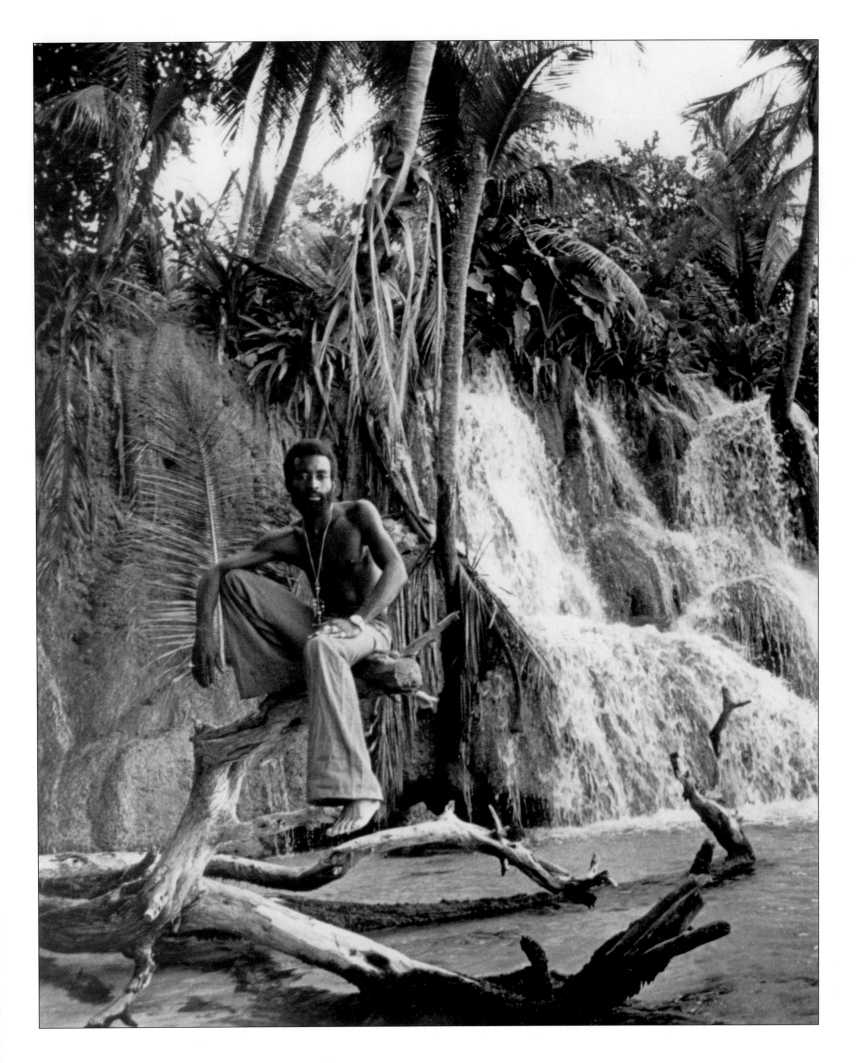

PETER TOSH WAS REGGAE'S MOST NOTORIOUSLY OUTSPOKEN DEFENDER OF MANKIND'S RIGHT TO SMOKE "JAH HOLY HERB."
HE SUFFERED MIGHTILY FOR THIS STANCE, SURVIVING SEVERAL NEAR-FATAL BEATINGS BY POLICE. SONGS RELATING DIRECTLY TO
THIS INCLUDE "LEGALIZE IT", "BUSH DOCTOR" AND "NAH GO A JAIL [FE GANJA NO MORE]."

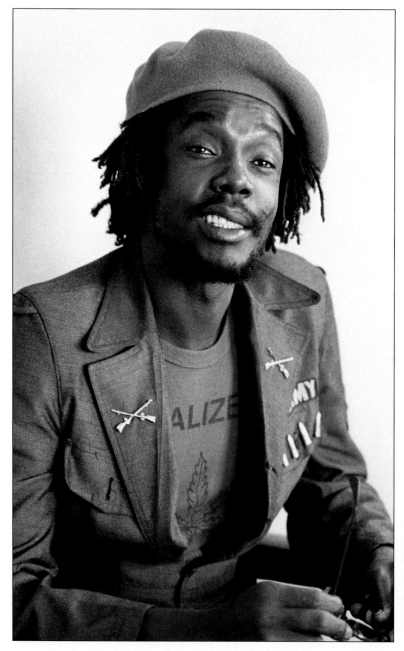
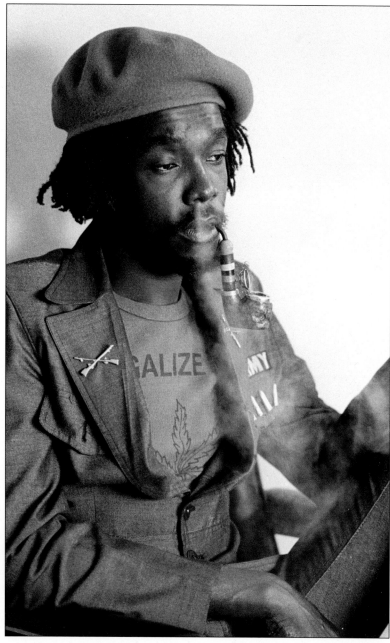

"TEAR DOWN YOUR DYLANS, YOUR GUEVERAS, YOUR MAXFIELD PARISHES AND YOUR MAPS OF MIDDLE EARTH
AND PIN UP YOUR 1976 STYLE HERO — PETER 'LEGALIZE IT' TOSH."

— STEVE BAROW, *BLACK ECHOES*, JULY 1976

Above & Opposite:
Kim recalls her time
with Tosh: "Tosh
was so expressive
and cooperative
and enthusiastic,
photographing
him was a pure
pleasure."

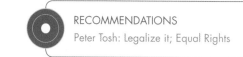
RECOMMENDATIONS
Peter Tosh: Legalize it; Equal Rights

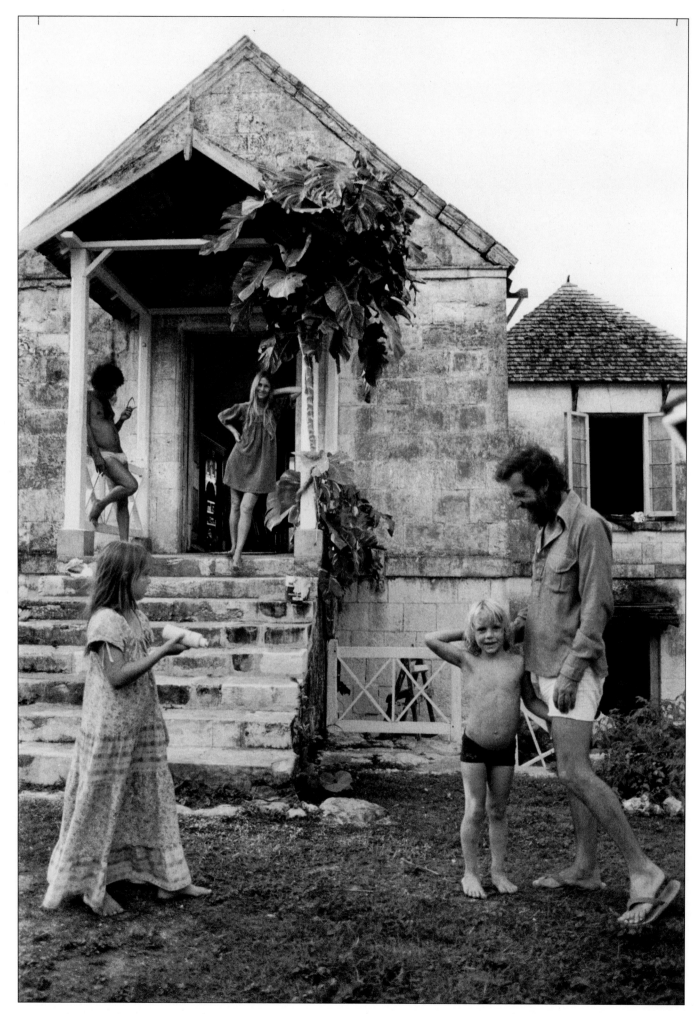

Right: Perry Henzell's home, his wife Sally on the steps and "Country Man" to her left.
Perry directed *The Harder They Come* starring Jimmy Cliff, which introduced reggae to the world.

"THE HARDER THEY COME MAY TURN OUT TO BE THE *BLACKBOARD JUNGLE* OF THE 1970S. JUST AS IT WAS DIFFICULT FOR ANY TEENAGER WHO SAW *BLACKBOARD JUNGLE* TO FORGET THE EXCITING EMOTIONAL CHILL THAT CAME FROM HEARING BILL HALEY'S "ROCK AROUND THE CLOCK" OVER THE FILM'S OPENING CREDITS, IT IS UNLIKELY THAT MANY MUSIC FANS WHO SEE *THE HARDER THEY COME* WILL BE ABLE TO ESCAPE THE SPELL OF REGGAE... IT'S A MAGNIFICENT SOUNDTRACK ALBUM." — ROBERT HILBURN

Above: Esther Anderson, Jamaican actress and co-founder of Island Records. She helped Perry Henzell raise the funding he needed to complete *The Harder They Come* and was an advocate for Jimmy Cliff to play the lead. She has been romantically linked to not only Bob Marley, but Chris Blackwell and Marlon Brando.

DELROY WILSON WAS A CHILD STAR CALLED "THE BOY WONDER," RECORDING HIS FIRST SINGLE AT AGE 13, WHO GREW UP TO BE ONE OF REGGAE'S PREMIER VOCALISTS. HIS "BETTER MUST COME" BECAME A POLITICAL ANTHEM FOR LEFTIST PRIME MINISTER MICHAEL MANLEY'S PEOPLE'S NATIONAL PARTY.

Above (L to R):
DJ Lester Bullock
(given the gangster
name Dillinger by
Lee Perry). His rap
"Cocaine in my
Brain" brought him to
international fame;
Delroy Wilson, one
of reggae's premiere
vocalists.

Above (L to R): Pete
Weston, founder
of Micron Records;
Kerrie "Junior" Byles
(aka King Chubby),
a tortured figure
whose records are
considered classics.

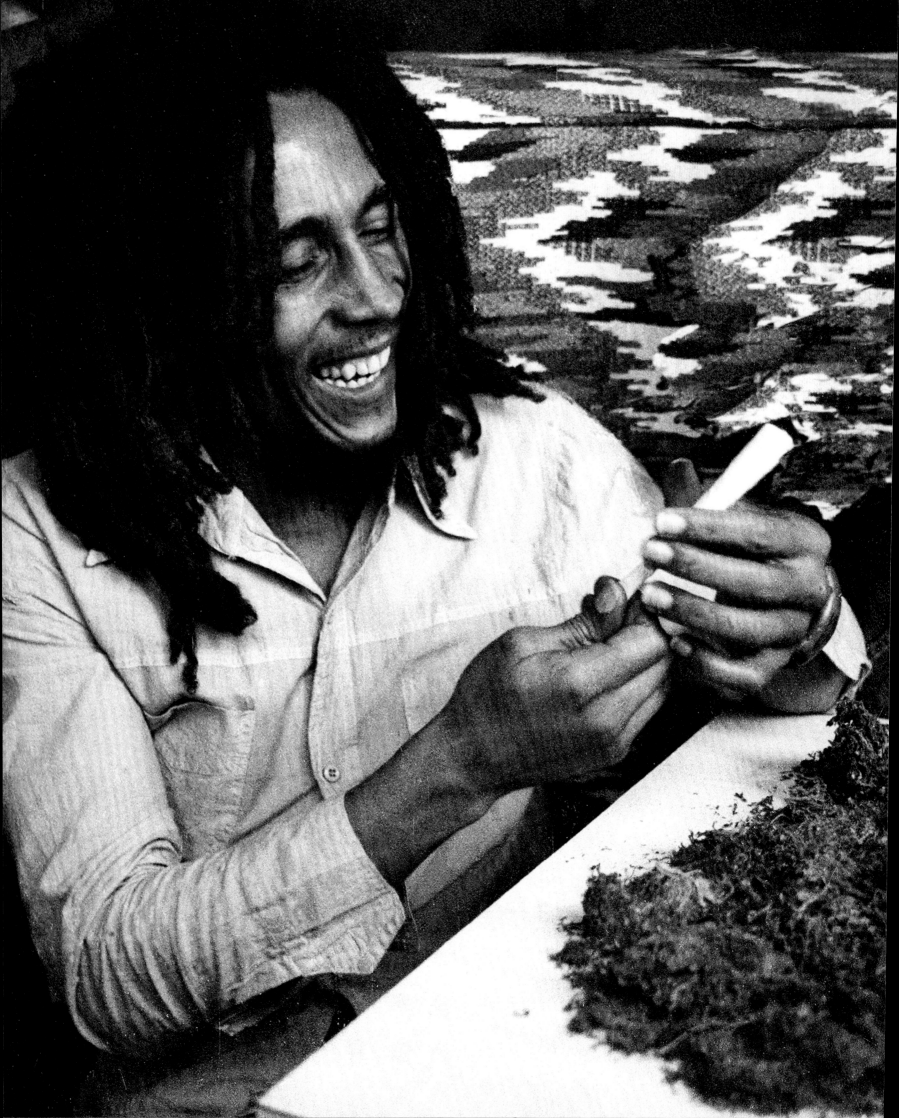

SOUTHERN CALIFORNIA, 1976

Jeff Walker

1976 was a banner year for both Marley and Island's overall reggae campaign. *Burnin'* and *Catch a Fire* were both re-issued early in the year and we released *Rastaman Vibration* on April 30 (which would reach number eight on Billboard's Top Albums chart).

And after being personally invited by Pete Townshend, Toots and the Maytals were in the midst of an American tour opening for The Who after Island released Toot's now classic album *Reggae Got Soul*. Toots was also one of the sweetest, most energetic, determined people I've ever known and the only reggae performer who came close to being the kind of "showman" that James Brown personified onstage.

Island was also releasing the landmark soundtrack album from Perry Henzell and Jimmy Cliff's *The Harder They Come*, the Heptones' *Night Food*, Burning Spear's roots classic *Marcus Garvey*, Jimmy Cliff's *Strugglin' Man*, Max Romeo's *War ina Babylon*, Dillinger's *CB200* and Third World's self-titled debut album.

The Wailers' Rastaman Vibration tour began in April 1976 and I joined up with them in Philadelphia where Bob and I talked about that year's tour publicity and some interviews we had planned when he got to LA. Bob was most enthusiastic about an offer to be on the cover of *High Times* magazine and readily agreed to do a photo shoot with Kim in July. Needless to say, herb as a sacrament and a gift from Jah as cited in the bible, is a very important part of Rastafarian philosophy and it was very important to Bob

that others understood its role in their lives and beliefs.

The band arrived in LA on May 26 to play the Roxy again, this time with Donald Kinsey on guitar and all three of the I-Three. The was one of the greatest performances I had ever seen Bob give. This time I also had the privilege of introducing Bob to another Beatle and once again his reaction was, only now face to face with Ringo — an enthusiastic "Ras Beatle!" as they greeted each other. Alas, this meeting took place in the dark recesses of On the Rox, the secret party floor above the Roxy and no picture was taken.

During some down time between the Roxy and playing the Santa Barbara County Bowl, Kim and I went down to Bob's hotel to shoot a private session for the now iconic *High Times* cover that would feature Bob smiling over a mound of herb. His delight that afternoon is pretty evident in these never before seen photos of that session.

Two days later, as the sun set on Bob Marley as he neared the end of their outdoor concert May 31 at the Santa Barbara County Bowl, none of us could have imagined what lay ahead in the next few years — from the attempt on Bob's life in his home as he was rehearsing for the Smile Jamaica concert (meant to help simmer down a very tense political climate in Kingston) to the diagnosis that would eventually take his life way too soon. But on that day in Santa Barbara, in an idyllic setting, Bob was at the peak of his powers and his legend would only continue to grow.

THE *HIGH TIMES* SHOOT

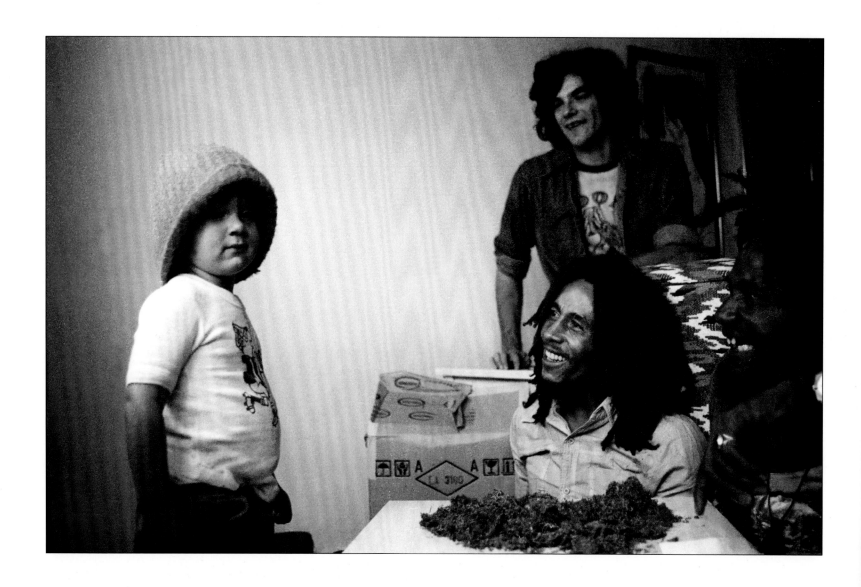

Previous Page: Bob at the *High Times* shoot in Southern California, happily sampling the props.

Above: Orion Walker, Bob, Jeff and Seeco during the *High Times* photo session, West Hollywood, July 1975.

Right: Bob and Seeco Patterson at the *High Times* cover session shot in West Hollywood.

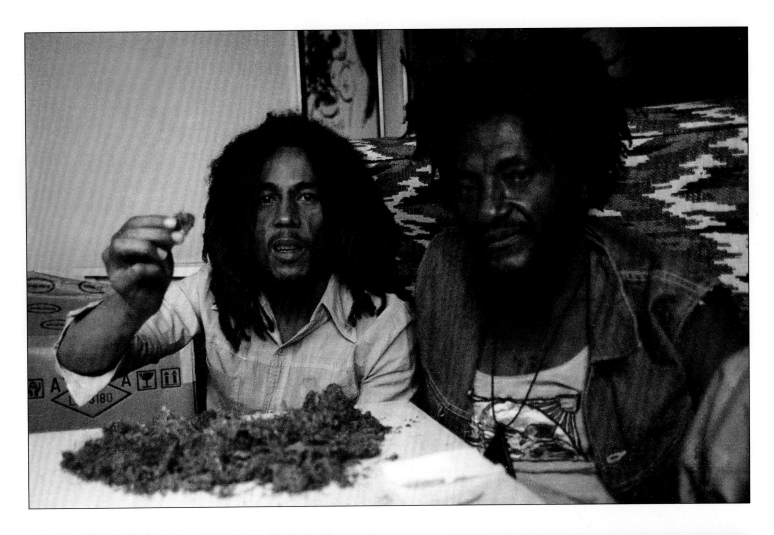

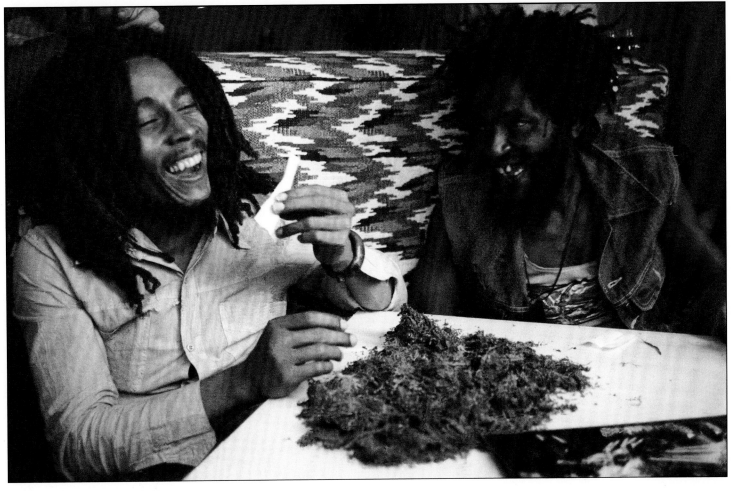

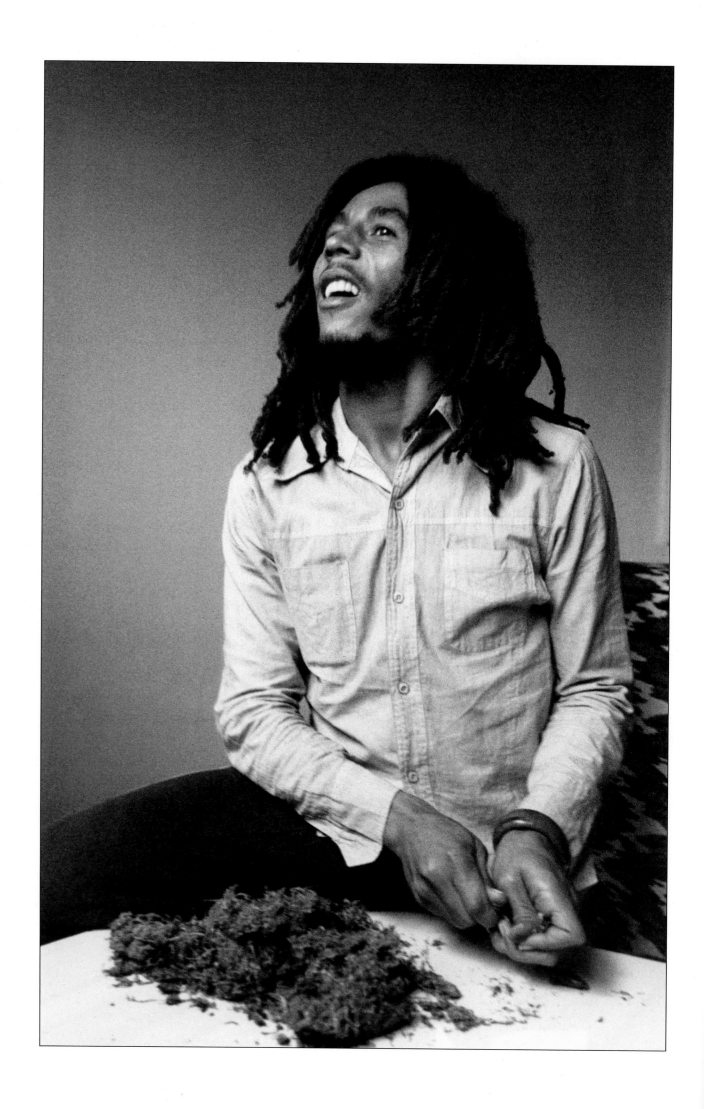

Right: Bob looks up at the *High Times* shoot, 1975.

Opposite: Cover shot used by *High Times* magazine for the Sept 1975 issue.

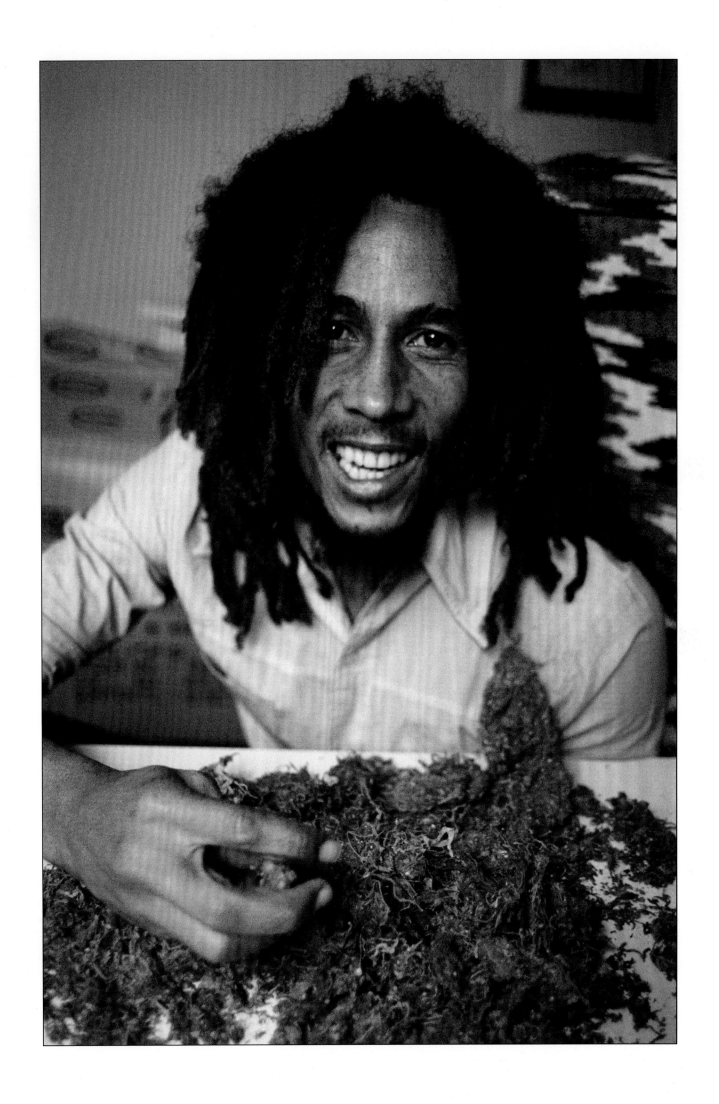

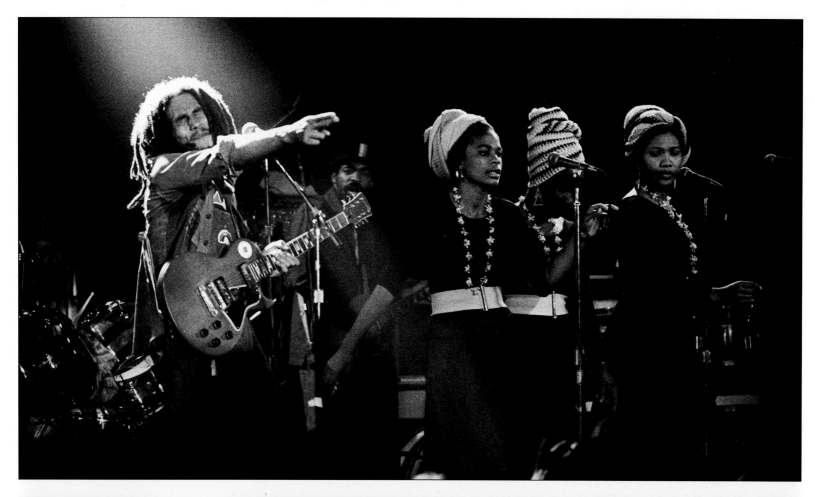

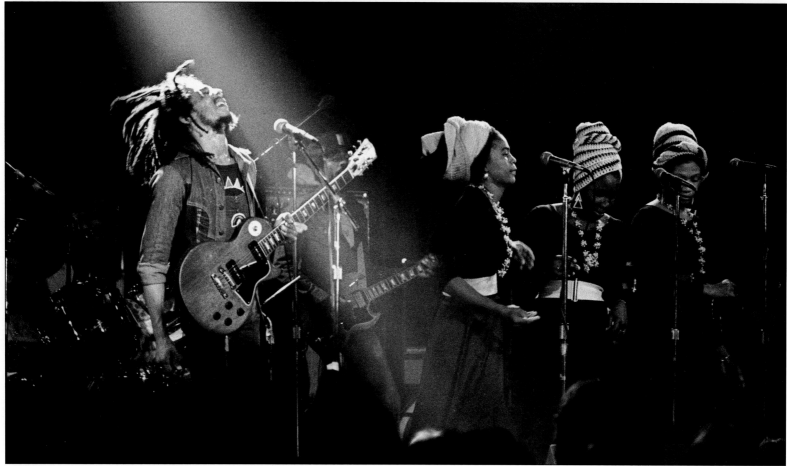

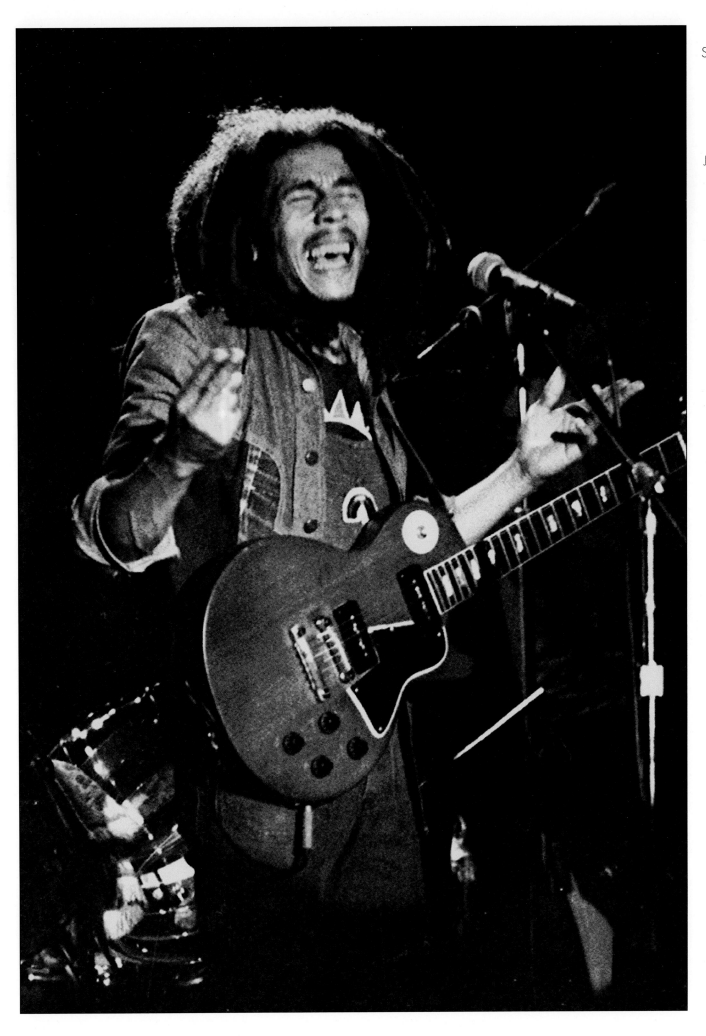

"BOB MARLEY IS SUPERB, ONE OF THE FEW REAL 'STARS' I'VE EVER SEEN."
— MARTY BALIN OF JEFFERSON AIRPLANE

"MARLEY IS FANTASTIC, INCREDIBLE. HIS LYRICS SHOULD BE PRINTED ON THE FRONT PAGE OF EVERY NEWSPAPER."
— DR JOHN

Opposite & Left: Bob performing "I Shot the Sheriff" at the Roxy with the I-Three, Judy Mowatt, Rita Marley and Marcia Griffith, 1976.

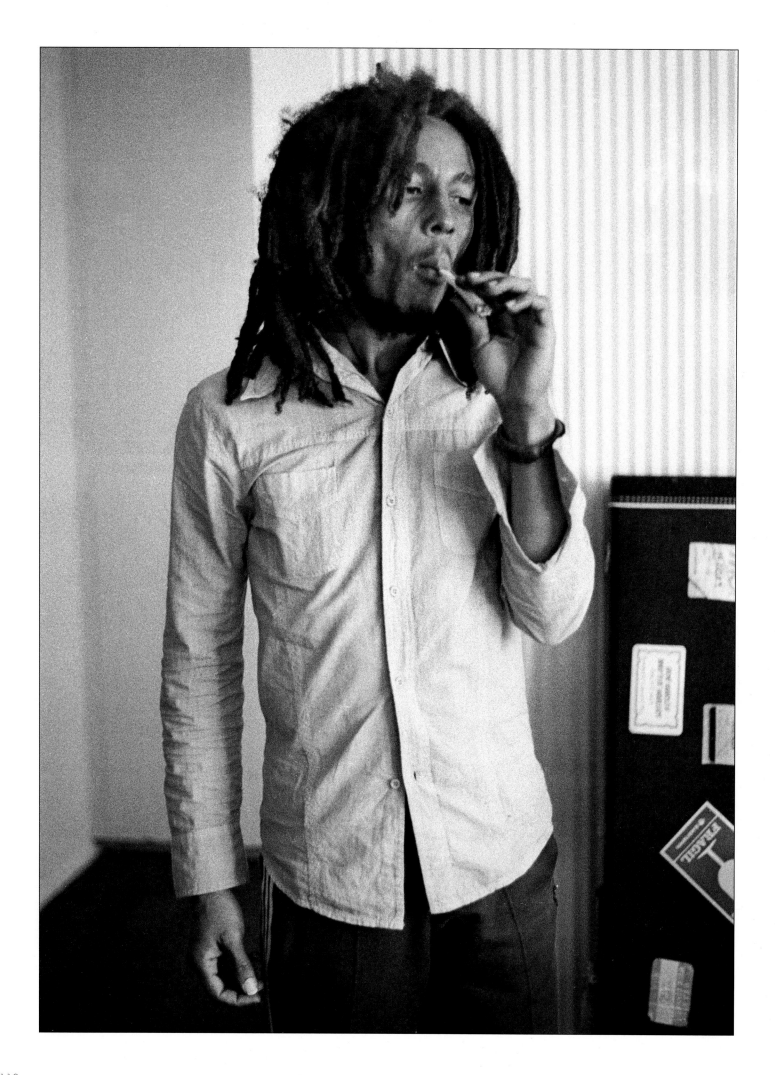

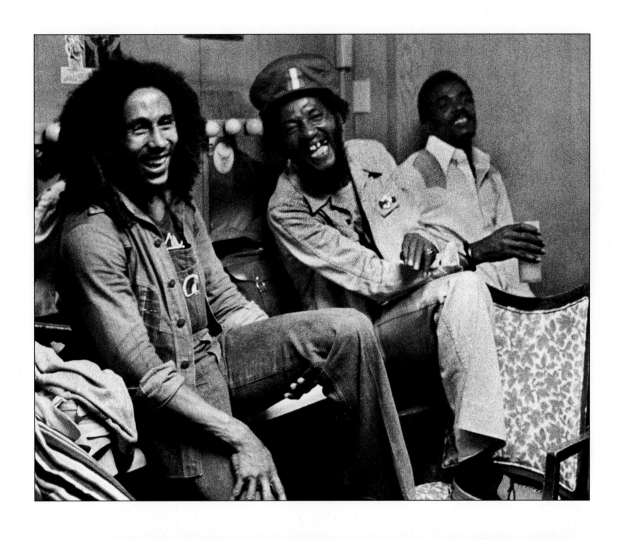

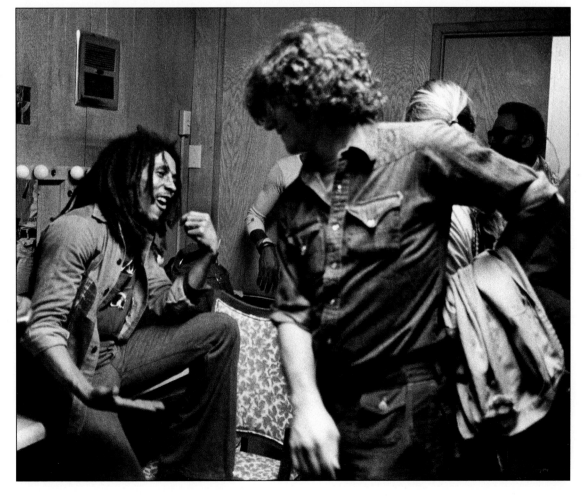

Left: Bob relaxes and smokes a spliff in his hotel room.

Above: Bob, Seeco and drummer, Carly Barrett backstage at the Roxy after the show.

Below: Jeff gives Bob five after the show, with stage mixer Dennis Thompson visible in the background.

SANTA BARBARA CONCERT

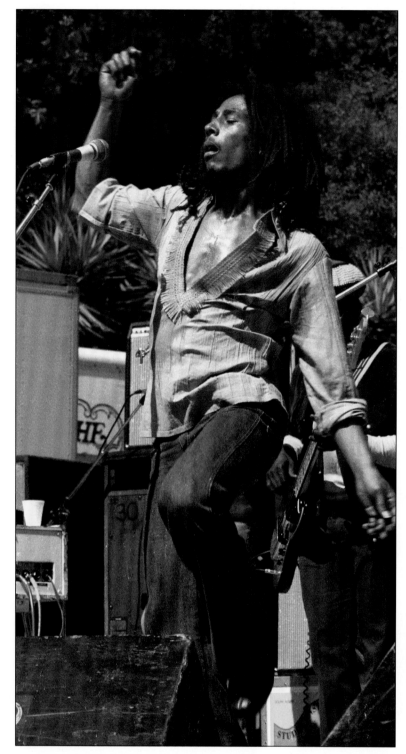 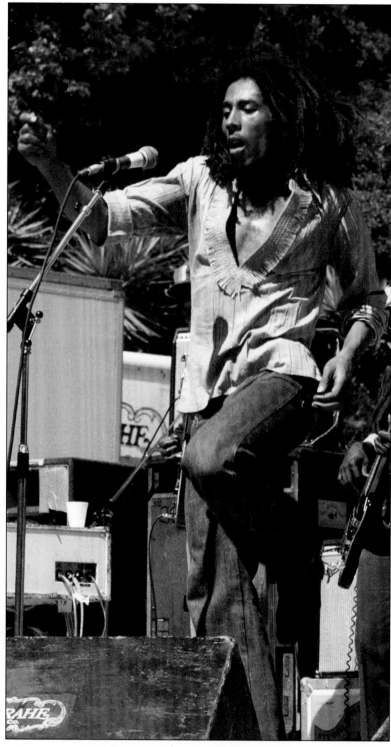

THE SANTA BARBARA COUNTY BOWL WAS ONE OF BOB'S FAVORITE PLACES TO PLAY IN THE USA. HE PERFORMED THERE SEVERAL TIMES, INCLUDING HIS ALL-TIME FAVORITE AMERICAN SHOW ON JULY 23, 1978 ON HAILE SELASSIE'S BIRTHDAY. THE FOLLOWING YEAR HE WAS FILMED THERE IN LATE NOVEMBER. THESE PHOTOS ARE FROM HIS 1976 PERFORMANCE. — JEFF WALKER

Above & Opposite:
Bob performs at
the Santa Barbara
County Bowl, 1976.

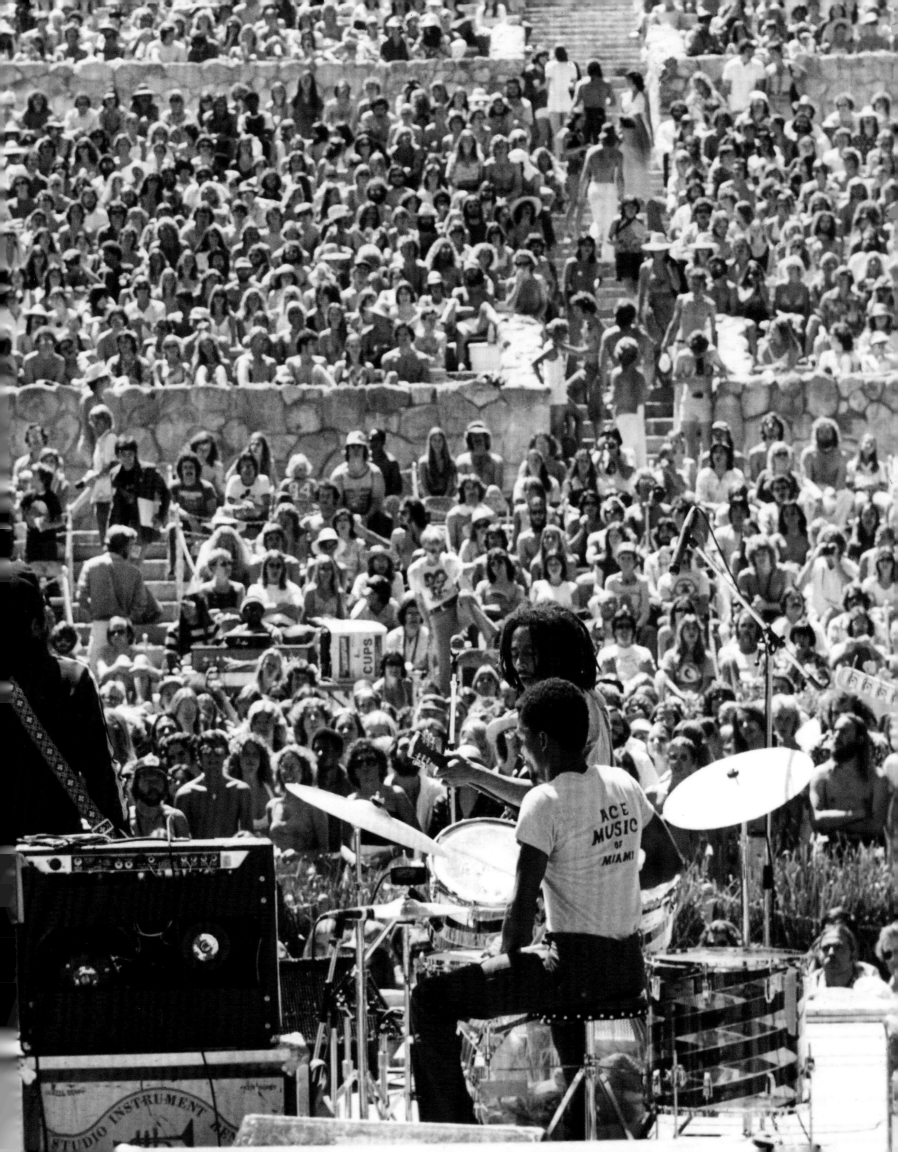

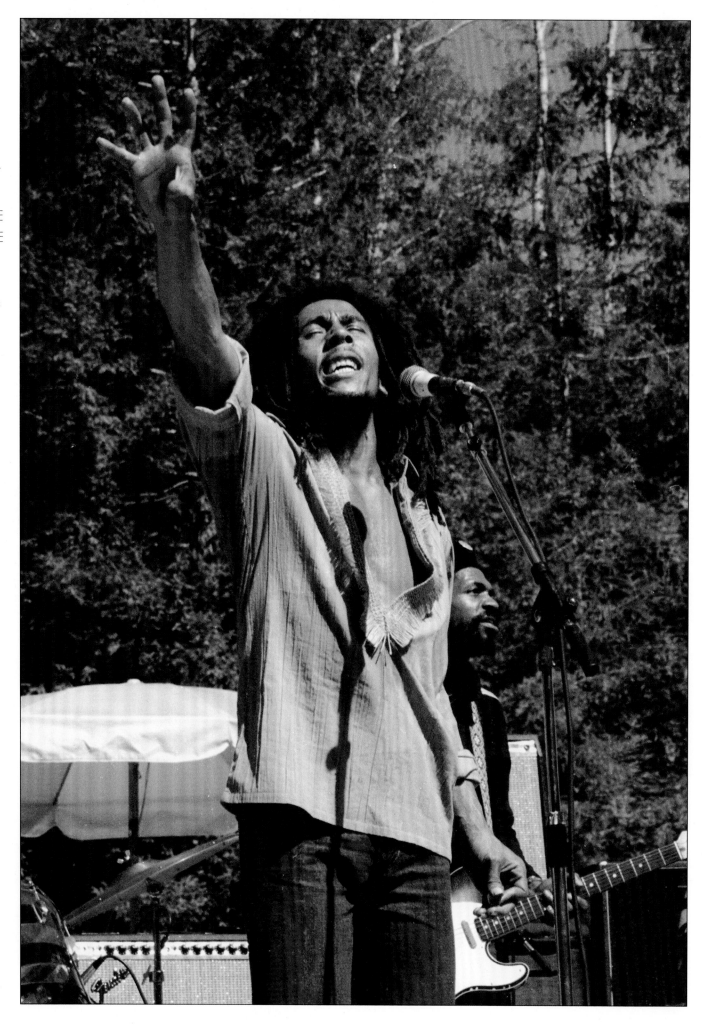

"THE WAILERS KICKED OUT PILE DRIVING RHYTHMS, DRIVING THE AUDIENCE INTO NEAR FRENZY. MARLEY IS ELECTRO-MAGNETIC... HE PERSONIFIES THE ULTIMATE BODY MUSIC. ITS PRESLEY ROCK & ROLL WITH AN URGENCY OF LYRIC: MARLEY IS SIMPLY THE JAMAICAN JAGGER."
— *THE CHICAGO READER*

Opposite: "Chinna" Smith on lead guitar, Bob and bassist, Family Man perform.

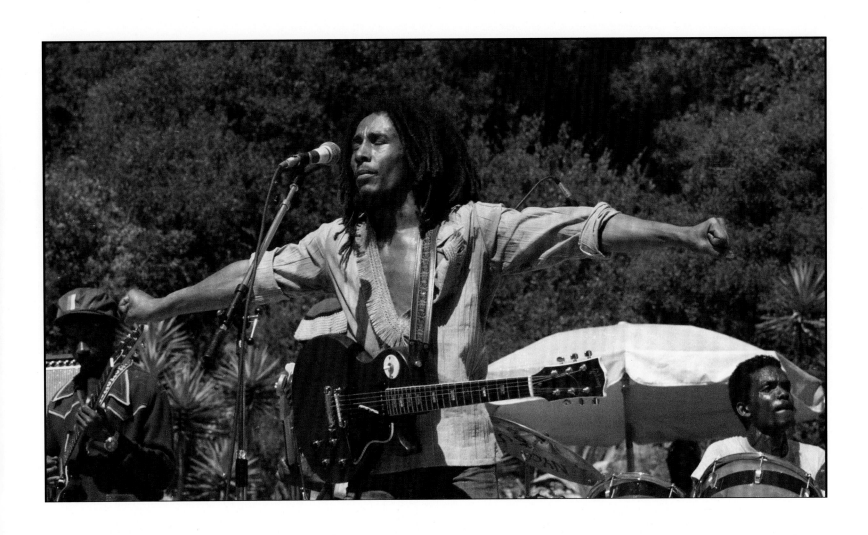

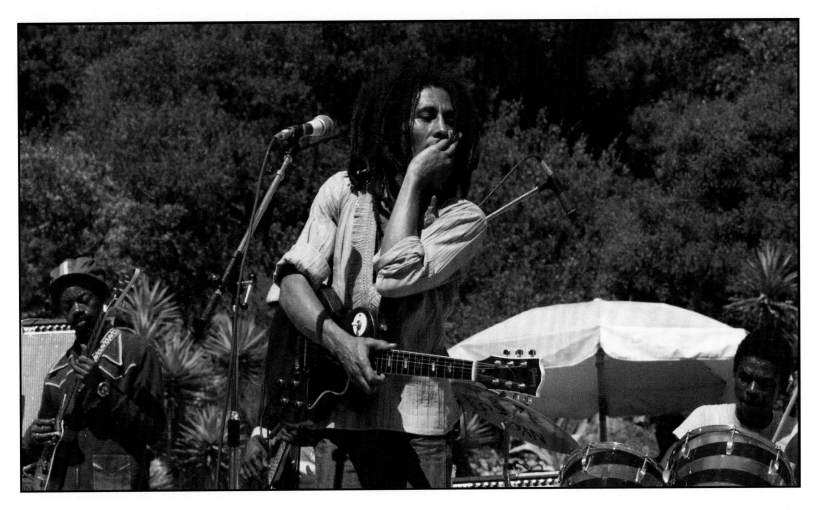

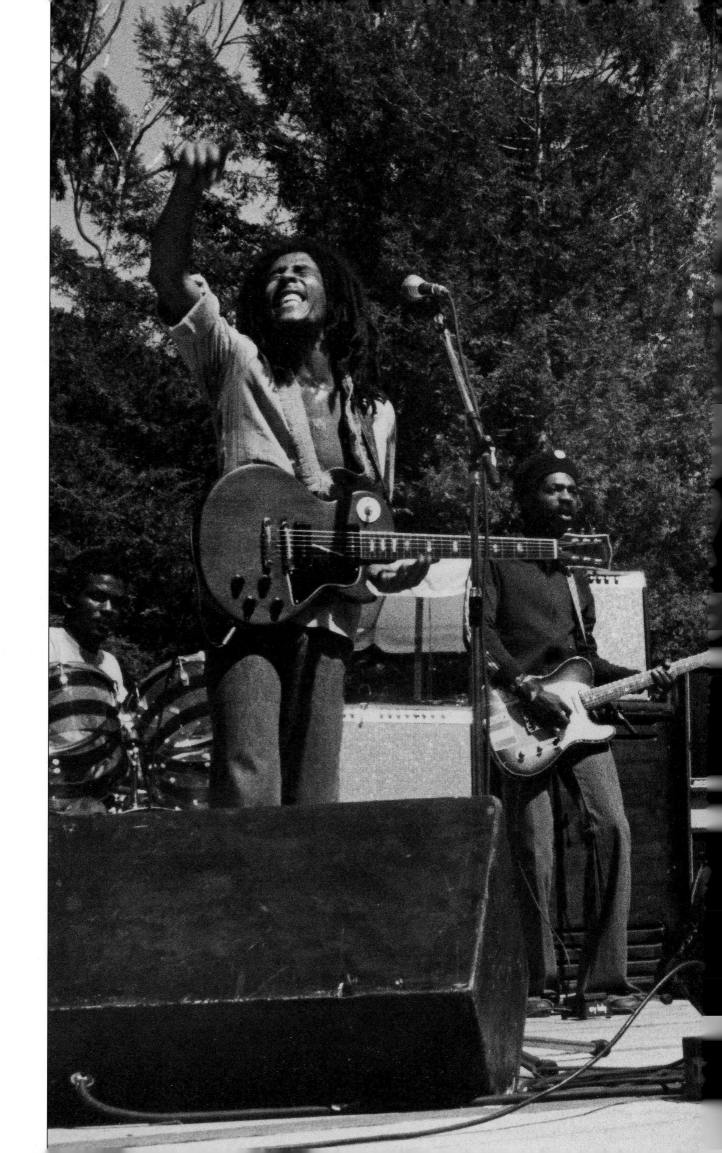

"MARLEY IS A
STRIKINGLY
COMPELLING
FIGURE... HE
HAS BEEN
CALLED THE MICK
JAGGER (FOR HIS
INTENSENESS AND
SENSUALNESS)
AND THE BOB
DYLAN (FOR
HIS SOCIAL
CONSCIOUSNESS)
OF REGGAE."
— ROBERT HILBURN,
LA TIMES

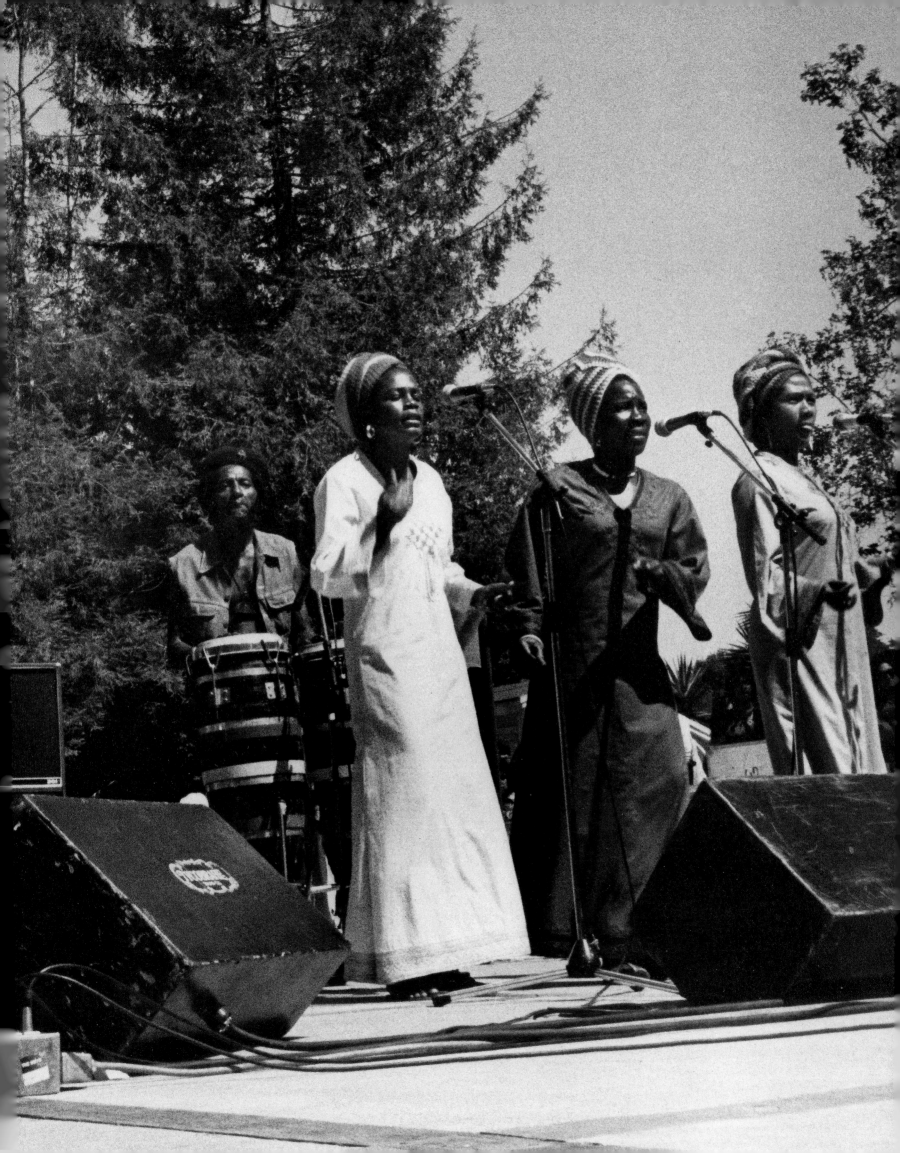

THIRD WORLD

"THIRD WORLD IS THE KIND OF ROCK, SOUL, REGGAE FUSION THAT VARIOUS WHITE ROCK BANDS HAVE ATTEMPTED IN THE PAST AND SIGNALLY FAILED; POSSIBLY BECAUSE THEY START AT ROCK AND AIM TOWARDS REGGAE. THIRD WORLD CARRY IT OFF BEAUTIFULLY BECAUSE THEY START AT REGGAE AND AIM TOWARDS ROCK." — CHARLES SHARR MURRAY, *NEW MUSICAL EXPRESS*

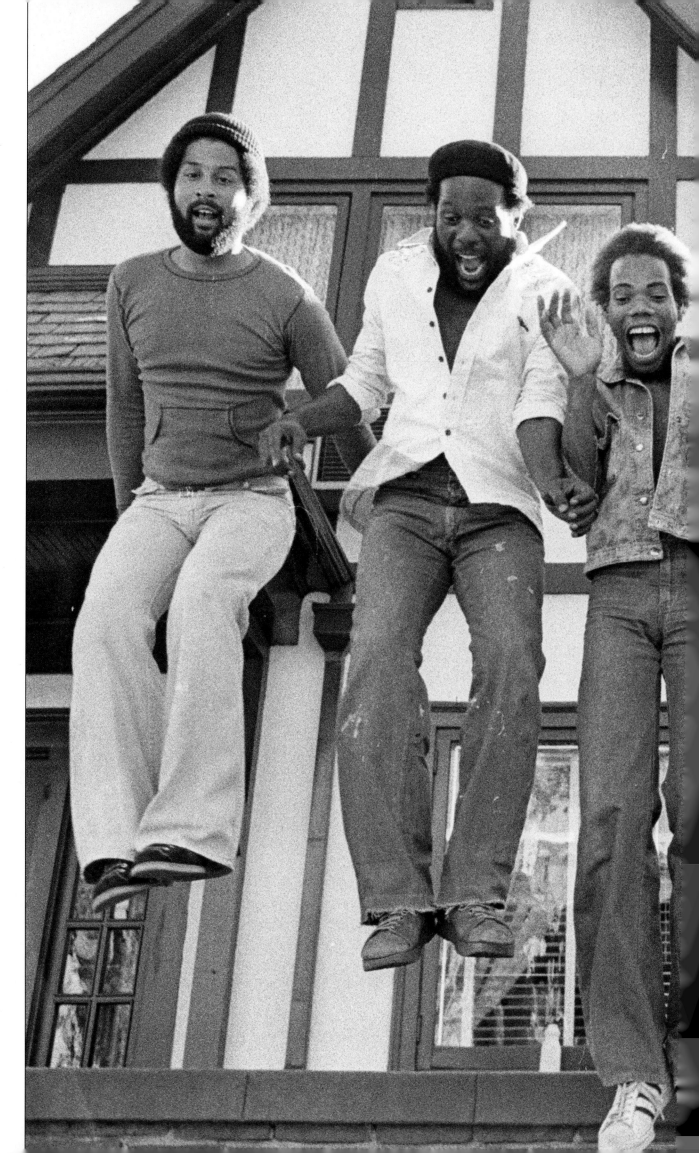

Right: Third World pictured in front of Island Records on Sunset Blvd, Hollywood.

126

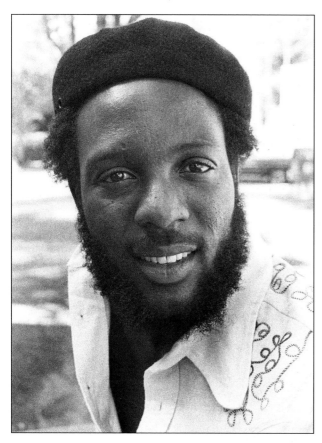

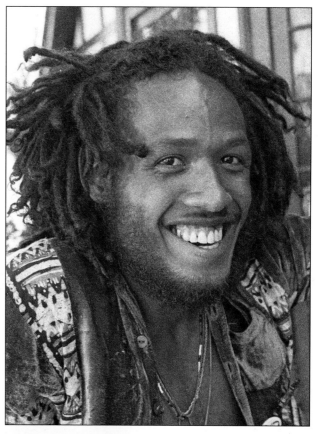

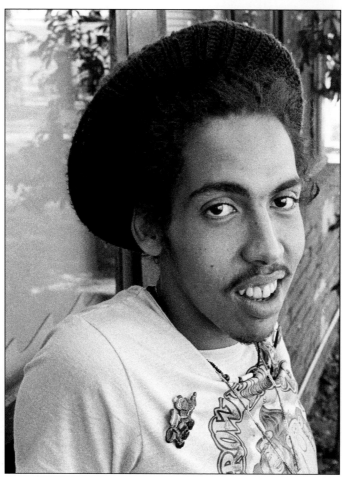

 RECOMMENDATIONS
Third World: (O'Jays cover) Now That We Found Love; 96 Degrees In The Shade

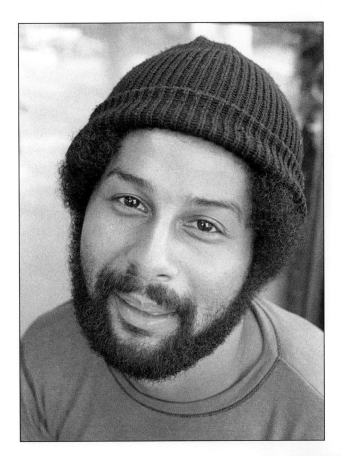
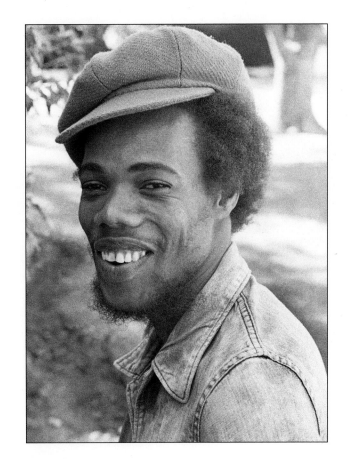
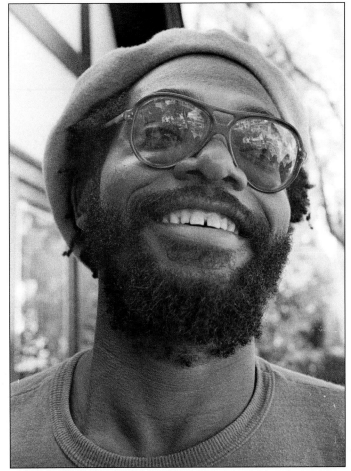

Top Row (L to R): William "Bunny Rugs" Clarke (lead vocal/guitar), Irvin "Carrot" Jarrett (percussion), Willie "Root" Stewart (drums) and Michael "Ibo" Cooper (keyboards). Bottom Row (L to R): Stephen "Cat" Coore (guitar/cello), Richard Daley (bass).

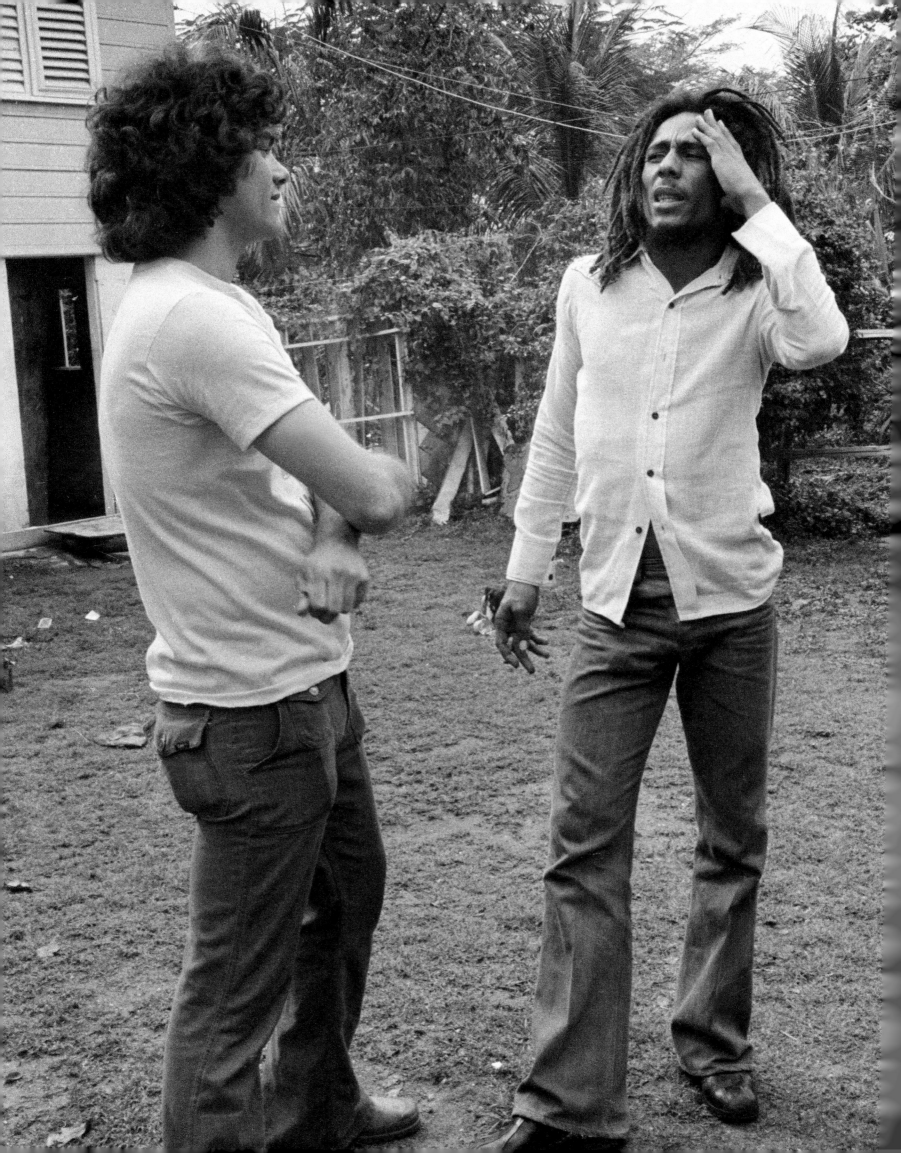

JAMAICA, SEPTEMBER 1976

Jeff Walker

As the head of publicity for Island Records from 1974 to 1977, one aspect of my job description was fairly straightforward — to generate media and press coverage of Bob Marley and other reggae artists in order to help those musicians and Island get more air play and, ultimately, sell more records.

In the Spring of 1976, Bob was preparing to release what is arguably his masterpiece, *Rastaman Vibration* and it seemed to me at the time that inviting some of the best rock journalists of the era to meet Bob on his undeniably exotic home turf and experience Jamaica would be a very effective way to accomplish this in an honest and organic way. I mean, if you're going to invite Lester Bangs (the brilliant and iconoclastic writer of *Creem* magazine) to go on a third world adventure, you know an incredible article will come of it, if nothing else.

Now remember, the 1970s were unquestionably the golden age of rock journalism and I consider myself very lucky to have been a part of that community. I've been a huge music fan for as long as I can remember and when I started writing album and concert reviews in 1971, it was mainly so I could get on record companies mailing lists

and would be sent free records and invited to concerts. I had no idea it would lead to the career I ended up having.

It was also a time when the door between the music industry and the press that covered it had kind of a swinging and it was fairly common for people to work on both sides of that door at different times. Personally, in a seven-year stretch, I went from freelancer to becoming the first alternative press liaison for the PR firm Rogers & Cowan to editor of *Music World* to publicist at UA Records and then Island Records, then in 1978 back to journalism as the West Coast Editor of *Crawdaddy* magazine.

I always looked at these jobs as two sides of the same coin — whether I was covering an artist whose music I loved or working on behalf of another, the end result and intentions were the same — to help expose that artist to more potential fans and create a bigger audience for them.

In Marley's case, his last two albums, *Natty Dread* and *Bob Marley and the Wailers... Live* were critic's favorites and reggae's popularity was continuing to grow, mainly among white college-aged fans in cities such as New York, Boston, Philadelphia, Seattle, San Francisco and Los Angeles. As a result of Bob's 1975 tour and the

initial album releases of the artists we interviewed and photographed on our first trip to Jamaica, awareness of this new music was higher than ever and we did manage to a get a level of press coverage usually given to much more established stars. However, at that point, overall record sales and radio airplay were still not where they should have been and Marley had still not broken into then disco-dominated black radio. With *Rastaman Vibration* about to be released, we obviously still had a lot more work to do. We also had no idea yet if and when the Wailers would be touring the US again.

Thankfully, the rock press loved the Wailers so it only made sense to take advantage of that to whatever degree we could. This is where the 'myth making' part of publicity comes in — and I don't mean creating a false image — the kind of myth making I mean is about building the stage on which an artist's career, image and reputation can be anchored while the artist himself becomes larger than life; it's very simply about creating a mystique that will capture the public's imagination. It's the same approach to star making that Hollywood has been taking since its own golden age. There was never

any question that Bob Marley had enough charisma and talent to become a worldwide star and his message was so important that he demanded to be heard, but not unless hearing his music and seeing him perform became a whole lot easier.

My own experiences in Jamaica over these few years were life changing and transcendent, but full of challenges too. Yes, it was also a time of political and social turmoil there — extreme poverty in Trenchtown, sporadic street violence and gun court were all harsh realities in Kingston, but the people we met, rastas or not, were never anything but warm and welcoming and the countryside and beaches outside of Kingston were among the most beautiful I had ever seen. It seemed almost Eden-like in many places — you could actually live off what grew on trees and sleep under the stars. There were a few scary moments, mostly encountering police at roadblocks (and the next year I would be in Jamaica on my way to Bob's house when news of his shooting was breaking on the radio). But the fact is I had experienced far scarier incidents when I was living in the East Village in the 1960s going to NYU or being tear-

gassed by police in Washington DC for protesting the war in Vietnam. We felt totally safe in Jamaica, even to the point we had no hesitation in bringing our three year-old son Orion with us on this next trip and spent much of our time driving all over the island unaccompanied.

One such incident in the heart of downtown Kingston illustrated both the volatility and paranoia just below the surface, but also how quickly those feelings could dissipate, simply by invoking the music. We were driving through downtown going to various record stores and were blown away to see that the walls of virtually every store and studio we visited were covered with pictures that Kim had taken the year before. I had taken pains to send photos back to everyone she had shot and those official Island 8 x 10s were now literally all over Jamaica, complete with the Island Records logo and Kim's photo credit. At one point we drove to the Kingston bus station to photograph the huge billboard for Bunny Wailer's album *Blackheart Man*. I was holding Orion in my arms nearby while Kim clicked away when she was suddenly accosted by two very large and hostile men accusing her of being with the CIA, demanding to know what she was doing. I immediately rushed over to them explaining that we worked for Island and Bob Marley we were just documenting the billboard. They backed down, but still suspicious, and it wasn't until they heard Kim's name and recognized it from the photos in the record stores ("Ah! We know 'bout Kim!") that they suddenly became as warm and friendly as they were hostile just moments earlier. At that point, they started helping her get the shots she needed, and even directed us back through traffic.

Frankly, we loved Jamaica and although I knew American sensibilities might be frustrated by the 'soon come' pace of life in the country, I hoped there would be enough other distractions to make any waiting time at least enjoyable and worthwhile. I figured that each writer would essentially take from Jamaica whatever they brought to it and that the meeting of these two worlds would inevitably lead to interesting stories. There was no need to spin anything and there was no agenda other than to hopefully interview Bob at some point and meet other key people involved in reggae while they were there. And so that's exactly what I did. Lester Bangs did come to Jamaica and he subsequently wrote an amazing

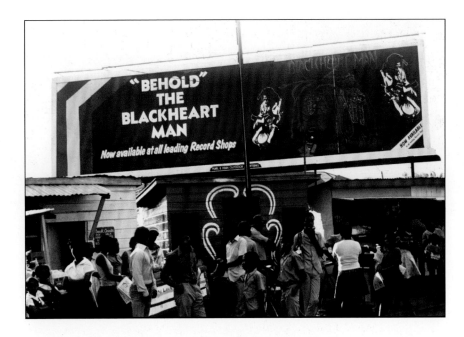

piece for *Creem* called "Innocents in Babylon" (reprinted in the collection of Lester's works called *Mainlines, Blood Feasts and Bad Taste*) and for those of you who go and read it, I'll admit here that I'm the guy he nicknames "Wooly."

In addition to Lester Bangs, other writers whose lives intersected with Bob Marley in Jamaica over that month in 1976 included Ed McCormack and Cameron Crowe for *Rolling Stone*, Timothy White for *Crawdaddy*, Mitch Cohen for *Phonograph Record Magazine*, freelancers David Rensin and Stephen Davis (with photographer Peter Simon) as well as Dave DeVoss and photographer David Burnett for *Time* magazine.

All of the above went on to publish books or articles about Marley and the reggae movement. Cameron Crowe has very kindly written some of his own reminiscences especially for this book, but the other excerpts and quotes are taken from the range of articles written by the above writers about their experiences in Jamaica during this particular trip.

Kim and I felt totally at home in Jamaica and casual or professional relationships had grown into friendships. Being able to introduce so many friends who shared my love for this music to this world and these musicians was a true privilege. Kim's camera lens still rarely left her eye, but this time the trust had already been established and she captured Bob and many others at their most relaxed and unguarded. The connection between Kim and her subjects comes through loud and clear even now and these great artists seem as alive and vibrant as they did during that magical era.

BUNNY WAILER

When Jeff was meeting with Tommy Cowan he asked Tommy if he knew how to reach the very reclusive Bunny. Tommy said that all Jeff had to do was call him, but that Bunny didn't have a phone. Jeff laughed and asked how he should call him then and Tommy said, "Just go outside and call him, he'll hear you." So we went outside under this gnarled old tree and Jeff basically called out loud to Bunny that he needed to meet with him about his album and would be back at Tommy's the next day. When we returned the next morning, Bunny was there waiting and immediately said to Jeff, "You called?"

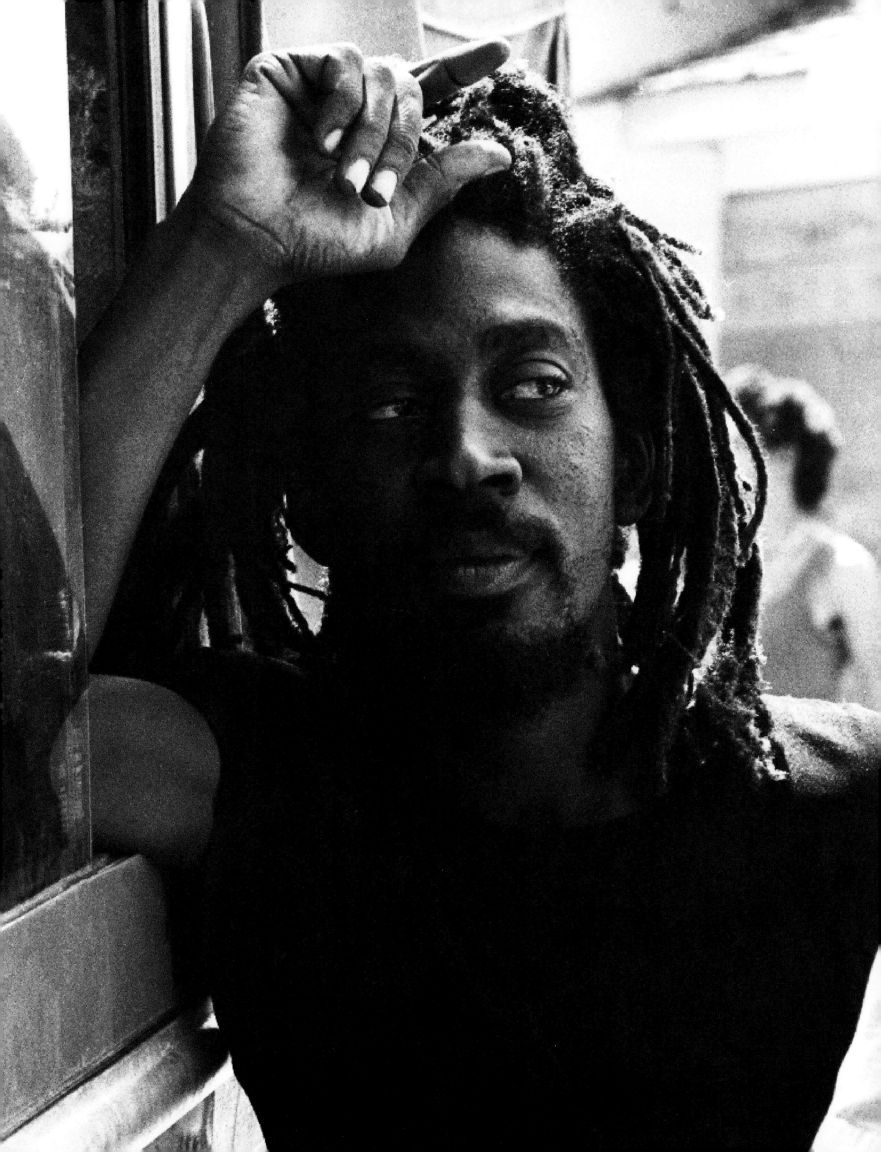

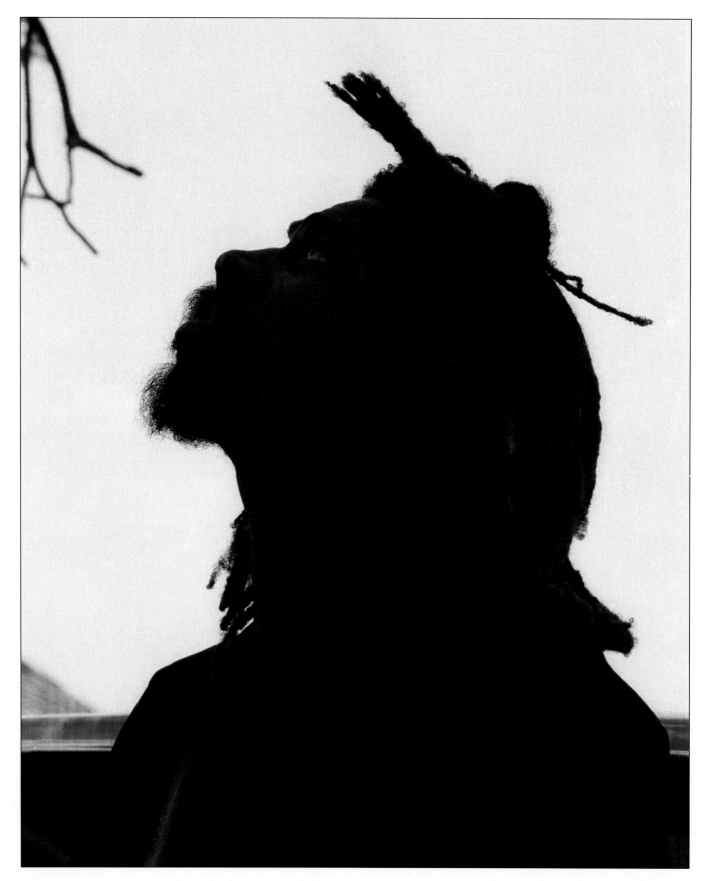

Right: Kim recalls meeting Bunny Wailer: "I had heard that once a photographer had asked if he could photograph him and Bunny replied 'I don't let dead men take my pictcha' and the photgrapher died suddenly a few weeks later. I figured the fact that Bunny allowed me to photograph him meant I'd be around for awhile."

Opposite: As Jeff recalls: "When he was negotiating his contract with Island, Bunny insisted there be a death clause in it stating that if Chris Blackwell should die, his contract with Island would become null and void. When asked why he wanted this clause, Bunny replied 'because then I know I can always get out of my contract.'"

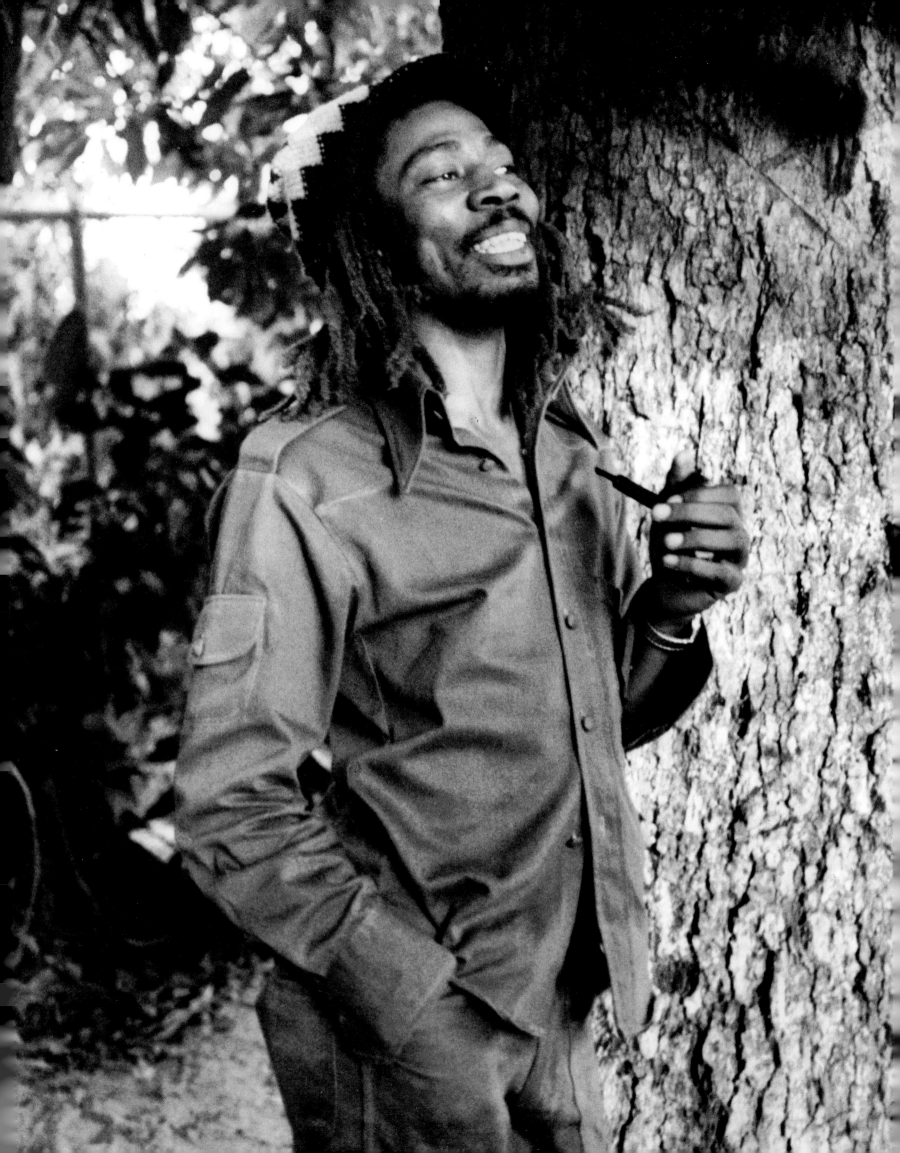

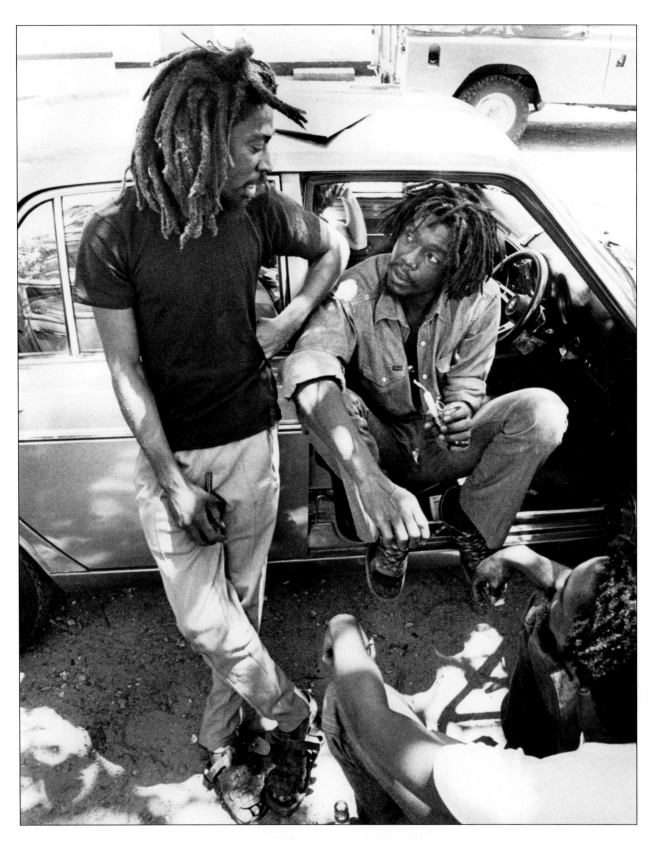

Left: Bunny Wailer and Peter Tosh share a smoke and a chat in Jamaica, 1976.

Opposite: Kim recalls introducing her son, Orion, to Bunny Wailer.

"BUNNY'S ALBUM *BLACKHEART MAN* IS ONE OF THE MOST BEAUTIFUL REGGAE ALBUMS EVER MADE. THE MUSIC IS LIKE FLOATING DOWN A WARM RIVER OF HONEY... BUT THE WORDS PIERCE DEEPLY. IT WAS ALSO ONE OF THE ALBUMS WE PLAYED REGULARLY FOR RY WHEN HE WAS GOING TO SLEEP... ALTHOUGH WE HAD TO SKIP ONE TRACK THAT KIND OF SCARED HIM. SO, WHEN RY MET HIM, IT WASN'T REALLY SURPRISING THAT HE MARCHED UP TO BUNNY AND SAID 'I DON'T LIKE ARMEGGEDEON, ARMAGGEDEON,' TO WHICH BUNNY REPLIED 'WELL... DON'T WORRY, IT WON'T HURT THE CHILDREN,' WHICH INITIATED A REASSURING PHILOSOPHICAL CONVERSATION BETWEEN THE BLACKHEART MAN AND MY THREE-YEAR-OLD."

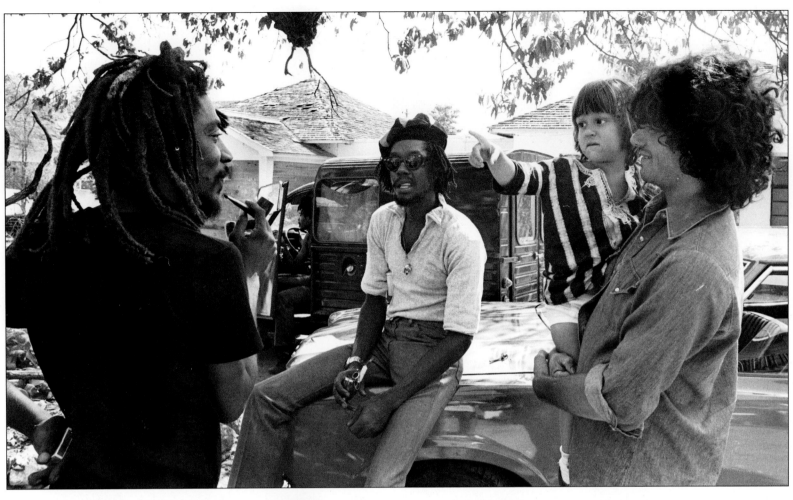

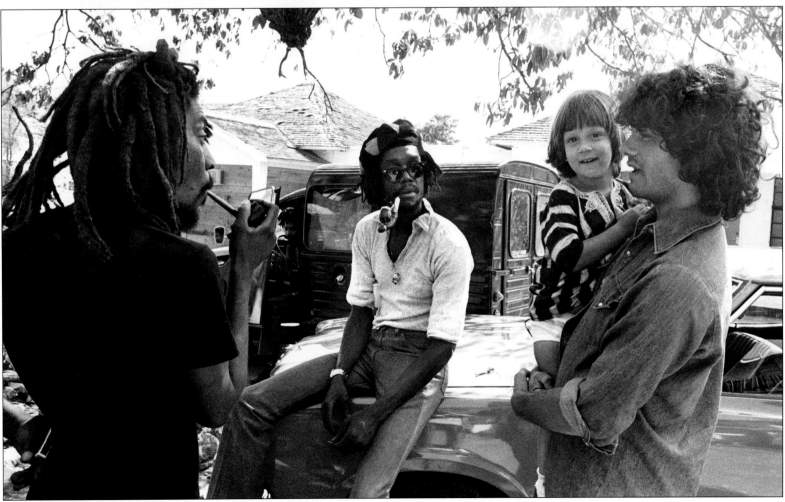

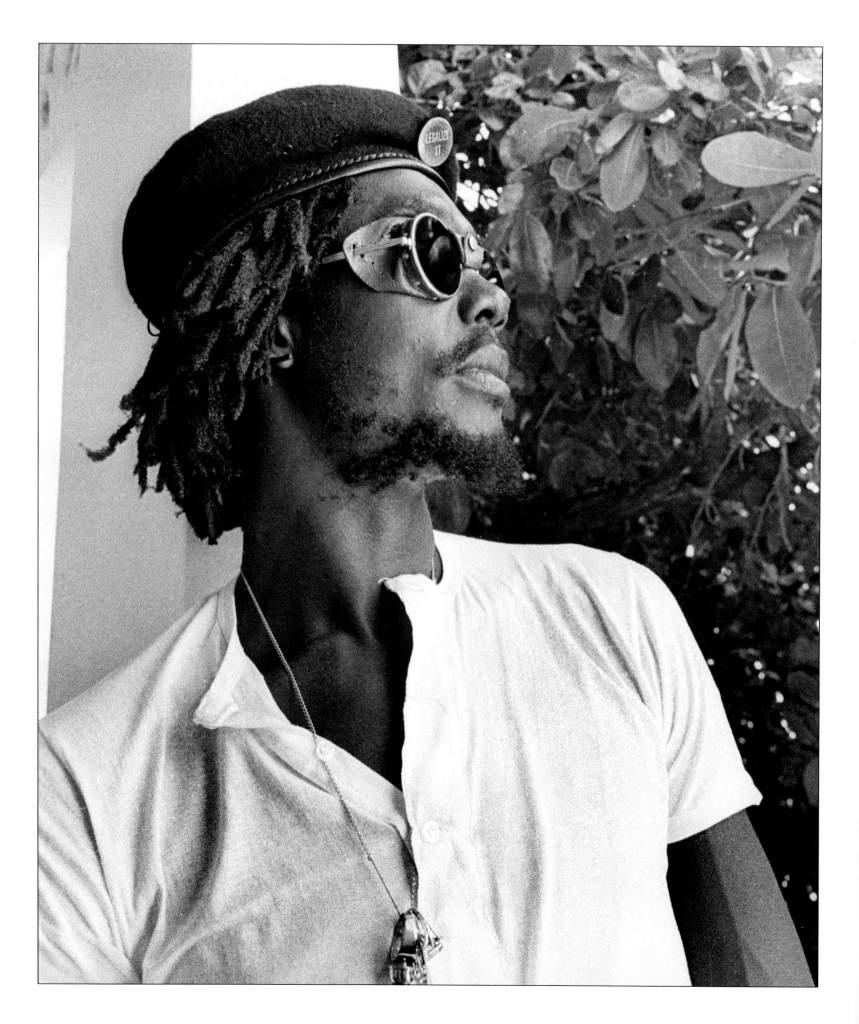

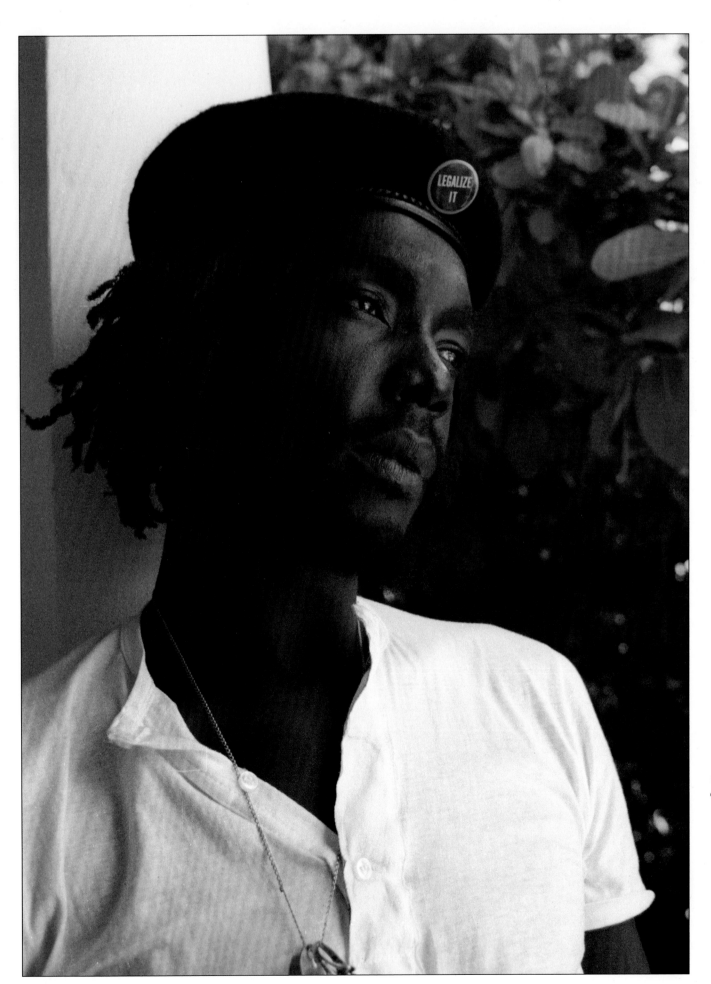

Opposite: The photo of Peter Tosh used as the cover on *Equal Rights*, his most highly acclaimed album. It shows the image of him in all his dread militance.

Left: This is the Peter Tosh that Kim remembers, gentle and thoughtful.

"MILITANT? ME DON'T JOIN THE ARMY. I'M A MISSIONARY, NOT A MILITARY. WHEN YOU'RE TALKIN' ABOUT THE MILITARY YOU'RE ASSOCIATIN' ME WITH GUNS AND MISSILES AND ALL THOSE KINDA THINGS. WHEN YOU CALL ME, YOU MUST SAY MISSIONARY. I DEAL WITH RIGHTEOUSNESS... I WORK FOR THE ALMIGHTY. I AM A RASTAMAN, SEEN, WHO JUST COME GET THE BLESSING FROM JAH TO PAINT MY PICTURE MUSICALLY AND IT WILL BE SO BLESSED THAT IT MUST HYPNOTIZE MY AUDIENCE, SEEN. SO I MAN IS JUST TRYING TO ACCOMPLISH THIS MISSION, AND TO GO HOME... MY MESSAGE IS THAT THE SPIRIT IS IN THE WORD... THE WORD IS LOVE, LIFE, DIGNITY, CREATION: RASTAFARI." — PETER TOSH

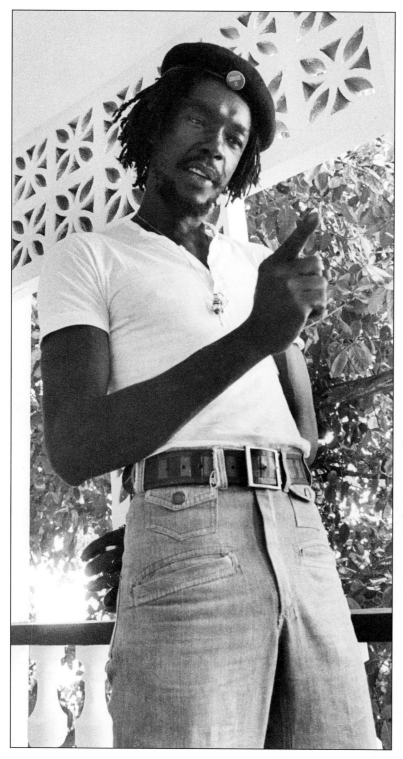
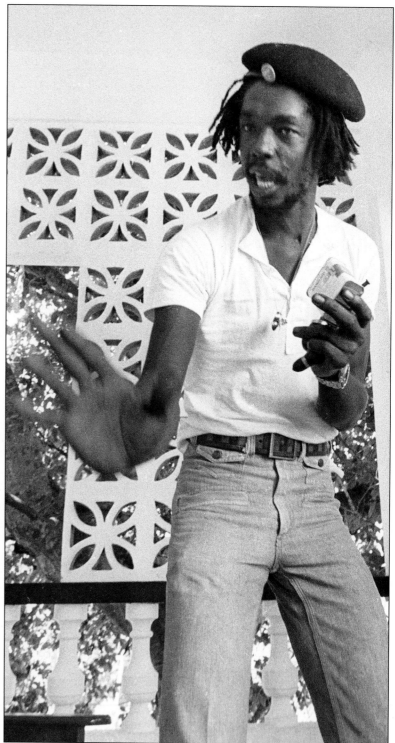

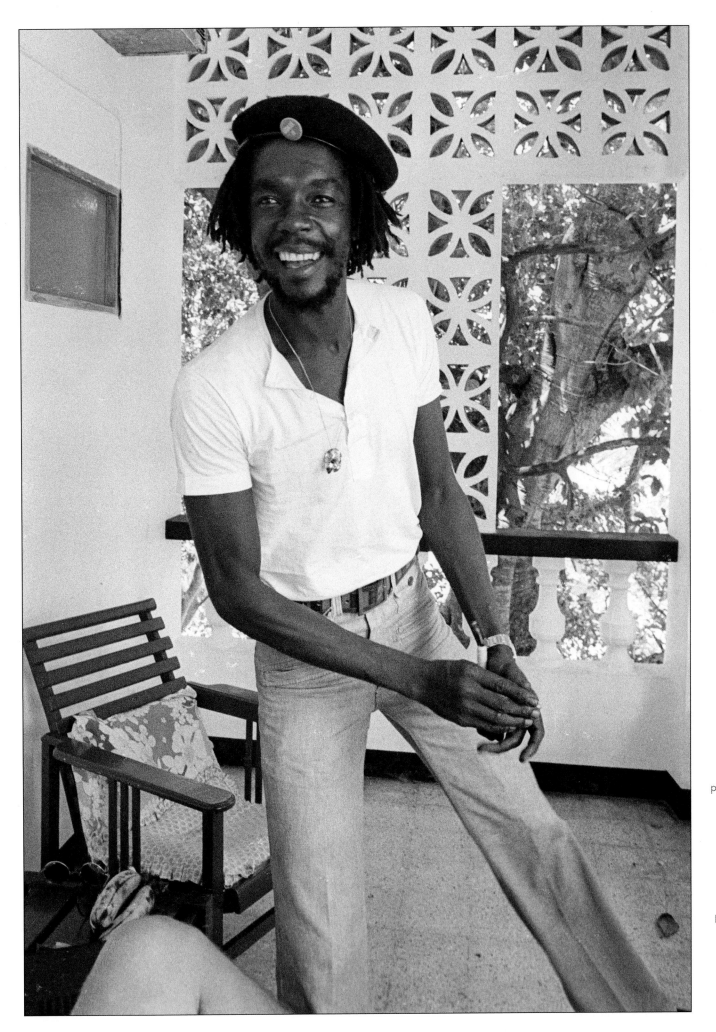

L to R: Peter pontificated at length to Cameron Crowe on the way of the world and injustice. "Babylon is where they tell you that what is right is wrong, and what is wrong is right. Everywhere today is Babylon." "I don't want no peace — I want equal rights and justice!"

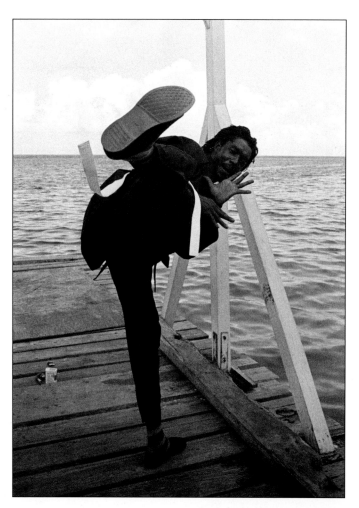

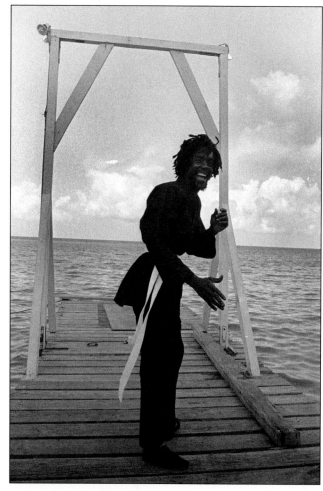

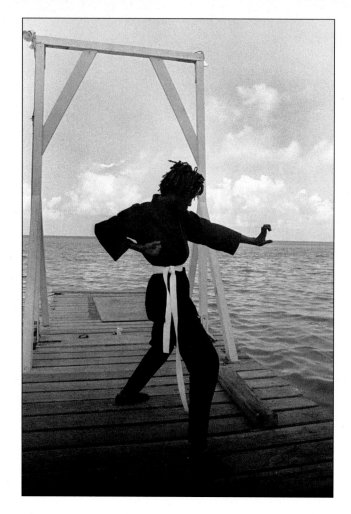

Above: Peter showed up in his black gi ready to demonstrate his martial arts skills on a north coast pier, 1976.

Opposite: Peter Tosh with Donald Kinsey, noted American blues and rock musician, who was discovered by Island Records playing in his band "White Lightning" with his brother and Busta Cherry Jones and joined Peter's band in 1975 playing on "Legalize It."

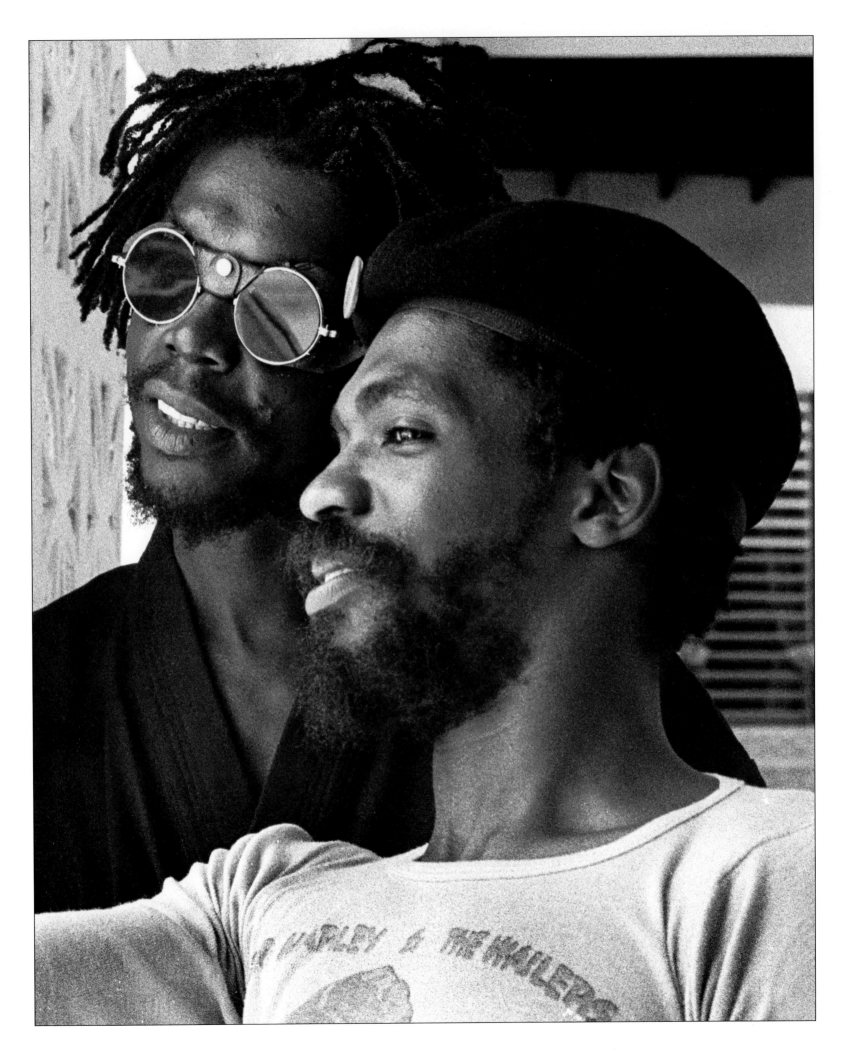

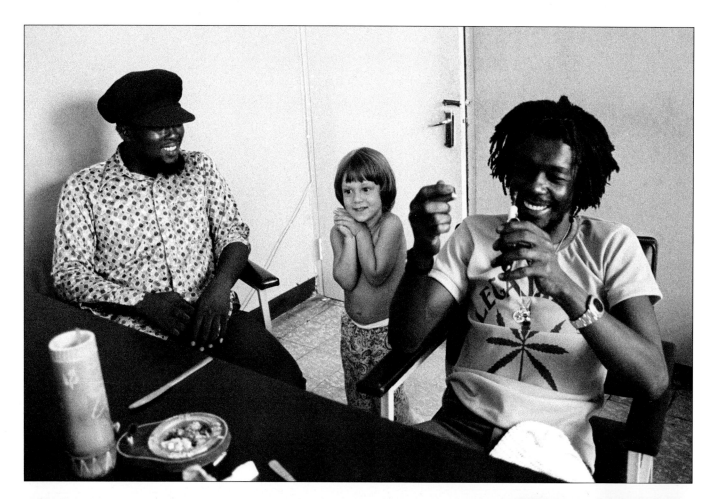

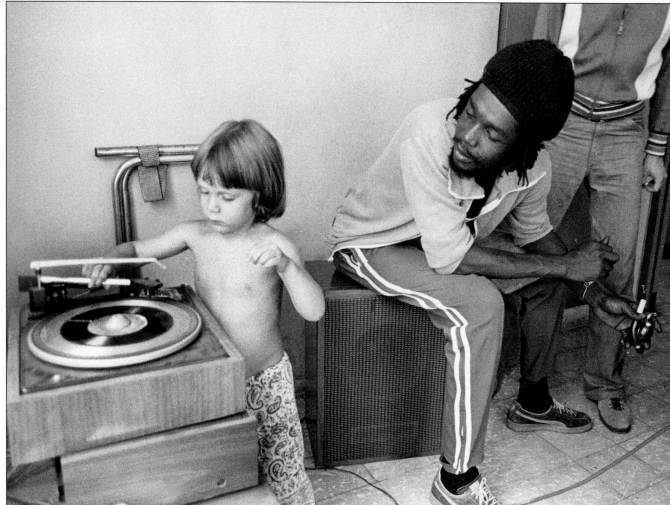

This Page: Peter Tosh, Orion and Robbie Shakespeare at Tommy Cowan's recording studio, 1976.

Opposite: As Kim recalls: "Orion was thrilled to be around Peter. Orion had learned to read by age three so he could read the liner notes on reggae albums and was a huge fan of Peter's."

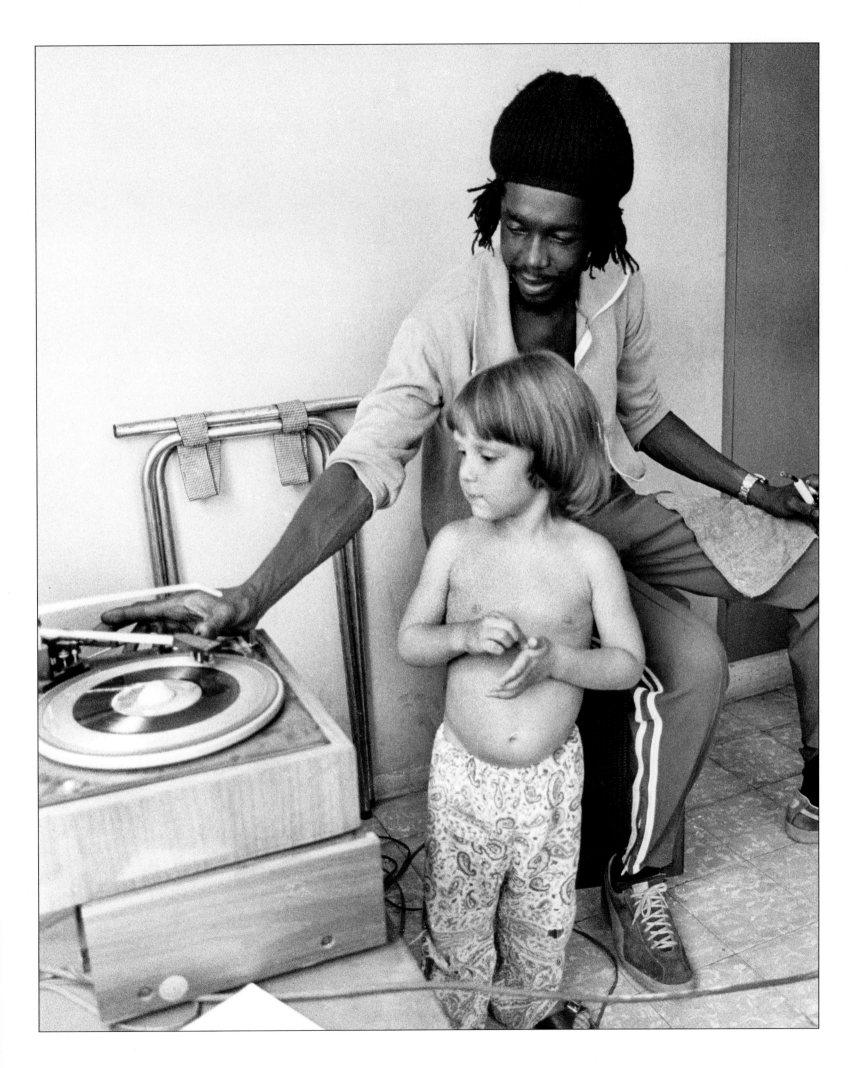

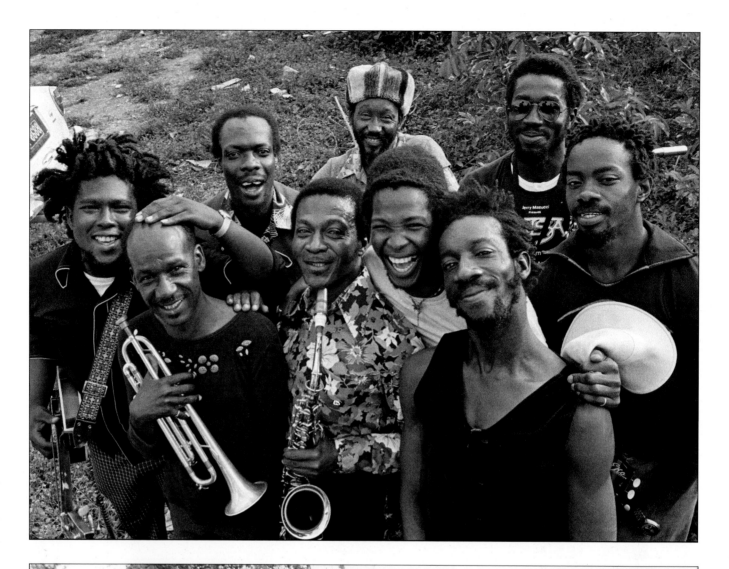

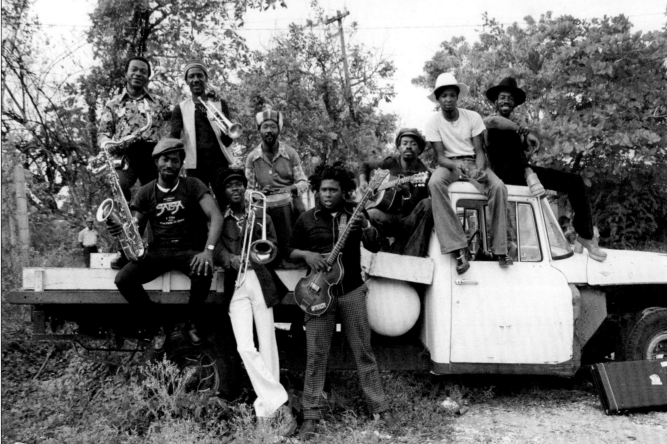

Above and Right: The Black Disciples, including Robbie Shakespeare, Bobby Ellis, Herman Marquis, Bernard "Touter" Harvey, Leroy "Horsemouth" Wallace, Earl "Chinna" Smith, Vincent "Trommy" Gordon, Noel "Skully" Simms, "Dirty Harry" Hall.

Opposite: Robbie Shakespeare.

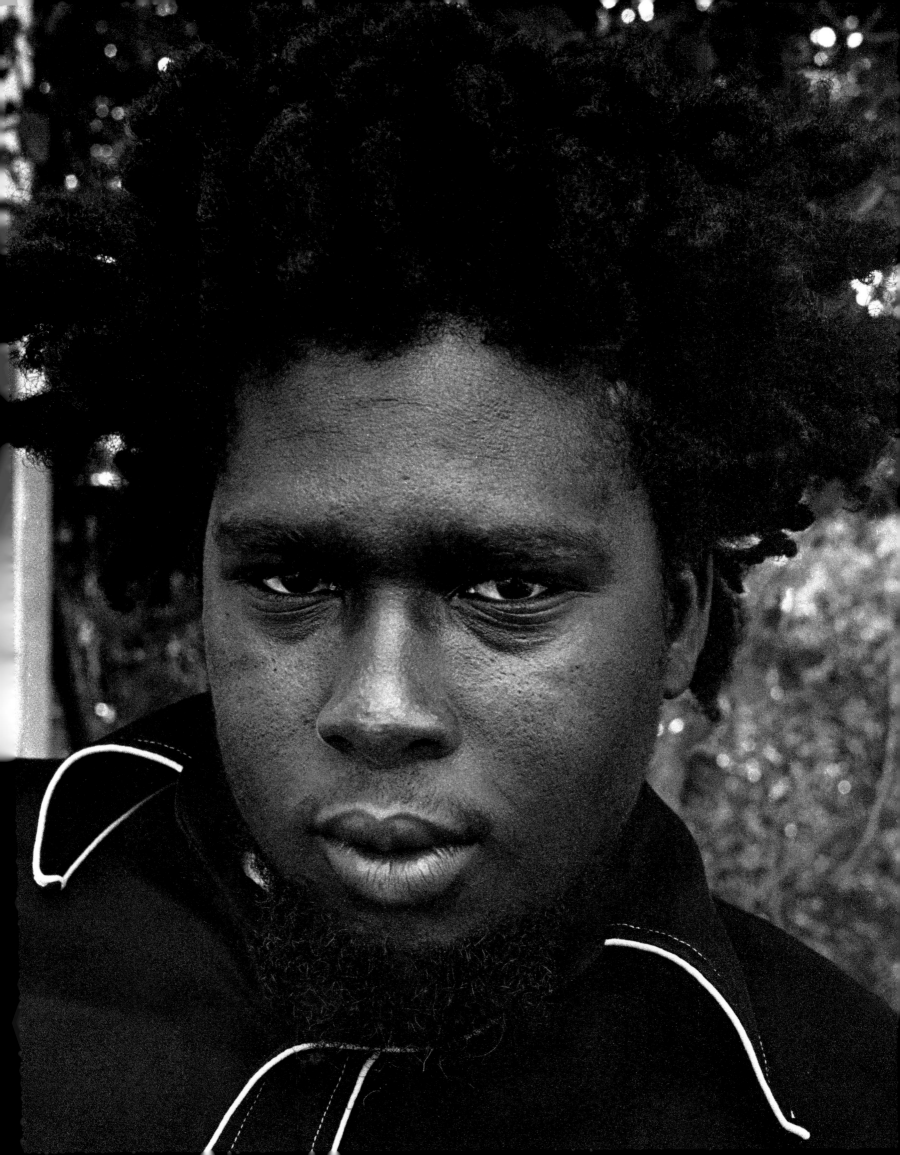

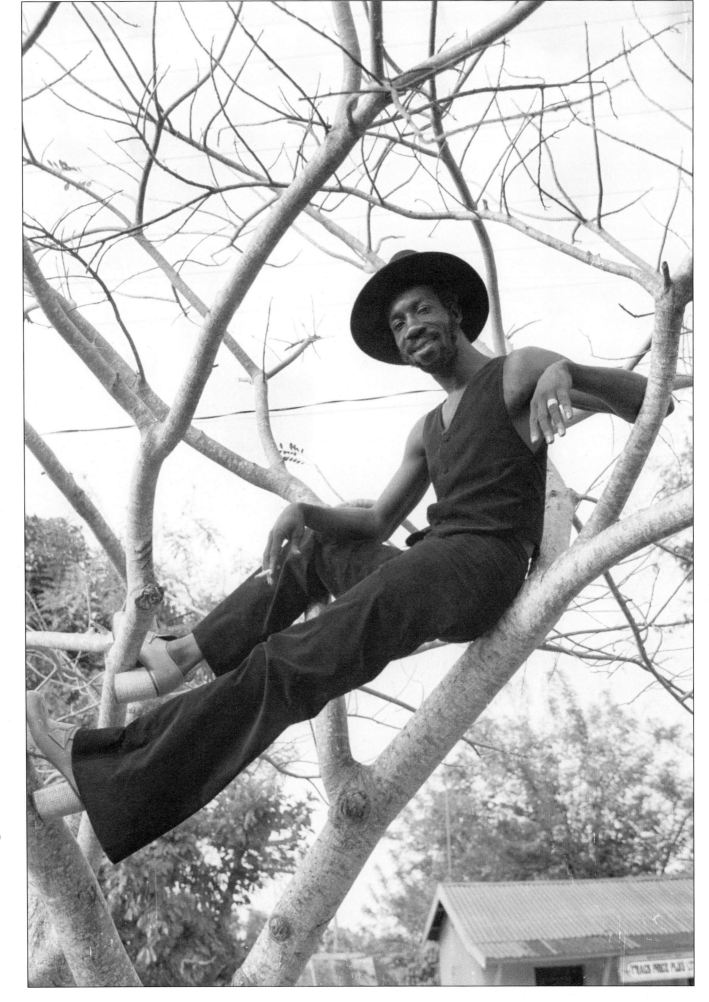

Right: Leroy "Horsemouth" Wallace, emerged from the Alpha Boys' School as a drummer and co-starred in the movie *Rockers*. Known as one of the most dependable studio session drummers, he recorded a rap record called "Universal Love" under the name Mad Roy.

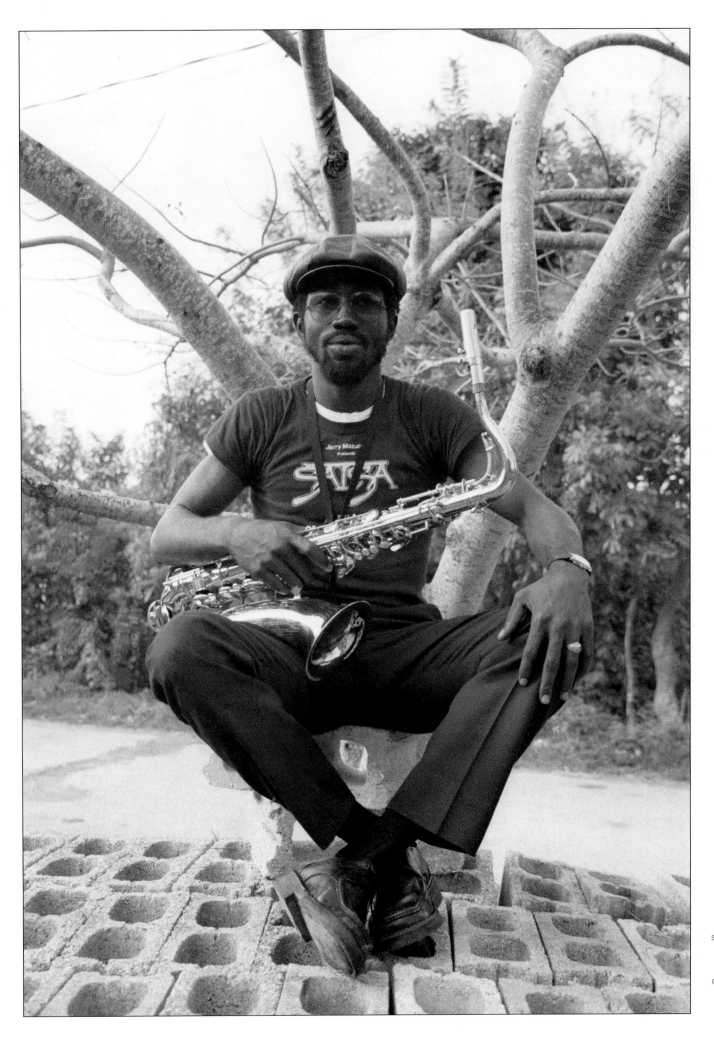

Left: Richard "Dirty Harry" Hall was a session hornsman for Lee Perry's Upsetters and numerous other aggregates, pictured here in 1976.

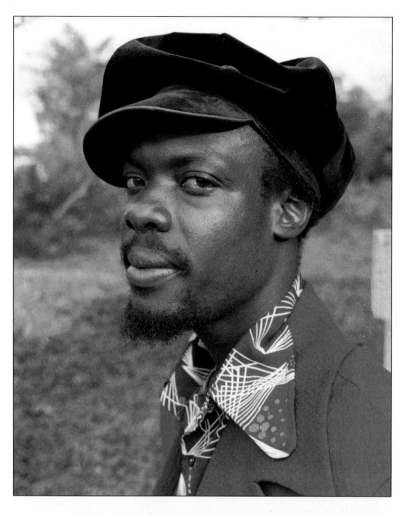
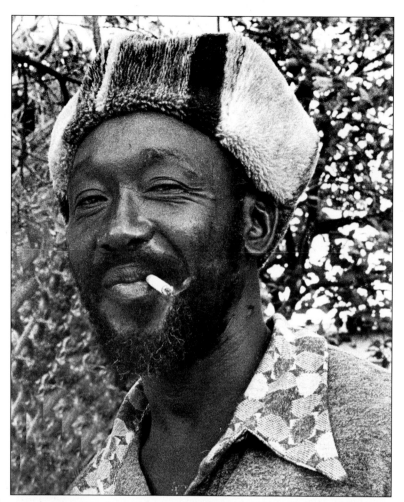
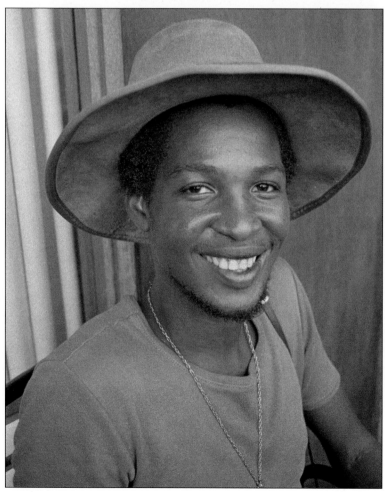
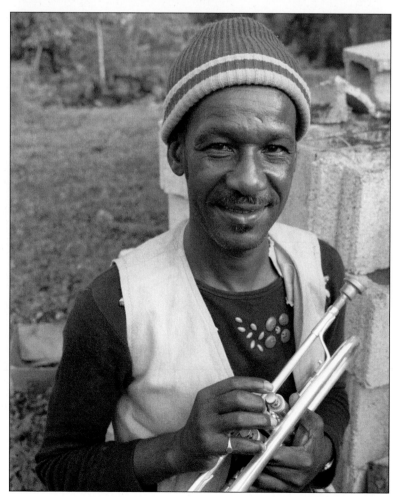

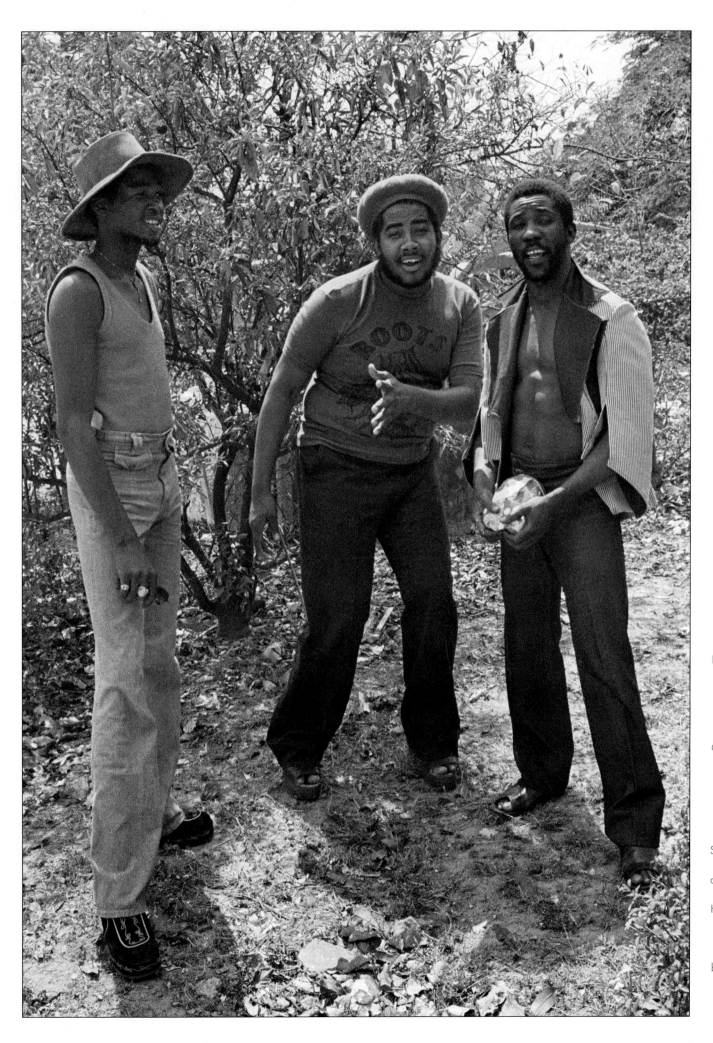

Left (L to R): "Touter" Harvey, Jacob Miller and Toots Hibbert. The only known photo of them all together.

Opposite (Clockwise from Top Left): Vincent Gordon; Noel "Skully" Simms; Bobby Ellis, a long time member of Burning Spear's touring band and constantly in demand as a session player; "Touter" Harvey (keyboardist) who played on all the tracks of *Rastaman Vibration* but got no credit. He is a current member of Inner Circle.

Right: Jacob Miller teases producer Tommy Cowan about his short locks. Famous as the voice of Sunsplash in Jamaica and on its world tours, Tommy Cowan was a promoter, label owner and producer of groups like Israel Vibration, Ras Michael and the Sons of Negus and the Cimarons. He would eventually shave his locks and become a Christian preacher.

Opposite: Jacob Miller was, at the time of his death in 1980, the biggest and most beloved star in Jamaica and the lead vocalist of Inner Circle. Two films captured his essense, *Heartland Reggae*, which includes his gang-uniting performance at the One Love Peace Concert, and the Rabelaisian *Rockers*. He was incredibly sweet and funny.

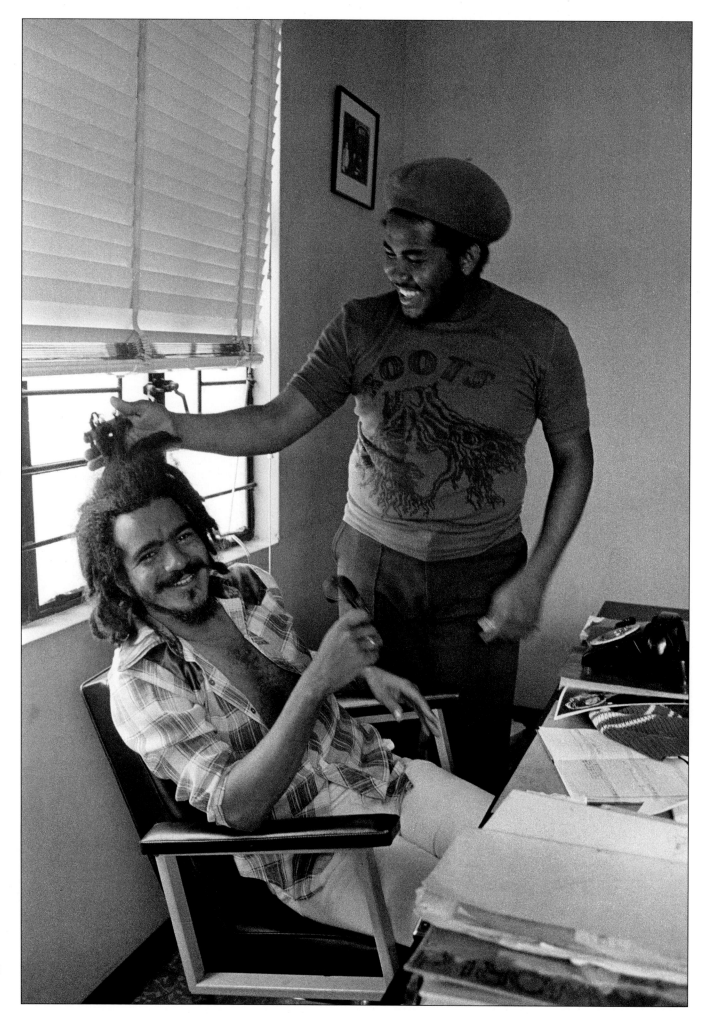

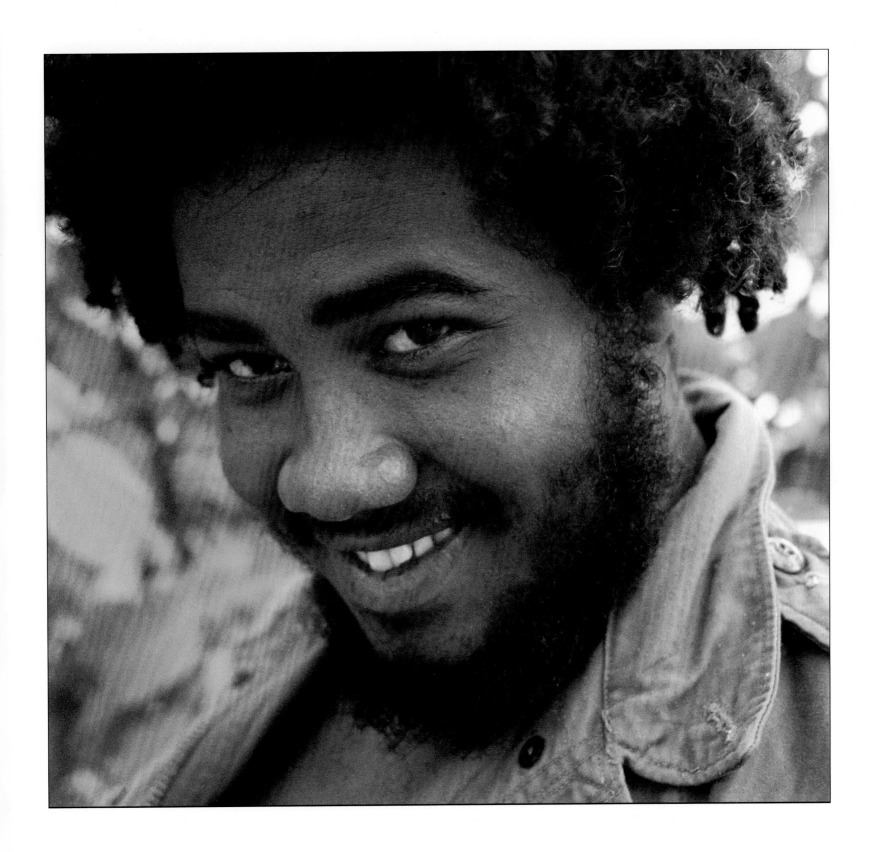

JACOB MILLER WAS CLOSE TO BOB MARLEY, WHO WAS KNOWN TO PROMOTE HIM AS "MY FAVOURITE SINGER." MILLER HAD PLANNED TO PERFORM ALONG WITH BOB MARLEY AND INNER CIRCLE IN BRAZIL AND THEN TO TOUR WITH THEM; THIS TOUR WAS CANCELLED AFTER HE PASSED AWAY IN A CAR ACCIDENT IN 1980 AT AGE 27.

RECOMMENDATIONS
Inner Circle with Jacob Miller: Shakey Girl; Tired Fe Lick Weed In A Bush

INNER CIRCLE

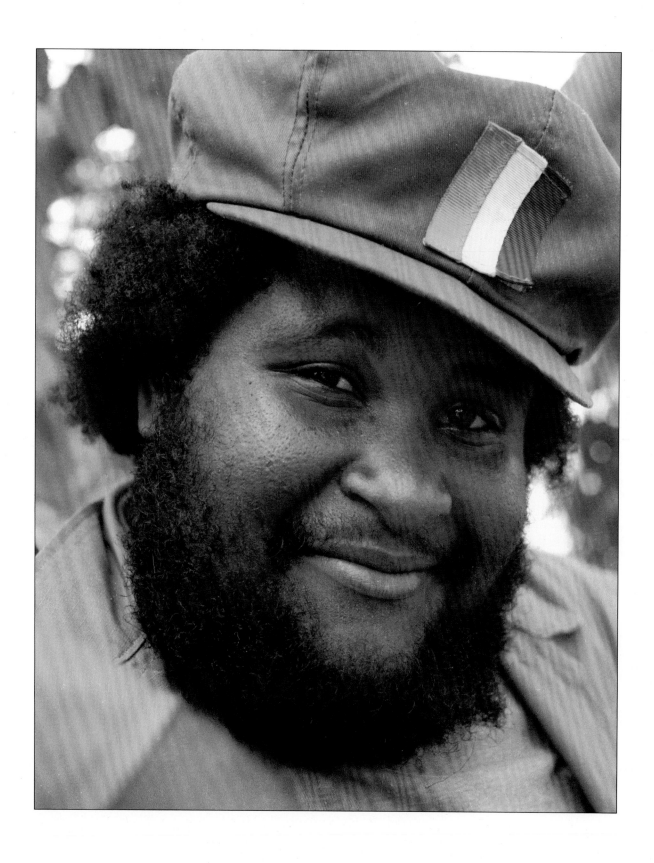

Above: Roger
Lewis of band Inner
Circle, one half of
the Fatman Riddim
Section.

RECOMMENDATIONS
Inner Circle with Jacob Miller: All Night Till Daylight; Tenement Yard

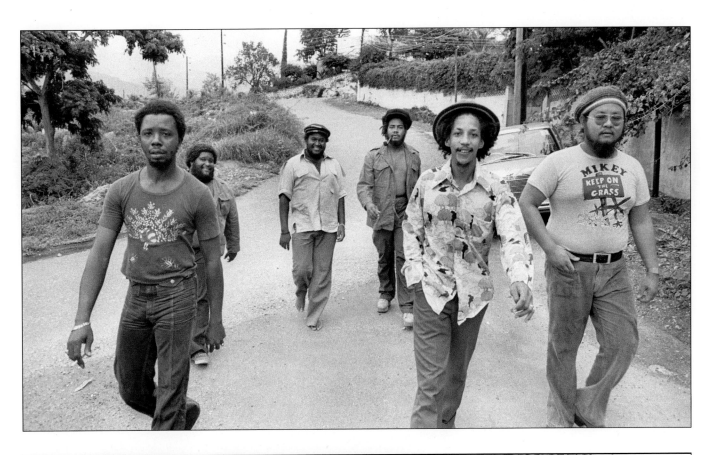

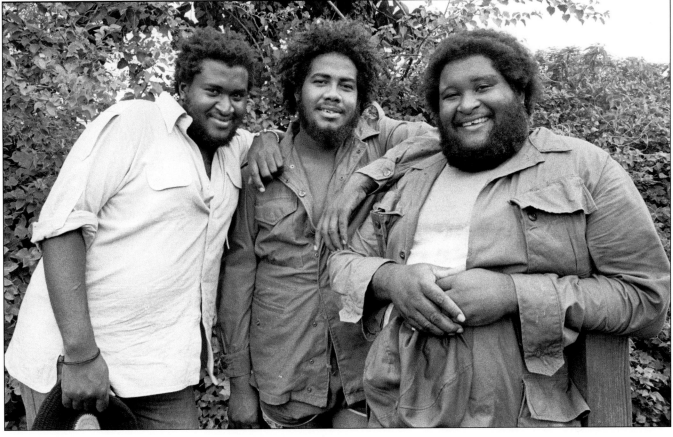

Above: Inner Circle:
Mikey "Boo"
Richards, Roger
Lewis, Ian Lewis,
Jacob Miller,
Augustus Pablo
and Mikey "Mao"
Chung.

Below: Jacob Miller
with the Fatman
Riddim Section
brothers Roger and
Ian Lewis, 1976.

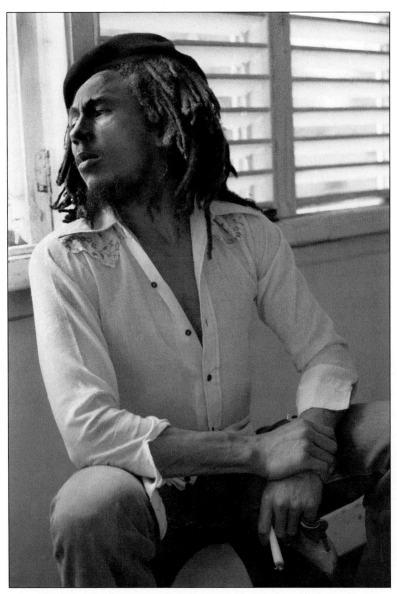 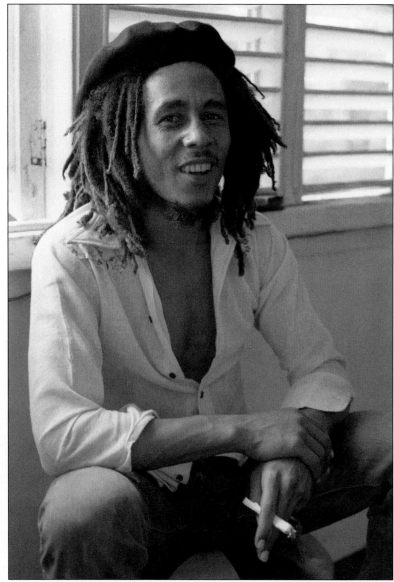

L to R: Bob at home wearing a beret, reminiscent of another cultural icon, Che Guevara. Today Bob and Che are the two most ubiquitous images of rebellion in the world, but Bob never shot anybody... not even a sheriff.

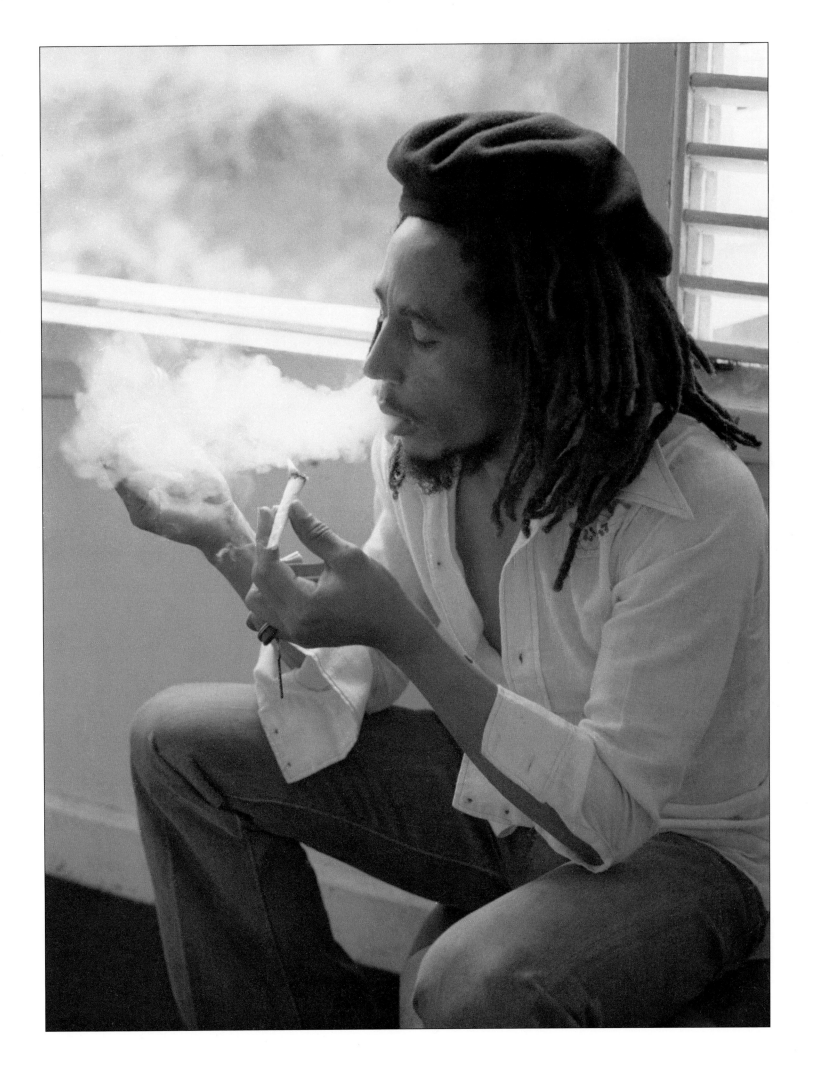

POSTSCRIPT

The trip with Cameron was the last time we were all in Jamaica together and the closest to an actual vacation when we could simply relax and enjoy everything we had come to love over the last several years. By late 1976, Kim had begun working as a still photographer for films and television, and was about to embark on her professional career as John Carpenter's go-to still person for several films (including *Halloween* and *Escape from New York*) and wouldn't be able to accompany me on later trips.

I would return to Kingston for the last time in December of 1976, with a film crew in tow, to meet with Chris Blackwell, Perry Henzell and Bob about filming the Smile Jamaica concert planned several days later.

But everything changed before that meeting could even take place when a gang of gun-bearing thugs invaded Bob's home on Hope Road and shot up the place, almost killing Don Taylor and hitting Bob and several others.

The next time I would see Bob was at the hospital in Kingston that night, after his bullet wounds had been tended to, and over the next few days at Blackwell's Strawberry Hill estate as the difficult decision about whether he should still perform at the Smile Jamaica concert was made. Bob ultimately did perform a legendary concert that night with only one hand held 16mm camera filming the remarkable event. Never had I missed Kim's eye more.

The last time I would meet with Bob was November 27, 1979, during what would be his final US tour, to show him and the band and their entire traveling family the documentary I had made about the events leading up to the Smile Jamaica concert and then the footage of them performing that night. They all loved it, but it was also obviously bittersweet on so many levels. Unfortunately, that film was never finished and the footage of that historic concert has never been officially released.

Bob's passing on May 11, 1981 unquestionably ended the Golden Age of reggae this book celebrates. The music itself is still vibrant and has millions of fans around the world and Bob Marley's songs and his albums with Peter Tosh, Bunny Livingston, the I-Three and all the Wailers are timeless and as powerful and relevant as ever. But the vast array of talent, personalities and great music that defined the brief period covered in this book has never been even remotely equaled.

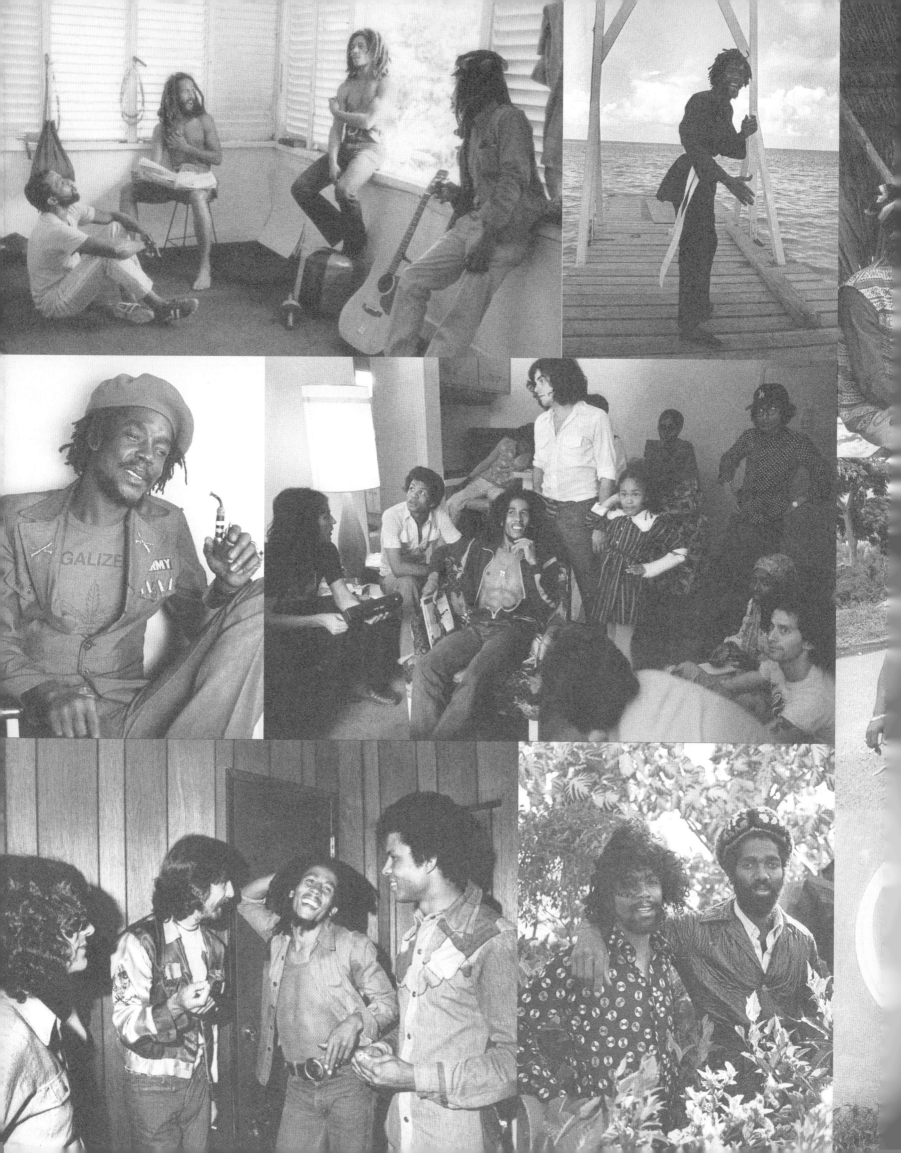